KRISTEN R. G

When the Berlin Wall fell in 1989, Kristen R.
Ghodsee was travelling in Europe. She spent the
summer of 1990 witnessing first-hand the initial
hope and euphoria that followed the sudden
and unexpected collapse of state socialism in the
former Eastern Bloc. The political and economic
chaos that followed inspired Ghodsee to pursue
an academic career studying how ordinary
people's lives – and women's particularly – were
changed by this upheaval.

For the last two decades, she has visited the region
regularly and lived for over three years in Bulgaria
and the Eastern parts of reunified Germany.
Now a professor of Russian and East European
Studies at the University of Pennsylvania, she
has won many awards for her work, including
a Guggenheim Fellowship, and has written six
books on gender, socialism, and post socialism.
Her essays and articles have appeared in many
outlets, including *The Washington Post* and *The
New York Times*.

KRISTEN R. GHODSEE

Why Women Have Better Sex Under Socialism

And Other Arguments for Economic
Independence

VINTAGE

5 7 9 10 8 6

Vintage
20 Vauxhall Bridge Road,
London SW1V 2SA

Vintage is part of the Penguin Random House group of companies
whose addresses can be found at global.penguinrandomhouse.com.

Penguin
Random House
UK

First published in the US by Nation Books in 2018
First published in the UK by The Bodley Head in 2018
First published by Vintage in 2019

penguin.co.uk/vintage

A CIP catalogue record for this book is available from the British Library

ISBN 9781529110579

Printed and bound in Great Britain by Clays Ltd, Elcograf S.p.A.

Penguin Random House is committed to a sustainable future
for our business, our readers and our planet. This book is
made from Forest Stewardship Council® certified paper.

For Hayden, Jo, and Nana

CONTENTS

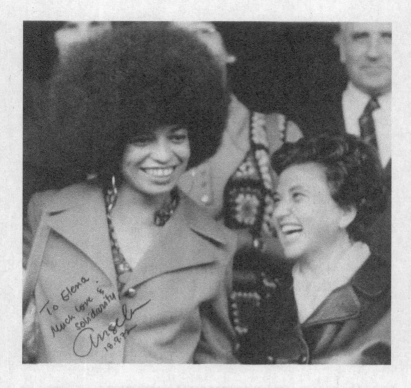

Elena Lagadinova (right, with Angela Davis) (1930–2017): The youngest female partisan fighting against Bulgaria's Nazi-allied monarchy during World War II. She earned her PhD in agrobiology and worked as a research scientist before she became the president of the Committee of the Bulgarian Women's Movement. Lagadinova led the Bulgarian delegation to the 1975 United Nations First World Conference on Women. Because free markets discriminate against those who bear children, Lagadinova believed that only state intervention could support women in their dual roles as workers and mothers. *Courtesy of Elena Lagadinova.*

PREFACE FOR READERS OUTSIDE THE USA

Americans have a bad reputation for being insular, ignorant, and arrogant (not to mention loud, overweight, and poorly dressed). For many residents of the USA, the rest of the world barely exists unless our government happens to be bombing some part of it. So when I first learned that this book was going to be published internationally, I cringed at how America-centric it seemed since all of my scholarly work focuses on Eastern Europe. In my defense, this book was born because of a short editorial I wrote in *The New York Times* in August 2017—'Why Women Had Better Sex Under Socialism'—which caused a storm of interest and debate. As my words zinged across the fibers of cyberspace, the US publishing house Nation Books asked me if I would like the chance to develop my arguments at greater length, providing references to all of the research and evidence upon which they were based. One of the biggest criticisms of my Op-Ed was that I didn't provide enough proof to substantiate my claims, something quite hard in a 1200-word piece, so I jumped at the opportunity to share this unique body of scholarship with interested readers. In all of those initial conversations with my editor, the idea was that I should speak directly to young

American women infuriated and newly mobilized by the sexist politics of our pussy-grabbing Tweeter-in-Chief. This was to be a short book substantiating and expanding upon my argument tailored to Millennials and members of Generation Z born long after the fall of the Berlin Wall, but caged in an American culture still infused with virulent anti-communism.

As far as capitalism goes, the United States embraces a pretty savage version of it, and I know this personally because I have been fortunate enough to have lived, worked, and studied in Africa, Asia, and Europe for over a decade of my life: a year in Ghana, three years in Japan, three years in Bulgaria, and another three years or so in Western Europe. When I compare the lifestyles of ordinary people in Europe or Asia with those of my American compatriots, the stark difference in the perceived role of the government in providing a social safety net still shocks me. Americans speak derisively of the "Nanny State" while the rest of the developed world enjoys policies that provide some form of national health care, free or subsidized higher education, and paid maternity leaves to name just a few things. Even in the poorest member state of the European Union, socially marginalized Bulgarians enjoy more social protection than Americans who fall on hard times. In some ways, I just wanted to let young Americans know that—despite what conservative politicians want them to believe—democratic socialism can work and must be shorn of the historical baggage of the failed twentieth-century experiments with state socialism in Eastern Europe. Just as today's ideals of the free market have been decoupled from their past associations with slavery and imperialism, the ideal of a state that can

guarantee human dignity in the face of rapacious global capitalism must be disentangled from its past association with forced collectivization, labor camps, and purges. This is not to deny history—slavery, imperialism, collectivization, gulags, and purges must always inform our collective understandings of the historical development of capitalism and socialism. But political and economic systems evolve and change over time; proponents of the unfettered free market embrace this dynamism for capitalism, but are loath to accept it for socialism. My hope was to inspire American readers to think critically about the history they are taught in schools and to learn from the experiences of other countries that have experimented with socialism in its variegated forms.

To mitigate the original focus on a younger American audience, I have made some small adjustments to this version of the text, including a few new points and statistics that speak more directly to British and European readers. It's also important to keep in mind that the status and reputation of socialism in Britain and Western Europe is different from the kind of knee-jerk anti-left bias we have in the US where even the slightest mention of socialized medicine leads to frenzied screaming about totalitarianism. Britain, for example, has a rich history of socialism that stretches back all the way to the Civil War. It had its first Socialist minority government in 1924 under Ramsay MacDonald, including the famous commitment in Clause IV of its constitution to common ownership of industry. In research that I did for an earlier book on the historical memory of World War II, I studied the life of a British Special Operations Officer named Frank Thompson who died fighting

with the anti-fascist partisan rebels in Bulgaria. In the late 1930s, when he studied at Oxford, Iris Murdoch convinced Thompson to join the Communist Party of Great Britain and many young and idealistic British men and women committed themselves to leftist politics in the years leading up to the war, including Thompson's younger brother, Edward Palmer Thompson, the great labor historian. It is therefore no surprise that the UK had a majority democratic socialist government in 1945 under Clement Atlee. It was socialism that helped rebuild Britain after the devastations of war.

The reputation of socialism took a severe battering after 1989, and many European countries embraced neoliberal economic policies and tried to pare back their social spending. In the UK, Labour removed Clause IV in 1994 under Tony Blair and distanced itself from its socialist roots. Even so, the word "socialism" fails to elicit the same degree of vitriol as it does in the US, and the UK never experienced a real Red Scare where the government bullied, intimidated, and ruined the lives of those with Marxist sympathies. It is one of the great ironies of American history that a country that valorises political rights (such as freedom of conscience and association) once cruelly persecuted those who either held unpopular beliefs or happened to have some contact with those who did. McCarthyism continues to cast a long shadow on American political discourse.

But socialism is still viewed with suspicion in the UK. Critics of Jeremy Corbyn call him a "populist," and the legacy media describe Spain's Podemos and Greece's Syriza as the left-wing equivalents of far-right nationalist parties like UKIP, Golden Dawn, or the National Front. Although

three decades have passed since the collapse of East European state socialism, many ordinary people still associate socialist ideas with "extremism." Common ownership of industry now sounds like a wildly radical proposition, which just goes to show how completely the neoliberal ideology has come to dominate our mainstream political discourse and thinking. To paraphrase the cultural theorist Fredric Jameson: it is easier for many of us to imagine the end of the world than it is for us to imagine the end of capitalism.

This hegemony of neoliberal ideas, the blind faith in the free market, and the almost universal desire of economic elites to preserve their own wealth and privilege affects the political imagination in all developed countries. Thus, even though I recognize that the specific context is different in the UK and Western European countries such as France and the Netherlands—most obviously in terms of the state provision of healthcare and social security—the arguments of this book are no less pertinent. I also acknowledge that Britain has had female prime ministers, and that Angela Merkel has been the head of state in Germany for over a decade, but the vast majority of women are still suffering the injustices that capitalism creates and exacerbates. In the UK and Europe, most women are paid less than men for the same jobs and struggle to balance their work and family responsibilities. In countries where austerity policies have cut social services and supports, it is women who take up the slack, caring for the young, the sick, and the elderly while the bankers luxuriate in their riches.

Between 2014 and 2016, I lived for almost two years in Germany and Finland, and I watched with great trepidation the rise of new right-wing forces across the continent:

Viktor Orbán in Hungary, the Law and Justice Party in Poland, PEGIDA and the Alternativ für Deutschland (AfD) in Germany. But I also spent the month of August 2016 living in London and doing research in the British Library and the National Archives. Once the general shock of the Brexit vote started to wear off, I was heartened to meet young Brits excited about Corbyn and the possibility of having a real Labour Party again. In some ways, this book is more relevant to the British context than it is to the American one, since there is a genuine opportunity for achieving social and economic changes based on socialist principles in the UK. The same is probably true of other European countries where—if left parties could find a way to work together—they might gain parliamentary control and be able to take a stand against austerity and the human carnage it has created across the Continent.

But perhaps the most important message of this book is that things can change. Economic elites invested in the status quo want you to get frustrated and check out of the political process. They fuel your disgust and revel in your apathy. The possibility for real political change may be easier in some countries than in others, but it is a historical constant no matter where you live. Empires rise and fall and no one understands this better than those of you who live in nations that have existed for longer than 250 years.

Of course, change doesn't always have to be good. Things can get a hell of a lot worse before they start to get better. If democracy falters in the United States, as seems more and more likely under the increasingly authoritarian tendencies of our current president, please remember: the majority of us did not vote for him, and there were many

Americans fighting the nativist tide. When the time comes, I do hope you will find a way to forgive our arrogance, ignorance, and insularity. Some of us might need political asylum.

Kristen R. Ghodsee
Sofia, Bulgaria
June 8, 2018

AUTHOR'S NOTE

For the last twenty years, I have studied the social impacts of the political and economic transition from state socialism to capitalism in Eastern Europe. Although I first traveled through the region just months after the fall of the Berlin Wall in 1989, my professional interest began in 1997, when I started conducting research on the impacts of the collapse of communist ideology on ordinary people. First as a PhD student and later as a university professor, I lived for more than three years in Bulgaria and nineteen months in both eastern and western Germany. In the summer of 1990, I also spent two months traveling through Yugoslavia, Romania, Hungary, Czechoslovakia, and the soon-to-disappear German Democratic Republic. In the intervening years, I've been a frequent visitor to Eastern Europe, delivering invited lectures in cities such as Belgrade, Bucharest, Budapest, and Warsaw. Because I often travel by car, bus, and train, I've seen firsthand the ravages of neoliberal capitalism across the region: bleak landscapes pockmarked with the decrepit remains of once thriving factories giving way to new suburbs with Walmart-style megastores selling forty-two different types of shampoo. I've also studied how the institution of unregulated free markets in

Eastern Europe returned many women to a subordinate status, economically dependent on men.

Since 2004, I've published six scholarly books and over three dozen articles and essays, using empirical evidence gathered from archives, interviews, and extended ethnographic fieldwork in the region. In this book, I draw on over twenty years of research and teaching to write an introductory primer for a general audience interested in European socialist feminist theories, the experience of twentieth-century state socialism, and their lessons for the present day. After the unexpected surge in support for Bernie Sanders in the US, Jeremy Corbyn in the UK and European political parties such as Spain's Podemos and Greece's Syriza, socialist ideas are circulating more broadly. It is essential that we pause and learn from the experiences of the past, examining both good and bad. Because I believe in the pursuit of historical nuance, and that there were some redeeming qualities of state socialism, I will inevitably be accused of being an apologist for Stalinism. Vitriolic ad hominem attacks are the reality of our hyperpolarized political climate, and I find it quite ironic that those who claim to abhor totalitarianism have no trouble silencing speech or unleashing hysterical Twitter mobs. The German political theorist Rosa Luxemburg once said: "Freedom is always and exclusively freedom for the one who thinks differently." This book is about learning to think differently with regard to the state socialist past, our neoliberal capitalist present, and the path to our collective future.

Throughout this book, I use the term "state socialism" or "state socialist" to refer to the states of Eastern Europe and the Soviet Union dominated by ruling Communist

Parties where political freedoms were curtailed. I use the term "democratic socialism" or "democratic socialist" to refer to countries where socialist principles are championed by parties that compete in free and fair elections and where political rights are maintained. Although many parties referred to themselves as "communist," that term denotes the ideal of a society where all economic assets are collectively owned and the state and law have withered away. In no case has real communism been achieved, and therefore I try to avoid this term when referring to actually existing states.

On the topic of semantics, I have also endeavored to be sensitive to contemporary intersectional vocabularies. For example, when I talk about "women" in this book, I am primarily referring to cisgender women. The nineteenth- and twentieth-century socialist "woman question" did not consider the unique needs of trans women, but I have no desire to exclude or alienate trans women from the current discussion. Similarly, in my discussion of maternity, I do recognize that I am discussing those who are female-assigned-at-birth (FAB), but for the sake of simplicity, I use the word "woman" even though this category includes some who identify as men or other genders.

Because this is an introductory book, there will be places in the text where I don't go into full detail about the debates surrounding topics such as Universal Basic Income (UBI), surplus value extraction, or gender-based quotas. In particular, although I believe that they are absolutely essential, I don't spend a lot of time discussing universal single-payer health care or free public postsecondary education, because I feel these policies have been discussed at length elsewhere. I hope readers are inspired to explore

more about the issues raised within these pages, taking this book as an invitation for further exploration of the intersections of socialism and feminism. I also want to make it clear that this is not a scholarly treatise; those in search of theoretical frameworks and methodological debates should consult the books I've published with university presses. I also recognize the long and important tradition of Western socialist feminism, although it is not discussed in these pages. I encourage interested readers to refer to the books listed in the suggestions for further reading.

For all of the direct quotations and statistical claims made throughout the book, I include consolidated citations in an endnote at the end of the relevant paragraph. Few substantive endnotes accompany this text, so most readers can feel free to ignore the endnotes unless they have a question about a particular source. General historical material can be found in the suggestions for further reading. When discussing personal anecdotes, I have changed the names and identifying details to preserve anonymity.

Finally, with the many social ills plaguing the world today, some might find the chapters on intimate relations a bit too prurient for their taste; some might think that having better sex is a trivial reason to switch economic systems. But turn on the television, open a magazine, or surf the internet, and you will find a world saturated with sex. Capitalism has no problem commodifying sexuality and even preying on our relationship insecurities to sell us products and services we don't want or need. Neoliberal ideologies persuade us to view our bodies, our attentions, and our affections as things to be bought and sold. I want to turn the tables. To use the discussion of sexuality to expose the

shortcomings of unfettered free markets. If we can better understand how the current capitalist system has co-opted and commercialized basic human emotions, we have taken the first step toward rejecting market valuations that purport to quantify our fundamental worth as human beings. The political is personal.

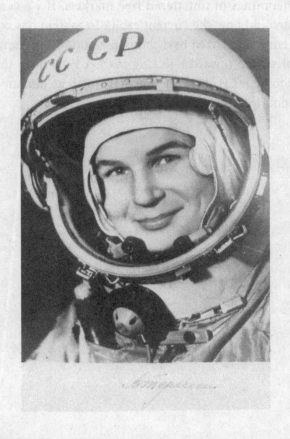

Valentina Tereshkova: (born 1937) The first woman in space, Tereshkova orbited the Earth forty-eight times in July 1963 on *Vostok 6*. After her career as a cosmonaut, Tereshkova became a prominent politician and led the Soviet delegation to the 1975 United Nations World Conference on Women. She is still widely viewed as a national heroine in Russia today. *Courtesy of Elena Lagadinova.*

YOU MIGHT BE SUFFERING FROM CAPITALISM

The argument of this book can be summed up suc-
cinctly: Unregulated capitalism is bad for women,
and if we adopt some ideas from socialism, women will
have better lives. If done properly, socialism leads to eco-
nomic independence, better labor conditions, better work/
family balance, and, yes, even better sex. Finding a way into
a better future requires learning from the mistakes of the
past, including a thoughtful assessment of the history of
twentieth-century state socialism in Eastern Europe.

That's it. If you like the idea of such outcomes, then
come along for an exploration of how we might change
things. If you are dubious because you don't understand
why capitalism as an economic system is uniquely bad for
women, and if you doubt that there could ever be anything
good about socialism, this short treatise will provide some
illumination. If you don't give a whit about women's lives
because you're a gynophobic right-wing internet troll, save
your money and get back to your parents' basement right
now; this isn't the book for you.

1

Of course, some might argue that unregulated capitalism sucks for almost *everyone*, but I want to focus on how capitalism disproportionately harms women. Competitive labor markets discriminate against those whose reproductive biology makes them primarily responsible for child bearing. Today, this means humans who get pink hats in the hospital and the letter "F" next to the name on their birth certificate (as if we've already failed by not coming into the world as a boy). Competitive labor markets also devalue those expected to be the primary caregivers of children. Although societal attitudes have evolved in this regard, our idealization of motherhood means that most of us still believe that baby needs mama a whole lot more than papa—at least until the child is old enough to play sports.

Others will argue that unregulated capitalism is not bad for *all* women. Yes, for those women lucky enough to sit at the top of the income distribution, the system works pretty well. Although women at the executive level still face gender pay gaps and remain underrepresented in leadership positions, on the whole things aren't too shabby for the Sheryl Sandbergs of the world. Of course, sexual harassment still hinders progress even for those at the top, and too many women believe that if you want to run with the big dogs, you may have to suck it up and ignore the groping and unwanted advances. And race plays an important role as well; white women do a lot better in aggregate than do women of color. But when we look at society as a whole, on average, women are comparatively worse off in countries where markets are less encumbered by regulation, taxation, and public enterprises than they are in nations where state revenues support greater levels of redistribution and larger social safety nets.

Choose your data source, and you find the same story. Unemployment and poverty plague women with children. Employers discriminate against women without children because they might have them in the future. In the United States in 2013, women over the age of sixty-five suffered from poverty at much greater rates than men and dominated those in the category of "extreme poverty." Globally, women face higher rates of economic deprivation. Women are often the last to be hired and the first to be fired in cyclical downturns, and when they do find employment, bosses pay them less than men. When states need to slash government spending on education, health care, or old age pensions, mothers, daughters, sisters, and wives must pick up the slack, diverting their energies to care for the young, the sick, and the elderly. Capitalism thrives on women's unpaid labor in the home because women's care work supports lower taxes. Lower taxes mean higher profits for those already at the top of the income ladder—mostly men.[1]

But capitalism was not always so savage. Throughout much of the twentieth century, state socialism presented an existential challenge to the worst excesses of the free market. The threat posed by Marxist ideologies forced Western governments to expand social safety nets to protect workers from the unpredictable but inevitable booms and busts of the capitalist economy. After the Berlin Wall fell, many celebrated the triumph of the West, consigning socialist ideas to the dustbin of history. But for all its faults, state socialism provided an important foil for capitalism. It was in response to a global discourse of social and economic rights—a discourse that appealed not only to the progressive populations of Africa, Asia, and Latin America but also to many men and women in Western Europe and North America—that

politicians agreed to improve working conditions for wage laborers as well as create social programs for children, the poor, the elderly, the sick, and the disabled, mitigating exploitation and the growth of income inequality. Although there were important antecedents in the 1980s, once state socialism collapsed, capitalism shook off the constraints of market regulation and income redistribution. Without the looming threat of a rival superpower, the last thirty years of global neoliberalism have witnessed a rapid shriveling of social programs that protect citizens from cyclical instability and financial crises and reduce the vast inequality of economic outcomes between those at the top and bottom of the income distribution.

For much of the twentieth century, Western capitalist countries also endeavored to outdo the East European countries in terms of women's rights, fueling progressive social change. For example, the state socialists in the USSR and Eastern Europe were so successful at giving women economic opportunities outside the home that initially, for two decades after the end of World War II, women's wage work was conflated with the evils of communism. The American way of life meant male breadwinners and female homemakers. But slowly, socialist championing of women's emancipation began to chip away at the *Leave It to Beaver* ideal. The Soviet launch of *Sputnik* in 1957 spurred American leaders to rethink the costs of maintaining traditional gender roles. They feared the state socialists enjoyed an advantage in technological development because they had double the brainpower; the Russians educated women and funneled the best and the brightest into scientific research.[2]

Fearing Eastern Bloc superiority in the space race, the American government passed the National Defense Education Act (NDEA) in 1958. Despite a continuing cultural desire for women to stay at home as dependent wives, the NDEA created new opportunities for talented girls to study science and math. Then, in 1961, President John F. Kennedy signed Executive Order 10980 to establish the first Presidential Commission on the Status of Women, citing national security concerns. This commission, chaired by Eleanor Roosevelt, laid the groundwork for the future US women's movement. Americans received a further shock in 1963, when Valentina Tereshkova became the first female cosmonaut, spending more time orbiting the Earth than all male astronauts in the United States had, combined. Later, Soviet and East European dominance at the Olympics spurred the passage of Title IX, so that the United States could identify and train more female athletes to snatch gold medals away from the ideological enemy.[3]

In response to state socialist prowess in the sciences, the American government sponsored an important study titled "Women in the Soviet Economy." The head of the study visited the USSR in 1955, 1962, and 1965 to examine Soviet policies to integrate women into the formal labor force as an example for American legislators. "Concern in recent years on the waste of women's talent and labor potential led to the appointment of the President's Commission on the Status of Women, which has issued a series of reports on various problems affecting women and their participation in economic, political, and social life," the 1966 report began. "For any formulation of policy directed toward the better use of our women power, it is important to know the experience

of other nations in utilizing the capabilities of women. For this reason as well as others, the Soviet experience is of particular interest at this time." The precedent set by the state socialist countries in Eastern Europe acted as an influential example for American politicians at the same historical moment that Betty Friedan published *The Feminine Mystique* and revealed how unsatisfied middle-class, white women felt with their circumscribed domestic lives. But in the current political climate, it may be hard to fathom how a rivalry between superpowers could have sparked interest in the status of women.[4]

Today, socialist ideas are enjoying a renaissance as young people across countries such as the United States, France, Great Britain, Greece, and Germany find inspiration in politicians like Bernie Sanders, Jean-Luc Mélenchon, Jeremy Corbyn, Yanis Varoufakis, and Sahra Wagenknecht. Citizens desire an alternative political path that would lead to a more egalitarian and sustainable future. To move forward, we must be able to discuss the past with no ideologically motivated attempts to whitewash or blackwash either our own history or the accomplishments of state socialism. On the one hand, any nuanced account of twentieth-century state socialism will inevitably encounter the sputtering and bluster of those who insist that it was pure evil, end of story. As the Czech writer Milan Kundera wrote in his famous novel *The Unbearable Lightness of Being*: "The people who struggle against what we call totalitarian regimes cannot function with queries and doubts. They, too, need certainties and simple truths to make the multitudes understand,

to provoke collective tears."[5] On the other hand, some young people today joke about "full communism now." Leftist millennials might not know about (or prefer to ignore) the real horrors inflicted on citizens in one-party states. Gruesome tales of the secret police, travel restrictions, consumer shortages, and labor camps are not just anticommunist propaganda. Our collective future depends on a balanced examination of the past so we can discard the bad and move forward with the good, especially where women's rights are concerned.

Since the middle of the nineteenth century, European social theorists argued that the female sex is uniquely disadvantaged in an economic system that prizes profits and private property over people. Throughout the 1970s, socialist feminists in the United States and Britain also asserted that smashing the patriarchy wasn't enough. Exploitation and inequality would persist so long as financial elites built their fortunes on the backs of docile women reproducing the labor force for free. But these early critiques were based on abstract theories with little empirical evidence to substantiate them. Slowly, over the course of the first half of the twentieth century, new democratic socialist and state socialist governments in Europe began to test these theories in practice. In East Germany, Scandinavia, the Soviet Union, and Eastern Europe, political leaders supported the idea of women's emancipation through their full incorporation into the labor force. These ideas soon spread to China, Cuba, and a wide variety of newly independent countries across the globe. Experiments with female economic independence fueled the twentieth-century women's movement and resulted in a revolution in the life paths open to women

previously confined to the domestic sphere. And nowhere in the world were there more women in the workforce than under state socialism.[6]

Women's emancipation infused the ideology of almost all state socialist regimes, with the Franco-Russian revolutionary Inessa Armand famously declaring: "If women's liberation is unthinkable without communism, then communism is unthinkable without women's liberation." Although important differences existed between countries and none achieved full equality in practice, these nations did expend vast resources to invest in women's education and training and to promote them in professions previously dominated by men. Understanding the demands of reproductive biology, they also attempted to socialize domestic work and child care by building a network of public crèches, kindergartens, laundries, and cafeterias. Extended, job-protected maternity leaves and child benefits allowed women to find at least a modicum of work/family balance. Moreover, twentieth-century state socialism did improve the material conditions of millions of women's lives; maternal and infant mortality declined, life expectancy increased, and illiteracy all but disappeared. To take just one example, the majority of Albanian women were illiterate before the imposition of socialism in 1945. Just ten years later, the entire population under forty could read and write, and by the 1980s half of Albania's university students were women.[7]

While different countries pursued different policies, in general state socialist governments reduced women's economic dependence on men by making men and women equal recipients of services from the socialist state. These policies helped to decouple love and intimacy

from economic considerations. When women enjoy their own sources of income, and the state guarantees social security in old age, illness, and disability, women have no economic reason to stay in abusive, unfulfilling, or otherwise unhealthy relationships. In countries such as Poland, Hungary, Czechoslovakia, Bulgaria, Yugoslavia, and East Germany, women's economic independence translated into a culture in which personal relationships could be freed from market influences. Women didn't have to marry for money.[8]

Of course, just as we can learn from the experiences of Eastern Europe, we shouldn't ignore the downsides. Women's rights in the Eastern Bloc failed to include a concern for same-sex couples and gender nonconformity. Abortion served as a primary form of birth control in the countries where it was available on demand. Most East European states strongly encouraged women to become mothers, with Romania, Albania, and the USSR under Stalin forcing women to have children they didn't want. State socialist governments suppressed discussions of sexual harassment, domestic violence, and rape. And although they tried to get men involved in housework and child care, men largely resisted challenges to traditional gender roles. Many women suffered under a double burden of mandatory formal employment and domestic work, as so well captured in Natalya Baranskaya's brilliant novella, *A Week Like Any Other*. Finally, in no country were women's rights promoted as a project to support women's individualism or self-actualization. Instead, the state supported women as workers and mothers so they could participate more fully in the collective life of the nation.[9]

After the fall of the Berlin Wall in 1989, new democratic governments rapidly privatized state assets and dismantled social safety nets. Men under these newly emerging capitalist economies regained their "natural" roles as family patriarchs, and women were expected to return home as mothers and wives supported by their husbands. Across Eastern Europe, post-1989 nationalists argued that capitalist competition would relieve women of the notorious double burden and restore familial and societal harmony by allowing men to reassert their masculine authority as breadwinners. However, this meant that men could once again wield financial power over women. For instance, the renowned historian of sexuality Dagmar Herzog shared a conversation with several East German men in their late forties in 2006. They told her that "it was really annoying that East German women had so much sexual self-confidence and economic independence. Money was useless, they complained. The few extra Eastern Marks that a doctor could make in contrast with, say, someone who worked in the theater, did absolutely no good, they explained, in luring or retaining women the way a doctor's salary could and did in the West. 'You had to be interesting.' What pressure. And as one revealed: 'I have much more power now as a man in unified Germany than I ever did in communist days.'" Furthermore, following the publication of my *New York Times* op-ed, "Why Women Had Better Sex Under Socialism," I did an interview with Doug Henwood on his radio show, *Behind the News*. One listener, a forty-six-year-old woman born in the Soviet Union, emailed the show to say that I had "nailed it" in my discussion of romantic relations in "the old

country," as she called it, "but also the way men lord it over women with money here [in the United States]."[10]

The collapse of state socialism in 1989 created a perfect laboratory to investigate the effects of capitalism on women's lives. The world could watch as free markets were conjured from the rubble of the planned economy, and these new markets variously affected different categories of workers. After decades of shortages, East Europeans eagerly exchanged authoritarianism for the promise of democracy and economic prosperity, throwing their countries open to Western capital and international trade. But there were unforeseen costs.

The rejection of the one-party state and the embrace of political freedoms came bundled with economic neoliberalism. New democratic governments privatized public enterprises to make room for new competitive labor markets where productivity would determine wages. Gone were the long lines for toilet paper and the black markets for jeans. Coming soon was a glorious consumer paradise free from shortages, famines, the secret police, and the labor camp. But after almost three decades, many Eastern Europeans still wait for a bright capitalist future. Others have abandoned all hope.[11]

The evidence is incontrovertible: like so many other women across the globe, women in Eastern Europe are once again commodities to be bought and sold—their price determined by the fickle fluctuations of supply and demand. Writing in the immediate aftermath of state socialism's collapse, the Croatian journalist Slavenka Drakulić explained, "We live surrounded by newly opened

porno shops, porno magazines, peepshows, stripteases, un-
employment, and galloping poverty. In the press they call
Budapest 'the city of love, the Bangkok of Eastern Europe.'
Romanian women are prostituting themselves for a single
dollar at the Romanian-Yugoslav border. In the midst of all
this, our anti-choice nationalist governments are threaten-
ing our right to abortion and telling us to multiply, to give
birth to more Poles, Hungarians, Czechs, Croats, Slovaks."
Today, Russian mail-order brides, Ukrainian sex workers,
Moldovan nannies, and Polish maids flood Western Eu-
rope. Unscrupulous middle men harvest blond hair from
poor Belorussian teenagers for New York wig makers. In St.
Petersburg, women attend academies for aspiring gold dig-
gers. Prague is an epicenter of the European porn industry.
Human traffickers prowl the streets of Sofia, Bucharest, and
Chişinău for hapless girls dreaming of a more prosperous
life in the West.[12]

Older citizens of Eastern Europe fondly recall the small
comforts and predictability of their life before 1989: free ed-
ucation and health care, no fear of unemployment and of
not having money to meet basic needs. A joke, told in many
East European languages, illustrates this sentiment:

In the middle of the night a woman screams and jumps
out of bed, eyes filled with terror. Her startled husband
watches her rush into the bathroom and open the medi-
cine cabinet. She then dashes to the kitchen and inspects
the inside of the refrigerator. Finally, she flings open a
window and gazes out onto the street below their apart-
ment. She takes a deep breath and returns to bed.

"What's wrong with you?" her husband says. "What happened?"

"I had a terrible nightmare," she says. "I dreamed that we had the medicine we needed, that our refrigerator was full of food, and that the streets outside were safe and clean."

"How is that a nightmare?"

The woman shakes her head and shudders. "I thought the Communists were back in power."

Opinion polls throughout the region continue to show that many citizens believe their lives were better before 1989, under authoritarianism. Although these polls may say more about disappointment with the present than they do about the desirability of the past, they complicate the totalitarian narrative. For example, a 2013 random poll of 1,055 adult Romanians found that only a third reported that their lives were worse off before 1989: 44 percent said their lives were better, and 16 percent said there was no change. These results were also gendered in interesting ways: whereas 47 percent of women thought that state socialism was better for their country, only 42 percent of men said the same. Similarly, whereas 36 percent of men claimed that life was worse before 1989, only 31 percent of women said life under the dictator Nicolae Ceaușescu was worse than the present. And this is from Romania, one of the most corrupt and oppressive regimes in the former Eastern Bloc where Ceaușescu gold-plated the flushing handle on his private toilet. Similar results emerged from surveys in Poland in 2011 and from an opinion poll conducted in eight other

former socialist nations in 2009. For citizens who have had the opportunity to live under two different economic systems, many now feel that capitalism is worse than the state socialism they were once so eager to cast aside.[13]

Back in the United States and Britain, the collapse of East European state socialism ushered in an era of Western capitalist triumphalism. Great Society ideas about how to regulate our economy and redistribute wealth to maximize the well-being of all citizens, including women, fell out of favor. The rise of what was called the Washington Consensus (born of Reaganomics) meant marketization, privatization, and the shredding of social safety nets in the name of efficiency. Throughout the 1990s and 2000s, citizens witnessed increasing deregulation of the financial, transportation, and utility sectors and the growing commodification of everyday life. We conflated freedom with free markets. After the global financial crisis in 2008, economic elites targeted already lean state budgets, slashing deeper into social programs while using taxpayer monies to bail out the bankers who created much of the mess in the first place. Occupy Wall Street called attention to structural inequality, but politicians on both sides of the aisle met rising public anger with the same old line: there is no alternative to capitalism.

This is a lie.

Conservative cold warriors will counter any attempt to complicate the history of twentieth-century state socialism with screaming about Stalin's famines and purges. In their imagination, the entire experience of state socialism consisted of people standing in bread lines and snitching

on their neighbors to the secret police. For seventy years in the Soviet Union and forty-five years in Eastern Europe, totalitarian leaders apparently shuttled everyone back and forth between labor camps and prisons, a godless Orwellian nightmare where people wore grey, unisex Mao suits and sported shaved heads. If babies were born, it's not because people chose to start families, but because the Party mass-inseminated the population to meet predetermined human production quotas. Anticommunists refuse to acknowledge the important differences among the wide variety of societies that embraced socialism or to credit them for their various achievements in science, education, health outcomes, culture, and sport. In the stereotypes promoted by Western leaders, state socialism was an inefficient economic system doomed to inevitable collapse *and* a terrifying red menace requiring billions of dollars of taxpayer money to contain. It's odd to consider how it could have been both.

Within Eastern Europe today, numerous Western-funded research institutes investigate the crimes of communism. In countries like Hungary, Bulgaria, and Romania (all German allies in World War II) the descendants of Nazi collaborators are keen to paint themselves as "victims of communism." Local politicians and economic elites who benefitted from the transition to free markets (particularly those who had the previously nationalized property of their grandparents restituted to them after 1989) collude to create one official totalitarian narrative about the past. For example, after a lecture I gave in Vienna in 2011, a young Bulgarian woman in the audience sent an email thanking me for my courage in discussing some of the positive legacies

of Todor Zhivkov, Bulgaria's leader from 1954 to 1989. "No
one [in Bulgaria] can talk about the nostalgia and the pains
of transition without being framed as a communist and as
someone who denies the crimes of the Zhivkov regime. So
the important issues you deal with are not present in the
discourse or media."[14] In nearby Romania, the literary
scholar Costi Rogozanu has criticized the East European
practice of using horror stories about the state socialist past
to justify the continued implementation of neoliberal eco-
nomic policies in the present: "Do you want a salary raise?
You are communist. Do you want public services? Do you
want to tax the rich and ease the burden on small produc-
ers and wage earners? You are a communist and you killed
my grandparents. Do you want public transportation in-
stead of highways? You are mega-communist and a [stupid]
hipster."[15]

Although it's important not to romanticize the state
socialist past, the ugly realities should not make us com-
pletely oblivious to the ideals of the early socialists, to the
various attempts to reform the system from within (such as
the Prague Spring, glasnost, or perestroika), or to the im-
portant role that socialist ideals played in inspiring national
independence movements in the Global South. Acknowl-
edging the bad does not negate the good. Just as there are
those who would like to whitewash American history by
downplaying, just for starters, Jim Crow, institutional rac-
ism, gun violence, or the unprecedented incarceration rate,
there are those who would blackwash the history of state
socialism, insisting that everything was evil.[16]

Today, we have over two hundred years of experi-
mentation with various forms of socialism, but the word

"socialism" still carries negative connotations. Howls about Stalin's Gulag and Ukrainian famines meet any mention of socialist principles. Opponents decry it as an economic system doomed to failure and inevitably leading to totalitarian terror, while ignoring the successful democratic socialist nations in Scandinavia. Europe was a battleground in the Cold War, and the northern European countries once had large, domestic communist and socialist parties that participated in the parliamentary process, promoting policies that ensured redistribution and social welfare. In the 1990s, while Russia, Hungary, and Poland liquidated state assets and dismantled their social safety nets, Denmark, Sweden, and Finland maintained generous public spending financed by government-owned industries and progressive taxation despite the global fashion for neoliberalism. The democratic socialist societies of Northern Europe show that it's possible to find a humane alternative to neoliberal capitalism. And although they aren't perfect or easy to replicate— they are ethnically homogenous and increasingly hostile to immigrants—they have found ways to combine the political freedoms of the West with the social securities of the East.

Northern Europe is not only the happiest place to live in the world but an oasis for women who enjoy more economic and political power than anywhere else on the planet. In a brilliant article in *Dissent*, "Cockblocked by Redistribution: A Pick-Up Artist in Denmark," Katie J. M. Baker exposed how the American womanizer Daryush Valizadeh (aka Roosh) warned his fans that Denmark was a veritable desert for men on the hunt for easy women. The country's generous social safety net and gender equalizing policies apparently render Valizadeh's alpha male seduction

techniques useless because Danish women don't need men
for financial security. In less egalitarian countries, women
understand that sexual relationships provide an avenue for
social mobility—the Cinderella fantasy. But when women
earn their own money and live in societies where the state
supports their independence, Prince Charming loses his
appeal. Roosh's book, *Don't Bang Denmark*, stands as a tes-
tament to the idea that redistributive policies can provide
women the stability and security that mitigates the effects
of discrimination in daily life.[17]

Young people are rediscovering the idea that democratic
governments have a role in ensuring a just economy. To-
day, corporations and wealthy elites influence politicians
to do their bidding through campaign contributions and
hired lobbyists: cut services for the poor to slash taxes
for the rich. The 2010 Supreme Court decision in *Citizens
United v. FEC* affirmed the idea that money equals speech
and therefore deserved protection under the First Amend-
ment of the Constitution. But as long as the United States
remains a representative democracy, ordinary people can
vote their economic interests and choose leaders who will
pursue policies of redistribution and support social safety
nets for all. By 2020, millennial voters will make up the
largest demographic group of the American electorate. And
young women make up half of the millennial population.
The math here is simple.

A June 2015 Gallup poll found that Americans ages
eighteen to twenty-nine were more willing to vote for a "so-
cialist" presidential candidate than any other age cohort,

and this was well before Bernie Sanders's primary campaign was in full swing. In addition, a January 2016 YouGov poll asked Americans, "Do you have a favorable or an unfavorable opinion of socialism?" The results showed a stark difference in the opinions of different age cohorts. For those over the age of sixty-five, 60 percent had an unfavorable opinion of socialism, compared to the 23 percent that reported a favorable opinion. For those between the ages of thirty and sixty-four, about a quarter reported a positive idea of socialism, but half of thirty- to forty-four-year-olds and 54 percent of forty-five- to sixty-four-year-olds maintained a negative view. Among the eighteen- to twenty-nine-year-olds, only about one quarter had an unfavorable view of socialism. A whopping 43 percent had a favorable opinion, greater than the percentage of eighteen- to twenty-nine-year-olds who had a positive opinion of capitalism (32 percent)! A follow-up poll by the Victims of Communism Memorial Foundation in October 2017 found that support for socialism continued to increase among the young: "For starters, as of this year, more Millennials would prefer to live in a socialist country (44 percent) than in a capitalist one (42 percent). Or even a communist country (7 percent). The percentage of Millennials who would prefer socialism to capitalism is a full ten points higher than that of the general population. The significance of this finding cannot be overstated—as of last year, Millennials surpassed Baby Boomers as the largest generational cohort in American society."[18]

This same study revealed fascinating gender differences in opinions on whether respondents viewed either capitalism or socialism as "favorable" or "unfavorable." Of the

2,300 Americans surveyed, women made up 51 percent of the sample, and their opinions often diverged significantly from those of men. When asked if they had a favorable view of capitalism as an economic system, 56 percent of men surveyed agreed compared to only 44 percent of women, a 12-percentage-point difference. Alternatively, 53 percent of men had an unfavorable view of socialism, compared to only 47 percent of women. Although men tended to have stronger political opinions overall, these gender differences suggest that women voters are more inclined toward redistributive policies. And these changes in political opinions are despite the efforts of conservative politicians to conflate all leftist ideals with the worst horrors of Stalinism. Perhaps millennials don't trust the authority of the baby boomer cold warriors, or perhaps the economic realities of the present day, with growing inequality and stagnant earnings for the bottom half of the income distribution, are more real than ghost stories about an "evil empire" that fell before they were born.[19]

George Orwell once wrote: "Who controls the past controls the future. Who controls the present controls the past."[20] Conservatives will do anything to suppress evidence that socialist experiments in the twentieth century (despite their collapse) did some good things for women, including policies that have been and can be implemented in democratic societies: paid maternity leaves, publicly funded child care, shorter and more flexible work weeks, free postsecondary education, universal health care, and other programs that would help both men and women to lead less precarious and more fulfilling lives. Many of these socialistic policies already exist in advanced Western countries,

countries where Fox News and knee-jerk anticommunism don't deter citizens from voting in their economic interests.

The current hyperpolarized political climate mitigates against a more nuanced view of the past. Conservative critics care little about the history of twentieth-century state socialism and its policies toward women. They want to maintain the status quo. For instance, the Washington DC–based Victims of Communism Memorial Foundation claims that "an entire generation of Americans is open to collectivist ideas because they don't know the truth. We tell the truth about communism because our vision is for a world free from the false hope of communism." Notice the slippage between "collectivist ideas" and "communism" as if the former always and inevitably become the latter. (If I want to own my snow blower in common with my neighbors, it must be because I'm secretly hoping they'll get sent to the Gulag.) This foundation designs high school curricula, pays for anticommunist billboards on Times Square, and hopes to build a victims of communism museum near the National Mall in Washington, DC (with funding from explicitly right-wing donors). They want to control history in the same way that the Soviet Union once manufactured the past to suit its own political ends. If you challenge their single-minded focus on the worst aspects of the past, you challenge their assertion that socialism will always fail no matter how or where it is tried in the future.[21]

Millennials and members of generation Z reject the Cold War baggage of their elders who once proclaimed, "Better dead than Red!" Young people wonder whether their lives would be less harried, insecure, and stressful if the government took a more active role in redistribution.

They have incentives to vote for leaders who understand that markets boom and bust and that ordinary people need protection from the sudden and often savage fluctuations of free markets. Right-wing populist leaders will try to scapegoat women, people of color, and immigrants to deflect blame from the real roots of economic injustice: the high concentration of wealth in the hands of fewer and fewer people. As ordinary men and women struggle and scramble to cover their basic needs in an economy that promises equal opportunities for social mobility, but in which 78 percent of African American children born between 1985 and 2000 grew up in highly disadvantaged neighborhoods (compared to only 5 percent of white children), citizens must join together to effect real political change.[22]

Let's be clear: *I don't advocate a return to any form of twentieth-century state socialism.* Those experiments failed under the weight of their own contradictions: the vast chasm between their stated ideals and the actual practices of authoritarian leaders. You shouldn't have to sacrifice toilet paper for medical care. Basic political freedoms don't need to be traded for guaranteed employment. But there were other paths not taken, such as those envisioned by early socialist theorists like Karl Liebknecht and Rosa Luxemburg. And no socialist experiment was ever allowed to flourish without facing the overt or covert opposition of the United States, whether direct confrontations like those in Korea and Vietnam or secret operations in places such as Cuba, Chile, or Nicaragua. Did somebody say, "Iran-Contra affair"? Besides, the historical circumstances of the twenty-first century differ from those of the twentieth century. As our global economy evolves and changes in response to new

technologies, citizens need access to a theoretical toolkit that contains the widest array of potential political solutions to the problems we will face in the coming years.

Just as European peasants once believed that God anointed kings and aristocrats to rule over them, today many believe the superrich have earned their money in a fair competition in free markets. But as suspicions of the so-called rigged economy grow, more and more youth are searching for alternatives. The seventeenth-century philosopher Spinoza once said, "If you want the future to be different from the present, study the past." Even if past experiments with socialism failed, there were a few successes. We should study these successes and salvage what we can of the most powerful theoretical and practical tools we have to limit the worst excesses of global capitalism today. Young women in particular have little to lose and much to gain from a collective effort to build more just, equitable, and sustainable societies.[23]

This book explains why.

Clara Zetkin (1857–1933): Editor of *Die Gleichheit* (*Equality*) a journal of the German Social Democratic Party, Zetkin was a key architect of socialist women's activism. She was the founder of International Women's Day in 1910, celebrated each year on March 8. After the outbreak of World War I, she split with the German Social Democratic Party and became active in the German Communist Party, serving as a member of the Constituent Assembly during the Weimar Republic. Zetkin believed that socialist men and women needed to work together to overthrow the bourgeoisie and disdained independent feminists. *Courtesy of Archiv der sozialen Demokratie/ Friedrich-Ebert-Foundation.*

1

WOMEN—LIKE MEN, BUT CHEAPER: ON WORK

When I was in my twenties, a dear friend of mine, whom I will call Lisa, worked in human resources for a large corporation in San Francisco. Lisa loved fashion, and my wardrobe still includes elegant ensembles she put together for me on our frequent bargain shopping excursions to Filene's Basement and various thrift stores on Fillmore Street. She had a knack for choosing discount designer treasures and assembling outfits that mixed Levi's with vintage Dior. Over the years, we kept in touch, commiserating over marriage and new motherhood. But whereas I started my life as a working mom on the tenure track, Lisa quit her job to become a stay-at-home mom as soon as she realized she was pregnant. Her husband earned enough to support her, and he preferred that she not be employed. His own mother had stayed home, and among their immediate friends, neighbors, and peers, this was the normal arrangement. Lisa claimed this was her choice; she wanted a break from the rat race of corporate America. She had a second child soon after the first and abandoned the idea of returning to the workforce. Lisa thought it was easier this way; she

would be physically there for her daughters in a way that I never could be for mine.

In those early years, while she baked cookies and organized playdates, I dropped my daughter off at a full-time day care center, five days a week, costing me a small fortune. While her girls napped, Lisa read novels, worked out, and cooked lavish meals. My first four years of motherhood coincided with my first three years on the tenure track. My life was a crushing routine of harried days. The first time I taught class with my shirt inside out, I cringed with embarrassment when a sympathetic student pointed to my seams. But after the third time, I stopped caring. As long as my skirt wasn't on backwards, it was fine. I often envied Lisa's choice, but I'd earned my PhD and landed a good job. I didn't want to quit. Once my daughter turned five, things got a bit easier. My first book came out, I earned tenure, and my daughter started first grade. Out from under the crippling day care bills, I started to reap the psychological and financial rewards of my perseverance.

A few years later, I spent a weekend with Lisa. Her husband offered to stay in with our three girls so she and I could head to the mall: dinner, a movie, and maybe a little shopping. Our social engagements usually included our children, so this was a real treat. I longed for a few hours of adult conversation with an old friend and no urgent demands for juice or ice cream or unexpected tantrums. A real girls' night out.

I'd been upstairs at her house getting ready when I realized I'd forgotten my hair dryer. I wanted to ask Lisa if I could borrow hers, but as I started down the steps, I heard Lisa fighting with her husband.

" . . . Please, Bill. It'll be embarrassing."

"No. You've spent enough money this month. I'll give you the card again after the statement rolls."

"But I shopped for the house and bought clothes for the girls. I didn't buy anything for me."

"You're always buying things for yourself and saying it's for the girls."

"But it *is* for the girls. They keep growing."

"You have enough clothes. You don't need anything else. I've given you enough for the dinner and the movie."

"Bill, please." Lisa's voice cracked.

I turned to tiptoe back up the stairs, praying they hadn't heard me. I hid in the bathroom until Lisa came up, jaw clenched and eyes pink.

We drove to the restaurant in silence. We ordered two courses, and I attempted to prolong the dinner until just before the film started. Lisa seemed grateful to linger.

After our second glass of Malbec she said, "Bill and I had a fight."

I looked down at my plate.

"He says we don't have sex often enough."

I looked up. That's not the fight I thought I heard.

She swirled her empty glass. "You think we have time for another one?"

"You go ahead," I said. "I'll drive."

She drank a third glass of wine, and we chatted about the reviews of the film we planned to see. When the check came, she opened her wallet and pushed some twenty-dollar bills across the table at me. I put down my credit card.

She looked at the American Express with my name on it, and sighed. "Bill only gives me cash."

"Why don't you let me get this?" I slid the money back at her. "Keep it."

She stared down at the table for a long moment. Finally, she said, "Thanks," and scooped the bills back into her wallet. "I'll fuck him tonight and pay you back tomorrow."

I sat there, stunned.

Lisa looked at her watch. "If we hurry, I can hit the Shiseido counter before the movie starts."

Sitting in the restaurant that night, I swore to myself that no matter how hard it was to balance my full-time job with care for my daughter, I would never put myself in Lisa's position if I had any choice in the matter. "Capitalism acts on women as a continual bribe to enter into sex relations for money, whether in or out of marriage; and against this bribe there stands nothing beyond the traditional respectability which Capitalism destroys by poverty," George Bernard Shaw wrote in 1928. Directly or indirectly, sex and money are always linked in women's lives, a remnant of our long history of oppression.[1]

Too many women find themselves in Lisa's situation, economically dependent on men for their basic livelihoods. Divorce laws and court orders for child support and alimony will offer Lisa some (possibly inadequate) protection if Bill ever seeks to divorce her, but she remains at his mercy while they are married. All of the labor she performs caring for their children, organizing their lives, and managing their home is invisible as far as the market is concerned. Lisa receives no wages and contributes no funds toward her own social security in old age. She accumulates no work

experience and creates a black hole on her résumé, one that will require explaining away if she ever hopes to rejoin the labor force. She even accesses medical care through her husband's employer. Everything she has she derives from Bill's income, and he can deny her access to their joint credit cards at will.

In Margaret Atwood's chilling dystopian novel, *The Handmaid's Tale*, the founders of the Republic of Gilead legislate a blanket prohibition on women's employment and the seizure of their personal savings. All at once, anyone designated female is fired from her job, and the money in her bank account is transferred into the accounts of her husband or nearest male relative, the first step in returning women to their "rightful place." The subjugation of women begins by making them economically dependent on men once more. Without money and without a means to earn it, women are helpless to determine the course of their own lives. Personal independence requires the resources to make your own choices.[2]

Free markets discriminate against women workers. At the beginning of the industrial revolution, the big bosses considered women inferior to their male counterparts (weaker, more emotional, less reliable, and so forth). The only way to convince an employer to hire a woman was through financial incentives: women cost less than men. If she demanded a wage equal to that of a man, the employer would just hire a man instead. Therefore, women's comparative advantage in the workplace from the very earliest days of capitalism is that they will do the same work as a man for less money. The idea of the family wage compounds the problem. When women finally entered the industrial labor

force en masse and began to dominate light industries (like sewing, weaving, laundry), employers paid women wages for a single person, not a family, even if they were single mothers or widows. Society insisted that women were the dependents of men, and working women were conveniently imagined as wives and daughters earning pocket money to purchase lace doilies for their dressing tables. Husbands and fathers were supposed to meet their major needs for food, shelter, and clothing.

Patriarchal cultures reduce women to economic dependence, treating them as a form of chattel to be traded among families. For centuries, the doctrine of coverture rendered married women the property of their husbands with no legal rights of their own. All of a woman's personal property transferred to her husband upon marriage. If your man wanted to hawk your rubies for rum, you had no right to refuse. Married West German women could not work outside the home without their husband's permission until 1957. Laws prohibiting married women from entering into contracts without their husbands' permission persisted in the United States until the 1960s. Women in Switzerland didn't earn the right to vote at the federal level until 1971.[3]

Under capitalism, industrialism reinforced a division of labor that concentrated men in the public sphere of formal employment and rendered women responsible for unpaid labor in the private sphere. In theory, male wages were high enough to allow men to support their wives and children. Women's free labor in the home subsidized the profits of employers because workers' families bore the cost of reproducing the future labor force. Without birth control, access to education, or opportunities for meaningful employment,

the woman was trapped within the confines of the family in perpetuity. "Under the capitalist system women found themselves worse off than men," Bernard Shaw wrote in 1928, "because, as Capitalism made a slave of the man, and then by paying women through him, made her his slave, she became the slave of a slave, which is the worst sort of slavery."[14]

As early as the mid-nineteenth century, feminists and socialists diverged on how best to liberate women. Wealthier women advocated for the Married Women's Property Acts and the right to vote without questioning the overall economic system that perpetuated women's subjugation. Socialists, such as the German theorists Clara Zetkin and August Bebel, believed women's liberation required their full incorporation into the labor force in societies in which the working classes collectively owned the factories and productive infrastructure. This was a much more audacious and perhaps utopian goal, but all subsequent experiments with socialism would include women's labor force participation as part of their program to refashion the economy on a more just and equitable basis.

The perception that a woman's labor is less valuable than a man's persists to this day. In a capitalist system, labor power (or the units of time we sell to our employers) is a commodity traded in the free market. The laws of supply and demand determine its price, as does the perceived value of that labor. Men are paid more because employers, clients, and customers perceive that they are worth more. Think about it: Why do cheap diners always have waitresses, but

expensive restaurants often have male waiters? In the comfort of our own homes, most of us grow up being served by women: grandmothers, mothers, wives, sisters, and sometimes daughters. But being served by men is rare, as is having men look after our basic needs. We pay a premium to have a man serve us our dinner because we perceive this service as more valuable, even if all he does is set a plate in front of you and grind fresh pepper onto your filet mignon. Similarly, although women have fed humanity for millennia, men dominate the culinary world. Apparently, customers prefer a side of testosterone with their mashed potatoes.[5]

In the past, women understood the general public valued their work less and took steps to mitigate against the effects of discrimination. Charlotte Brontë published her early novels under the pen name Currer Bell, and Mary Anne Evans wrote as George Eliot. More recently, both J. K. Rowling and E. L. James published books using their initials to obscure their gender. In Rowling's case, her publisher asked her to do this to attract boy readers who might reject a book written by a woman. In the world of university teaching, having a female-sounding name results in worse teaching evaluations, as students consistently rank male professors higher than their female counterparts. One 2015 experimental study found that assistant instructors who taught the same online class under two different gender identities received lower ratings for their female persona.[6]

Racism exacerbates gender discrimination. Hispanic and Black women suffer a larger wage gap than white women. When we talk about gender discrimination, we have to be careful not to privilege gender as the primary category of analysis, as some feminists have done in the

past. The state of being female is complicated by other categories such as class, race, ethnicity, sexual orientation, disability, religious belief, and so on. Yes, I am a woman, but I am also a Puerto Rican–Persian from an immigrant and working-class background (my grandmother had a third-grade education, and my mother only finished high school). The old concept of sisterhood ignores the structural aspects of capitalism that benefit white, middle-class women while disadvantaging working-class women of color, something that socialist women activists understood as early as the late nineteenth century. Within left circles, orthodox Marxists obsessed with class position are often called "brocialists," because they emphasize worker solidarity over issues of race and gender. Some feminists and brocialists will argue that too much focus on identity politics divides people and undermines the potential power base for mass movements for social change, but when examining structures of oppression, we must be mindful of the hierarchies of subjugation even while building strategic coalitions.

Taking an intersectional approach, for instance, helps us see how public-sector jobs have created important opportunities for different populations. While white working-class men once dominated private manufacturing jobs, government employment provided important avenues for African Americans who were (and remain) more likely than whites to work in the public sector. The public sector has historically offered jobs to religious minorities, people of color, and women who faced discrimination in the private sector, creating career opportunities for those disadvantaged by race or gender in competitive labor markets. Cuts in public sector employment after the Great Recession hit

African American women particularly hard, forcing them to seek work in private companies, where perceptions of the value of their labor are more influenced by the color of their skin and their gender.

A classic study showing the deep persistence of gender bias involved auditions for symphony orchestras. Women musicians were sorely underrepresented in professional orchestras before the introduction of an audition process whereby musicians played their instruments behind screens that separated them from the judges. In order to ensure total gender anonymity, musicians removed their shoes so that the footfalls of men and women would be indistinguishable to those making decisions. When those doing the auditioning judged musicians solely on their ability to play, "the percent of female musicians in the five highest-ranked orchestras in the nation increased from 6 percent in 1970 to 21 percent in 1993." This screen audition system would also eliminate racial biases.[7]

But we can't hide ourselves behind screens for all of our job interviews and interactions with potential employers. Our names give us away, and even if we manage to hide our gender behind initials or male pseudonyms, references use pronouns and other words that reveal our gender. Proving discrimination is difficult, and there are few repercussions for those who systematically pay women less than men for the same work. Furthermore, because women earn less than men, it makes economic sense for mothers to stay home with young children when affordable child care is scarce. When women do enter the labor force as part-time or flexible workers, they often do so without benefits and without wages sufficient to cover their basic needs. And as

women withdraw from the labor force to care for the young, the sick, or elderly relatives, discrimination against women workers becomes more entrenched, since employers view them as less reliable (more on this in the next chapter), and the cycle of women's economic dependence on men continues.

To counter the effects of discrimination and the wage gap, socialist countries devised policies to encourage or require women's formal labor force participation. To a greater or lesser degree, all state socialist countries in Eastern Europe demanded the full incorporation of women into paid employment. In the Soviet Union and particularly in Eastern Europe after World War II, labor shortages drove this policy. Women have always been used as a reserve army of labor when the men are off at war (just like American women's employment during the World War II era of Rosie the Riveter). But unlike the United States and West Germany, where women were "let go" after the soldiers returned home, East European states guaranteed women's full employment and invested vast resources in their education and training. These nations promoted women's labor in traditionally male professions such as mining and military service, and mass-produced images of women driving heavy machinery, especially tractors.[8]

For example, while American women were stocking their kitchens with the latest appliances during the postwar economic boom, the Bulgarian government encouraged girls to pursue careers in the new economy. In 1954, the state produced a short documentary film to celebrate the lives of women helping to transform agricultural Bulgaria into a modern, industrial power. This film, *I Am a Woman*

Tractor Driver, portrayed the daily lives of young women working in an actual women's tractor brigade. A peasant girl pens a letter to the female head of the brigade, asking how she could learn to drive a tractor. The film dramatizes the brigade leader's reply. She describes how socialism provides new opportunities for women who are now the equals of men. In the final moments of this twenty-five-minute film (which would have been shown in theaters across the country) the brigade leader explains that Bulgarian women can now be anything they want to be, as the audience sees short scenes of women working in traditionally male jobs. The final scene shows a pretty woman in the cockpit of an airplane, gazing up at the horizon as she readies for takeoff. The message is clear: for Bulgarian women, the sky is the limit.

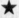

Official statistics from the International Labor Organization (ILO) demonstrate the disparity between the workforce participation rates in state socialist economies and those in market economies. In 1950, the female share of the total Soviet labor force was 51.8 percent, and the female share of the total workforce in Eastern Europe was 40.9 percent, compared to 28.3 percent in North America and 29.6 percent in Western Europe. By 1975, the United Nations' International Year of Women, women made up 49.7 percent of the Soviet Union's workforce and 43.7 percent of that in the Eastern Bloc, compared to 37.4 percent in North America and 32.7 percent in Western Europe. These findings led the ILO to conclude that the "analysis of data on women's participation in economic activity in the USSR and the socialist countries

of Europe shows that men and women in these countries enjoy equal rights in all areas of economic, political, and social life. The exercise of these rights is guaranteed by granting women equal opportunities with men in access to education and vocational training and in work."[9]

Of course, women's own accounts complicate the rosy picture painted by the ILO in 1985. Gender pay gaps still existed in East European countries. And despite the attempts to funnel women into traditionally male employment, there remained a gendered division of labor whereby women worked in white-collar professions, the service sector, and light industry, compared to men who worked in the higher-paid sectors of heavy industry, mining, and construction. But salaries mattered less when there was little to buy with one's wages and where formal employment itself guaranteed social services from the state. In many countries women had no choice; they were forced to work when their children were old enough to go to kindergarten. And women in state socialist countries suffered the double burden of housework and formal employment (a problem very familiar to many working women today). Consumer shortages plagued the economy, and both men and women waited in lines to acquire basic goods. But as workers, women contributed to their own pensions and developed their own skill sets. They benefitted from free health care, public education, and a generous social safety net that subsidized shelter, utilities, public transportation, and basic foodstuffs. In some countries, women could retire from formal employment up to five years earlier than men.

Despite the shortcomings of the command economy, the socialist system also promoted a culture in which

women's formal labor force participation was accepted and even celebrated. Before World War II, Eastern Bloc countries were deeply patriarchal, peasant societies with conservative gender relations emerging from both religion and traditional culture. Socialist ideologies challenged centuries of women's subjugation. Because the state required girls' education and compelled women into the labor force, their fathers and husbands couldn't force them to stay home. Women seized these opportunities for education and employment. When birthrates began to falter in the late 1960s, many Communist Party leaders worried that their investments in women would hurt their economies in the long run. They conducted sociological surveys and found that women indeed struggled with their dual responsibilities as workers and mothers. Some governments considered allowing women to return to the home, but when asked if they would be happier if their husbands earned enough to support the family, the majority of women rejected the traditional breadwinner/homemaker model. They wanted to work. In Natalya Baranskaya's novella about a harried Soviet working mom, the protagonist never once fantasizes about quitting her job, stating unequivocally that she loves her work.[10]

Reflecting on the achievements of state socialism compared to the situation of women in most East European countries prior to the Second World War, Hungarian sociologist Zsuzsa Ferge explained, "All in all . . . the *objective* situation of women has probably improved everywhere compared to the pre-war situation. Their paid work outside the home contributed to the well-being of the family (at least it helped to make ends meet); their educational

advancement and the work outside the home enriched (at least in a majority of cases) their life experience; their status as earners weakened their former oppression within and outside the family and made them (somewhat) less subservient in some walks of life. Also, it attenuated female poverty, especially in the case of mothers who practically all started to work, and of older women who obtained a pension in their own right." State socialist countries could promote women's economic autonomy because the state was the primary employer and it guaranteed each man and woman full employment as a right and a duty of citizenship. In the democratic socialist countries of northern Europe, women's employment is voluntary, but the state promotes their labor force participation by providing the social services necessary to help citizens combine their roles as workers and parents.[11]

Socialist states also try to counter the persistent discrimination against women by expanding opportunities for public sector employment. Although not as sexy as start-ups, governments can ensure women are paid equal (decent) wages for equal work and support women in their work and family responsibilities. According to a report from the Organization for Economic Co-operation and Development (OECD), the Scandinavian countries lead the world not only in terms of gender equality but also in terms of public sector employment. This is no coincidence. In 2015, 30 percent of total employment in Norway was government employment, followed by 29.1 percent in Denmark, 28.6 percent in Sweden, and 24.9 percent in Finland. The United Kingdom,

by contrast, employed only 16.4 percent of its total employed population in the public sector, and in the United States this figure was 15.3 percent. Even more remarkable is that women account for around 70 percent of all public employees in Norway, Denmark, Sweden, and Finland, and the OECD average is 58 percent. The authors of the report explain women's overrepresentation in the public sector partially because teachers and nurses are female-dominated professions, but also because of "more flexible working conditions in the public than in the private sector. For example, in sixteen OECD countries the public sector offers more child and family care arrangements than the private sector." Finally, studies reveal smaller wage gaps between men and women in the public sector.[12]

Public sector employment rates used to be higher in the United States until federal agencies began outsourcing, subcontracting to the private sector, or just slashing jobs. A 2013 report analyzing US employment trends showed a precipitous decline in public sector employment after the Great Recession, as states and localities pruned budgets after the crisis. The Hamilton Project examined government responses to previous recessions and found that cutting the jobs of teachers, emergency responders, and air traffic controllers during a time of high unemployment slowed the recovery and inflicted greater economic pain on American citizens, particularly on the younger generation, who were crowded into larger classrooms with fewer educators. "The ongoing recovery, which began when the Great Recession ended in June 2009, dramatically deviates from the usual pattern," write the project's researchers. "In the forty-six months following the end of the five other recent recessions,

government employment increased by an average of 1.7 million. During the current recovery, however, government employment has decreased by more than 500,000, and a disproportionate number of those losing jobs were women. Put together, the policy differences have led to 2.2 million fewer jobs today. Such a large contraction of the public sector during a recovery is unprecedented in recent American economic history." In the UK, meanwhile, dramatic austerity measures meant that public sector employment fell by 15.5 percent between September 2009 and April 2017, a reduction of nearly one million jobs, again primarily affecting women, who constitute the majority of public sector employees. [13]

Attitudes toward public sector employment reflect ideological divides about whether the government is more or less efficient than the market. Our banks are private because Americans believe that state-run banks (like a postal bank) would be more bureaucratic and less consumer-friendly than those forced to compete on free markets for depositors' money (even if the federal government provides deposit insurance up to $250,000 and bails out banks deemed "too big to fail"). Similarly, the United States rejects a national health system because our private health insurance supposedly provides better care at lower prices as a result of market competition. Although countless studies show that Americans pay more money for health care, Americans cling to the idea that markets produce better outcomes than state-run programs. Another example is in higher education, with the expansion of for-profit universities. A 2016 study shows that employers don't value for-profit college degrees as much as they value degrees from

public universities. Yet government funds provide sub-
stantial financial aid for students at these universities, thus
subsidizing profits for investors when those funds could be
used to strengthen the quality of public education instead.
Citizens in other societies, even our close allies in Canada
and the United Kingdom, understand that the profit mo-
tive sometimes undermines the public good. Nonetheless,
decades of underfunding mean that Britain's National
Health Service is now in a precarious condition, and once
again cuts to services primarily affect women, particularly
those with mental health issues and histories of trauma and
abuse. For example, in May 2018, a woman-only counsel-
ling service in Brighton was suddenly defunded despite
increasing need from precarious populations. In its place,
vulnerable women were going to be funneled into generic,
mix-gender programs where many would not feel safe. Too
often saving money takes precedence over meeting citizens'
needs. But spending money to support state services can
be a win-win situation, creating more public employment
while expanding vital social support to those who need it
most.[14]

Of course, some might argue that instead of expand-
ing public employment, the government could legislate pay
equality and enforce provisions to ensure that private sec-
tor firms pay women fairly, a step the Icelandic government
took beginning in early 2018 and the state of Massachusetts
took after July 1, 2018. But federal legislation on equal pay
in the United States has been relatively weak and without
real teeth, since the onus remains on women to prove pay
discrimination in court (and who has the money needed for
a lawsuit?). Attempts to strengthen the 1963 Equal Pay Act

have failed to win Republican support in Congress, most recently in April 2017 with the Paycheck Fairness Act, which did not receive a single Republican vote.

Critics will also claim that expanded public sector employment hurts growth and cripples the private sector, but private sector job expansion has not been able to reverse wage stagnation, the rise of the gig economy, or the incredible growth in inequality between the rich and the poor, as revealed by Thomas Piketty. Economists and legislators will have to debate the details, but given that as of 2017, just eight men own the same amount of wealth as the 3.6 billion people who make up the poorest half of humanity, redistribution is going to come in one form or another. Current levels of inequality are unsustainable in the long term. In a global economy buoyed by the credit-fueled consumer spending of the masses, the bubble will burst eventually. An acute crisis of overproduction and underconsumption looms on the horizon.[15]

The expansion of public services would support women in a second way. A wider social safety net means that women's lower private sector wages don't disadvantage them in terms of access to health care, clean water, child care, education, or security in old age. Rather than trying to legislate equality or coerce private companies into providing equal pay for equal work and giving women equal opportunities for promotion, women could join together to choose leaders who will lessen the social costs of gender discrimination through public policy. Another idea is some form of guaranteed employment like what they had in the state socialist countries. This is an old economic concept to prevent the human suffering caused during economic downturns. The

United Kingdom's Labour Party has proposed a job guar-
antee in which the state acts as the employer of last resort
for young people ages eighteen to twenty-five who are will-
ing to work but cannot find employment. Economists have
debated job guarantees for decades, and in 2017 the Cen-
ter for American Progress (CAP) threw its weight behind
a proposal for a new "Marshall Plan for America," which
would create 4.4 million new jobs. The CAP proposal calls
for a "large-scale, permanent program of public employ-
ment and infrastructure investment—similar to the Works
Progress Administration (WPA) during the Great Depres-
sion but modernized for the 21st century. It will increase
employment and wages for those without a college degree
while providing needed services that are currently out of
reach for lower-income households and cash-strapped state
and local governments."[16]

In September 2017, I attended Mass with my eighty-
nine-year-old grandmother in the San Diego church I
went to as a kid. On that Sunday, the priest introduced the
parable of the workers in the vineyard (Matthew 20:1–16)
by explaining that, for Americans, it was one of the most
controversial of the parables. In Jesus's story, a landowner
goes into town to hire day laborers for a fair wage in the
morning. He then returns to hire more men at noon and
later in the afternoon. Near sunset, the landowner returns
to find more idle men. He asks why they are not working,
and they explain that no one has hired them that day. The
landowner hires them and then proceeds to pay all of the
workers the same wage no matter how long they worked.
When the workers hired early in the morning complain
about the unfairness, the landowner chastises them: I

offered you a fair wage, and you accepted it. The landowner says, I am not being unfair to you. Or are you envious because I am generous? Although parables are typically interpreted allegorically, that day the priest used the story to talk about fair wages and immigration in his homily. "The landowner went into town and hired the men who needed work," he told us. "He didn't ask to see their documents." In the same way, perhaps, the parable also supports the idea of job guarantees. The landowner provided employment to all those willing and able to work, and he paid them a fair wage no matter how long they actually labored in the vineyard. From the landowner's perspective, it was a generous thing to do for people in need. For Americans, such generosity sounds suspiciously socialist.[17]

But let's face it: job guarantees would not only benefit women. In the long run if privately owned robots and A.I. take over our economy, organic men may find themselves just as devalued in competitive labor markets as today's organic women. The owners of inorganic life may be the real beneficiaries of our future unregulated free markets. Fears of the increasing automation have led some to promote the idea of the Universal Basic Income (UBI), sometimes called a Universal Citizen's Income or Citizen's Dividend. This would guarantee that all qualifying citizens received a fixed monthly payment to meet their basic needs. A generous UBI experiment has been tried in Finland, and many people across the political spectrum support the idea of some kind of flat payment to save people from the ravages of unemployment. This revenue could be generated from taxation of the private sector or from the profits of public enterprises. UBI could go a long way in promoting

gender equality, since women's unpaid labor in the home would be compensated. Of course, some critics fear that UBI will make people lazy, while others worry that it is just a way for the hyper-rich to gut the welfare state and buy off the masses with small cash payments while they luxuriate in their riches. It is an idea that requires much more debate, particularly from a socialist perspective.[18]

Whatever happens, any move toward employment assurances will require a substantial expansion of the public sector, which will have the added benefit of promoting gender equality by eliminating the wage gap between men and women. The irony here is that where state socialist regimes reduced women's economic dependence on men by making men and women equally dependent on the state, in a capitalist society our technological future may reduce women's economic dependence on men by making men and women equally dependent on the generosity of those who own our robot overlords. Some day in the near future, Bill may be begging a computer to give him his Friday night allowance so he can head to the sports bar with his buddies. There will be some cosmic justice when Siri informs Bill that he's already watched enough sports this month, and should stay home and spend some quality time with his wife and daughters.

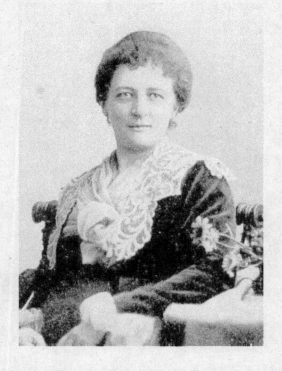

Lily Braun (1865–1916): Feminist writer and a politician within the German Social Democratic Party. Her 1901 book, *The Women's Question: Historical Development and Economic Aspect* proposed many novel solutions to the challenges faced by working mothers, including proposals for what she called "maternity insurance." Braun was a moderate and a reformer and did not believe that revolution was necessary to achieve socialism. *Courtesy of Lebendiges Museum Online (Deutsches Historisches Museum).*

2 WHAT TO EXPECT WHEN YOU'RE EXPECTING EXPLOITATION: ON MOTHERHOOD

One of my childhood friends, whom I will call Jake, hungered for financial success in a society where financial success reflected a kind of moral superiority. Jake valorized the idea of the American Dream. He saw goodness in the kind of Horatio Alger, pull-yourself-up-by-the-bootstraps hard work required to "make something" of yourself. Back then, I was already a feminist with concerns about economic inequality, while Jake, true to the spirit of the 1980s, believed that whoever dies with the most toys wins. We spent hours debating the pros and cons of capitalism, and the ways that Thatcherism and Reaganomics sucked or didn't suck. Jake embraced the Gordon Gekko zeitgeist of the age: "Greed is good." I wasn't buying it. But back in those days when domestic politics weren't so polarized, we managed to maintain our friendship throughout our college years. In the 1990s, while I was off teaching English and reading Karl Polanyi in Japan, Jake was hustling his way up the corporate ladder at a tech start-up.

One day in 1997, Jake informed me with great pleasure that he'd hired a promising young woman for a strategic position in his firm. She'd been a finalist with two other men, and with my voice ringing in his ears, he decided to take a chance on her. "They were all equally qualified on paper," he told me, "But after years of listening to your feminist rants, I convinced my boss that since women face so many barriers in tech, she had actually worked harder to get where she was than the men in the pool." I was struggling through my first year of graduate school at the time, and Jake's news warmed my heart; I'd made a little difference in the world.

Over the next few years, the woman proved herself clever, competent, and hard-working. Jake's company gave her a three-month paid sabbatical for some additional training, grooming her for a promotion. Then she announced she was pregnant. The start-up had no formal maternity leave policy, but Jake asked his boss to give her twelve paid weeks to stay home with her baby and make child care arrangements. Jake argued that they had already invested so much money in her training that a twelve-week leave would pay for itself in the long run. His boss reluctantly agreed.

The woman returned to work after the birth of her baby and tried her best to keep up with the demands of a small start-up. But she was nursing. And the baby kept her up at night. She would attend meetings bleary-eyed and unprepared. She called in sick when the nanny didn't show. She found a place in a good nursery, but if her son got sick, they sent him home. Her husband traveled for business, and she had no family in the area. Jake, always the optimist, believed things would improve once the child was older. He

even offered to babysit in a pinch. His star employee managed to hold on for six months. Then she quit.

That night Jake called me to share the news. Dejected and frustrated, he told me, "I'm never hiring a woman again."

"But she's just one woman," I said. "Not every woman is going to make her choice."

"There's no way my boss will let me," he said. His voice was low. "And it's the baby thing. I can't be sure of anything about any employee, but I can be certain that a man won't have a baby."

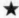

I think I hung up on him. But it really wasn't Jake's fault. What could he do in a system that provides no support for women when they become mothers, that forces women to choose between their careers and their families? Economists call this "statistical discrimination." The basic idea is that since employers can't directly observe the productivity of individual workers, they can make observations about demographic characteristics that are correlated with worker productivity. They make decisions based on the averages: if women are more likely to quit than men for personal reasons, employers assume that any given woman is more likely to quit than a man. Economists observe that the theory of statistical discrimination can create a vicious cycle. If women are (or used to be) more likely to quit, they will be paid less. If they are paid less, they are more likely to quit. This vicious cycle provides a very good justification for government intervention.[1]

The perception of women's comparative inferiority as workers is linked to their biological capacity for child bearing and nursing, and the concomitant social expectation that women will be the primary caregivers for babies and young children. And in some patriarchal fantasy world, our supposedly innate caring nature also makes us perfectly suited for nursing other sick, weak, or aged relatives. And since women are at home anyway, so the argument goes, we might as well do all of the shopping, cooking, cleaning, and emotional labor required to maintain a household, right? Someone has to do it, and that someone is almost always a woman, in part because the location of the tasks align, but also because she has been socialized from infancy to believe that it's her natural role. Baby dolls, EZ Bake ovens, and toy vacuum cleaners allow girls to play-practice the labors they will perform when they grow up.

Employers discriminate against those whose bodies can produce children because society attributes certain characteristics to the owners of those bodies. When scholars talk about men and women, they often make a distinction between the terms "sex" and "gender." The word "sex" means the biological difference between males and females and the word "gender" connotes the social roles that cultures expect to match the biology. For example, by sex I am a woman because I have the physiological equipment necessary for baby manufacturing, but my gender is also female because in many ways I conform to contemporary Western society's imagination of what a woman should be: I have long hair; I wear skirts, jewelry, and makeup; I enjoy romantic comedies and nice bath products; and although I might claim it's for my general health, I do a daily hour on the elliptical

trainer because I worry about my weight (okay, well, maybe it's only forty-five minutes, and it's not every day, but you get the idea). In other ways, however, my gender identity is more masculine: I have always worked full-time and earned my own money; I enjoy watching soccer, science fiction, and action movies; I love a good beer; and although I try to be polite about it, I always speak my mind even if my thoughts and opinions may offend. I suffer no fools, while according to some, real women tolerate gropers, mansplainers, and plain old idiots with a smile.

Gender discrimination arises because society constructs archetypes of the ideal man and the ideal woman based on their supposedly natural biological differences. This is not to say that men and women are the same—they are not—but only that our beliefs about how men and women behave are a figment of our collective imaginations—a powerful figment, yes, but a figment nonetheless. When a student ranks a professor with a female name lower than a professor with a male name, the student may assume that the male professor has more time and energy to dedicate to his teaching because he is not distracted by his care obligations outside of work. When employers like my friend Jake's boss see a woman's name on a job application, they immediately think that "woman" equals potential mother with priorities in life that take precedence over their careers. Employers also assume that men will put their careers over their families because they are supposedly less biologically attached to children. It doesn't matter if individual men decide to stay home with their children or if individual women sterilize themselves to overcome the challenges of work/family balance; our gender stereotypes of how men and women

behave are rooted in our ideas about the "natural" link between biological sex and how this informs our life choices.

I used to do a classroom exercise with my students to get them to think about the relationship between sex and gender. I borrowed a scenario from Ursula Le Guin's classic science fiction novel, *The Left Hand of Darkness*, where a man from earth is sent to work on a planet of "bisexual hermaphrodites." This means that all people have both male and female sexual organs and hormones. Throughout the month, there are seven-day periods when a portion of the population experiences a form of heat: an irresistible desire to copulate. At the initiation of sexual contact, one of the members of the pair becomes the male, and the other person becomes the female. In any given sexual encounter, an individual will randomly become either the male or the female. The member of the pair who becomes female can become pregnant and will then have a nine-month gestation period before giving birth. When an individual is not copulating or pregnant, they revert to a neutral state until their next sexual encounter, when the process repeats. Any one individual can therefore be both a father and a mother, and everyone is equally "at risk" for pregnancy and childbirth.

I asked my students to try to imagine how the society on this fictional planet would be arranged compared to our society in the United States. The first thing to go would be sex discrimination, since everyone would be biologically identical. All people are "hermaphrodites," so you couldn't use biological sex to create hierarchies. Of course, more attractive "bisexual hermaphrodites" might enjoy more privileges than the ugly ones, and the old might have more power over the young, but discrimination would not

be based on whether you can make babies. Similarly, the so-
cial roles linked to biology would be the same for everyone,
since most members of this society would be both mothers
and fathers to multiple children. My students also imagined
that the society on this fictional planet would be organized
to accommodate the demands of pregnancy and childbirth,
since every member of that society would benefit from col-
lectively organized forms of support.

Socialists have long understood that creating equity be-
tween men and women despite their biological sex differ-
ences requires collective forms of support for child rearing.
By the mid-nineteenth century, as women flooded into the
industrial labor force of Europe, socialists theorized that
you could not build strong worker's movements without the
participation of women. The German feminist Lily Braun
promoted the idea of a state-funded "maternity insurance"
as early as 1897. In this scheme, working women would en-
joy paid furloughs from their jobs both before and after de-
livery, with guarantees that their jobs would be held in their
absence. It's important to remember that as late as 1891, in
Germany female industrial workers toiled for a minimum
of sixty-five hours per week, even if they were with child.
Under these circumstances, pregnant women and girls
stayed at the assembly line until they gave birth, and if they
had no husband or family to support them, they returned
to work soon afterward. The infant and maternal mortal-
ity rate for working women was more than double that of
middle-class women because of the harsh conditions.

Although British and American feminists wanted to

support working mothers through nonstate charities, Braun proposed that funds for the maternity insurance be raised through a progressive income tax. The German government could then pay a woman's wages for a fixed period before and after the birth of her child. Everyone would contribute to a special pot of money that new mothers could draw on, much like unemployment insurance or a state pension. Braun asserted that since society benefitted from children, it should help bear the costs of raising them. Children are future soldiers, workers, and taxpayers. They are a benefit to all, not just to the parents who bring them into the world (and some parents of teenagers might argue that they are more of a benefit to society than they are to their parents). This is especially true in ethnically homogenous states, where societies place a premium on preserving a particular national identity.[2]

But Braun's proposal was expensive. It required new taxes and would redistribute wealth to the working classes, an idea that many middle-class men and women opposed. Braun's ideas also faced initial opposition from the Left. Because Braun was a reformer and believed that her maternity scheme could be implemented under capitalism, more radical German socialists like Clara Zetkin initially rejected her ideas, claiming they could only be realized under a socialist economy. Braun also favored communal living arrangements (communes) over state-funded nurseries and kindergartens, whereas Zetkin believed that housework and child care should be socialized. Nonetheless, Braun's proposals, in watered down form at least, were passed into law as early as 1899. And by the Second International Conference of Socialist Women in 1910, Braun's

ideas were incorporated into the official socialist platform with the support of Clara Zetkin and the Russian Alexandra Kollontai.

The fourth point on the 1910 socialist platform laid the foundation for all subsequent socialist policies regarding state responsibilities toward women workers. Under the title "Social Protection and Provision for Motherhood and Infants," the women of the Second International demanded an eight-hour working day. They proposed that pregnant women stop working (without previous notice) for eight weeks prior to the expected delivery date, and that women be granted a paid "motherhood insurance" of eight weeks if the child lived, which could be extended to thirteen weeks if the mother was willing and able to nurse the infant. Women would get a six-week leave for stillborn children, and all working women would enjoy these benefits, "including agricultural laborers, home workers and maid servants." These policies would be paid for by the permanent establishment of a special maternity fund out of tax revenues.[3]

Seven years later, Kollontai attempted to implement some of these policies in the Soviet Union after the Bolshevik revolution. Instead of burdening individual women with household chores and child care in addition to their industrial labor, the young Soviet state proposed to build kindergartens, crèches, children's homes, and public cafeterias and laundries. By 1919, the Eighth Congress of the Communist Party handed Kollontai a mandate to expand her work for Soviet women, and she secured state commitments to expend the funds necessary to build a wide network of social services. The year 1919 also saw the creation

of an organization called the Zhenotdel, the Women's Section, which would oversee the work of implementing the radical program of social reform that would lead to women's full emancipation.[4]

But Soviet enthusiasm for women's emancipation soon evaporated in the face of more pressing demographic, economic, and political concerns. After the country was devastated by the brutal years of the First World War, followed by the Civil War and the horrendous famine of 1921 and 1922, Lenin and the Bolsheviks did not have the funds to support Kollontai's plan. Hundreds of thousands of war orphans roamed the major cities, plaguing residents with petty crime and theft. The state lacked the resources to care for them; children's homes were overburdened and understaffed. Liberalization of divorce laws meant that fathers abandoned their pregnant wives, and poor enforcement of child support and alimony laws meant that those men who had survived the First World War, the Civil War, and the famine routinely skipped out on their responsibilities. Working women couldn't look after their children and hoped the state would step in and help, as Kollontai and the other women's activists had promised. In 1920, the Soviet Union had also become the first country in Europe to legalize abortion on demand during the first twelve weeks of pregnancy. Birthrates plummeted as women sought to limit the size of their families. Eventually there was fear that the falling birthrate combined with the devastations of war and famine would derail the country's plans for rapid modernization.[5]

No one ever wanted women's economic independence to come at the cost of motherhood, but this is what

happened. As the demands on Soviet women's time increased, they chose to delay or limit childbearing. Eventually, Stalin disbanded the Zhenotdel, declaring that the "woman question" had been solved. In 1936, he reversed most liberal policies, banned abortion, and reinstated the traditional family, on top of his sustained program of state terror and arbitrary purges. The rapidly industrializing Soviet state needed women to work, have babies, and do all of the care work the world's first socialist state could not yet afford to pay for. Soviet women were far from emancipated, and Alexandra Kollontai spent most of her remaining years in diplomatic exile.

While the Soviet experiment failed, Braun's ideas and the program of the socialist women in 1910 found fertile soil in the Scandinavian social democracies. The Danes introduced a two-week leave for working women as early as 1901, and by 1960 a universal, state-funded paid maternity leave was extended to all working women. In 1919, Finland passed maternity leave provisions for factory workers and professional women, and added job protections in 1922. Sweden introduced an unpaid maternity leave of four weeks as early as 1901, and by 1963, the government guaranteed women 180 days of job-protected maternity leave at 80 percent of their salaries. Compare this with the United States, which did not even pass a law outlawing discrimination against pregnant women until 1978. And American women didn't have a federal law for job-protected unpaid leave until 1993. We still don't have mandated paid maternity leave (but then again, we don't have mandated paid sick leave either).[6]

Eastern European countries also made early use of maternity leave provisions. Poland granted twelve weeks of fully paid maternity leave in 1924, but most countries introduced these provisions after World War II. These nations needed women to work because there was a shortage of male labor, but they had also invested heavily in women's education and professional training and did not want to lose their expertise (think back to Jake's reasoning in the beginning of this chapter). For example, the Czechoslovaks introduced the first maternity support policies in 1948, and by 1956 the Labor Code guaranteed women eighteen weeks of paid, job-protected leave. In Bulgaria, the 1971 constitution guaranteed women the right to maternity leaves. In 1973, Bulgarian women enjoyed a fully paid maternity leave of 120 days before and after the birth of the first child as well as an extra six months of leave paid at the national minimum wage. New mothers could also take unpaid leave until their child reached the age of three, when a place in a public kindergarten would be made available. Time on maternity leave counted as labor service toward a woman's pension, and all leaves were job-protected. Later, an amended law allowed fathers and grandparents to take parental leave in the place of the mother. The Bulgarians covered for those on parental leave with the labor of new university graduates. (In Bulgaria, postsecondary education was free for students who agreed to complete a period of mandatory national service after earning their degrees. These internships allowed young people to get work experience and ensured that a parent's job would be waiting when he or she returned from leave.)[7]

The 1973 Bulgarian Politburo decision also included language about reeducating men to be more active in the

home: "The reduction and alleviation of woman's household work depends greatly on the common participation of the two spouses in the organization of family life. It is therefore imperative: a) to combat outdated views, habits, and attitudes as regards the allocation of work within the family; b) to prepare young men for the performance of household duties from childhood and adolescence both by the school and society and by the family."[8]

In the pages of the Bulgarian women's magazine *The Woman Today*, editors published articles about men doing their fair share of the housework and encouraging men to be more active fathers to their children. In the Young Pioneers and the Komsomol, two gender-integrated youth organizations, boys and girls were socialized to treat each other as equals who both had important (albeit different) roles to play in building a socialist society. Where men did mandatory military service after secondary school, women's reproductive labors counted as an equivalent form of national service. In the end, these policies failed to challenge traditional gender roles, but it is important to recognize that there were at least attempts to redefine ideas about masculinity and femininity. Indeed, specific state efforts to encourage men to be more active fathers and participate more in housework can be found as early as the 1950s in Eastern Germany and Czechoslovakia. However, in the face of male recalcitrance, governments focused their efforts instead on the socialization of housework and child care, hoping to expand the network of communal kitchens and public laundries throughout the country.

As early as 1817, the British utopian socialist Robert Owen had suggested that children over the age of three

should be raised by local communities rather than in nuclear families, and this idea of the public provision of child care influenced all twentieth-century experiments with state socialism. In addition to maternity leaves, countries like Poland, Hungary, Czechoslovakia, Bulgaria, East Germany, and Yugoslavia invested state funds to expand the network of nursery schools (for children from birth to age three) and kindergartens (for children ages three to six) to support women's continued labor force participation. Of course, the quality of these child care facilities was uneven across the region and often left much to be desired; children got sick with more communicable diseases, and caregivers were often overwhelmed by the demands of too many children (problems common in day care centers today). But as with so many things in the command economy, planners allocated resources inefficiently, and demand always exceeded supply. In my research in the archives of the Bulgarian Women's Committee, for instance, I discovered many letters to the relevant ministries complaining about the lack of funds allocated for the crèches and kindergartens. Here again, the northern European countries of Sweden, Norway, Denmark, and Finland did much better. They invested state funds to build child care facilities to promote women's full employment. By the end of the Cold War, Scandinavian female labor force participation rates were second only to those of women in the Eastern Bloc.[9]

Upon publication of my op-ed in the *New York Times*, I received countless messages from Western readers who discussed their own frustrations. Many women who grew up in the Eastern Bloc also wrote me to relate their memories

and opinions about life under socialism, confirming with their personal anecdotes that not all was so bleak behind the Iron Curtain. My favorite letter came from a woman living in Switzerland, born into a middle-class family in Czechoslovakia in 1943. She detailed her own recollections of life under state socialism:

> When I got married, we had to work to be able to pay off loans both for the flat as well as furniture we had bought. Within a year, we had our first child. The "generous" maternity leave was eight months after which I went back to work. I had to gently wake our little daughter every morning at 5:30 am as the day care center opened at 6:00 am and it took us 15 minutes by tram to get there. Once at the day care center, I had to dress her in a uniform and hurry to take the bus at 6:30 am to get to work. I often only just managed to catch the bus and it was not unusual that the doors of the bus would close behind me with part of my coat still hanging outside. At the time, my husband was getting off work at 2 pm which meant that he could pick up our daughter, buy some groceries and prepare dinner in time for my return at around 5 pm. Shortly after that, we would put our daughter to bed as the next day promised the same rushed routine as the day before. My husband and I were both tired after such a day. . . .[10]

The Swiss-Czechoslovak woman actually meant this description of her former life as a *criticism* of the German version of the op-ed. She felt that her life was too harried

for sex with her husband. As a working mother, I certainly understand how difficult it is to manage work/family balance, but I don't think this woman (age seventy-four when she wrote me in 2017) realized the extent of her privilege in state socialist Czechoslovakia compared to the situation of working women today. In her criticism, she mentions that she and her husband had their own private flat, she had eight months of maternity leave, their child had a spot in a state-funded day care center fifteen minutes from home, and her husband got off work at two p.m. and picked up their daughter, bought groceries, and prepared dinner before she returned home at five. She tells me that she and her husband were exhausted by this "rushed routine," but I suspect she has no idea how luxurious this routine might sound to women, even European women, trying to balance work and family today. In fact, the Cambridge Women's Pornography Cooperative publishes a book called *Porn for Women* that features men who pick up their children, buy groceries, and cook dinner before their wives get home from work.[11]

For many women, access to affordable and quality child care is more important than maternity leave, especially if the latter is not job-protected. When I first started out as an assistant professor, I was far removed from my family, and I placed my infant daughter in the on-campus day care center full time for five days a week. One of my colleagues had three children under the age of four—two three-year-old twin girls and a one-year-old son. This colleague, whom I

will call Leslie, had been an established professional before motherhood and had no desire to forfeit her career. She had accepted a three-quarters-time job well below her qualifications, and her husband also arranged to drop down to a four-day week. Leslie paid for the remaining three full days of child care for her three children directly through a payroll deduction. At the end of each month she would waltz into my office with her pay stub. After taxes, insurance payments, and the cost of childcare, Leslie earned about seventy cents a month. She worked thirty hours a week, and often put in unpaid extra time for evening events, for less than $9.00 of take-home pay *per year*. And she did this for three years!

I once asked Leslie why she didn't just stay home with the kids, and she admitted that she often fantasized about it. But she refused to give up her work life, and she feared having a gap on her résumé. "I've seen too many professional women get completely derailed after taking time out of the labor force," she explained. "I'm working for nothing now, but it will pay off when my kids are old enough to go to school and I can just go out and get another full-time position."

Consider Leslie's situation compared to that of Ilse, a composite woman based on research into the experiences of a typical East German woman growing up in the 1980s. Immediately after World War II, the East Germans mobilized women into the labor force. The East German state fully supported women in the workplace, and while it encouraged marriage, being a wife was not considered a precursor to motherhood. Since there weren't enough men to go around, the state invested heavily in supporting single

mothers. In particular, the East German government idealized early motherhood and built special "mother-and-child" housing at universities where students could live with their babies. If Ilse was an average East German woman, she had her first child by the age of twenty-four, probably before she graduated from college, which meant she avoided the fertility decline associated with delayed childbearing. The government heavily subsidized housing, children's clothing, basic foods, and other expenses associated with child rearing, as well as providing women like Ilse with access to child care whenever they needed it. By 1989, out-of-wedlock births accounted for about 34 percent of all births (compared to only 10 percent in West Germany), but unlike most places in the capitalist West, single motherhood did not lead to destitution. One of my Bulgarian friends earned his degree in Leipzig in the 1990s. He recalls knowing two female students for three years before he realized that they were the mothers of small children. Nothing about motherhood interfered with their education, because their infants were cared for in campus nurseries.[12]

By contrast, women in Western Germany, like women in the United States, returned home to be dependent housewives and mothers after World War II, confined to the *Kinder, Küche, Kirche* (children, kitchen, church). As noted earlier, West German law required a husband's consent before a woman could work outside of the home until 1957, and until 1977 family law insisted that married women were not to let their jobs interfere with their household responsibilities. On a practical level, school schedules and a lack of afterschool care rendered it almost impossible for West German women to work full time. Married mothers

worked mostly in part-time jobs with a larger gender wage gap than that found in the East.[13]

Of course, not all socialist countries supported women's economic independence to the extent of the East Germans (who were locked in their own Cold War rivalry with the West Germans). The Soviets relegalized abortion in 1955 but remained decidedly pro-natalist, and even the most basic sex education was absent in the public discourse. Romania and Albania were *terrible* in terms of women's reproductive freedoms, with the state forcing women to have babies by restricting access to birth control, sex education, and abortion. Although initially legal in Romania, the infamous Decree 770 of 1966 outlawed abortion in an effort to reverse the population decline, and the law was strengthened in the 1980s to include mandatory gynecological exams for women of reproductive age. The Romanian state essentially nationalized women's bodies, and many women sought dangerous, illegal abortions, as dramatized in the brilliant 2007 film *4 Months, 3 Weeks and 2 Days*.[14]

The key message here is that you do not have to have an authoritarian regime to implement policies that ease the conflict between fertility and employment. Today, almost every country in the world has some form of guaranteed paid maternity leave for women, and many are instituting parental leaves with mandatory paternity leave components. In Iceland, the most gender-equal country on the globe according to the World Economic Forum, fathers get ninety days of leave, and 90 percent of them take it. The state supports both parents to combine their work and

family responsibilities, providing the way for full gender equality in the home as well as the workplace.[15]

While state socialism had its downsides, the sudden change of East European women's fortunes after 1989 amply demonstrates how free markets quickly erode women's potential for economic autonomy. In Central Europe, for instance, post-1989 governments pursued conscious policies of "refamilization" to support the transition from state socialism to neoliberal capitalism. As state enterprises closed or were sold to private investors, unemployment rates skyrocketed. Too many workers competed for too few jobs. At the same time, the new democratic states reduced their public expenditures by defunding crèches and kindergartens. Public child care establishments closed, and new private facilities required substantial fees. Some governments made up for closing kindergartens by extending parental leaves for up to four years, but at far lower rates of wage compensation and without job protections.[16]

These policies conspired to force women back into the home. Without state-funded child care or well-paid maternity leave, and in a new economic climate where employers had a large army of the unemployed from which to choose, many women were pushed out of the labor market. From a macroeconomic perspective, this proved a boon to transitioning states. Unemployment rates dropped (and thus the need for social benefits), and women now performed for free the care work the state had once subsidized in order to promote gender equality. Later, when deeper budget cuts hit pensioners and the health care system, women already at home looking after their children could now care for the sick and the old—at great savings to the state budget.[17]

Given that many women preferred formal employment to the unpaid drudgery of housework, it should not be surprising that post-1989 birthrates plunged. Although birthrates in Eastern Europe were higher than those in Western Europe before 1989, they began to fall as soon as the refamilization process began. The institution of free markets actually hindered rather than helped new family formation. Nowhere was this more profound than in Eastern Germany, where skyrocketing unemployment and the collapse of support for child care contributed to an unprecedented and uncoordinated drop in fertility, what the West German press called the "birth strike." Over a five-year period, the birthrate in the East German states of reunified Germany fell by 60 percent. Although the fertility rates have climbed out of the pits of the 1990s in some countries, the former state socialist nations of Eastern Europe have some of the lowest birthrates in the world today. In 2017, Bulgaria had the fastest-shrinking population in the world, and sixteen of the top twenty nations facing the steepest expected population declines by 2030 were former state socialist nations.[18]

The irony is that as women were being forced back into the home in Eastern Germany, many East German women moved to the West looking for better paid jobs, and these women brought with them a set of expectations that helped West German women find their way into the workplace. The young East Germans who flooded into West Germany after 1989 were the children of working mothers, and they thought it absolutely normal that women would leave their children in kindergartens. When I lived in Freiburg, I met a West German woman who served as the managing director of a well-known academic publishing house in Stuttgart.

"Thank God for those East German women," she said, and explained that she wouldn't have had a career without them. Before 1989, West German women were expected to stay home with their children. "But when the East German women came over," she told me, "they were used to having crèches and kindergartens, and they demanded them."

Not everyone is a fan of half-hearted government-mandated paid maternity leave policies, especially those that are not enforced. Some feminists object to these policies because they fear they will disadvantage women in competitive labor markets. Employers will prefer to hire men who will not get pregnant, like my friend Jake's boss. This is why some nations have instituted take-it-or-lose-it paternity leaves to try to equalize the expectation for men's and women's care responsibilities. Sweden now requires that new mothers and fathers take a mandatory sixty days of leave each in order to qualify for the state's generous benefits. Free marketers argue that companies should be free to set their own priorities without interference from the federal government, but corporate self-regulation has had a pretty abysmal success rate. As of 2013, only an estimated 12 percent of American workers were covered by paid parental leave policies. And this is completely predictable in a free market scenario. No business wants to be known as the one with the generous maternity leave policies because it fears that the women most likely to have babies will flock to it over its competitors. But if the law requires that all companies must offer the same job-protected leave, and if the government picks up part of the tab, as in Braun's maternity insurance plan,

then many employers would be willing to support these pol-
icies. It would mean they could hire the most promising job
candidates and invest in training them with a high degree
of certainty that they would reap the benefits of that train-
ing. Thus, the only way to ensure that all women benefit
from these policies (not just wealthier, professional women
working in already enlightened companies) is to have the
full weight of the federal, state, or local government behind
them.[19]

These same employers could count on workers continu-
ing after childbirth if high quality and reasonably priced
child care were readily accessible to all parents of young
children. After all, Jake's star employee did not leave after
having her baby. She left, reluctantly, when the weight of an
inflexible work life and a patchwork of complicated child
care arrangements came crashing down on her exhausted
head. The biggest help to working women would be the ex-
pansion of high-quality, federally funded child care, which
would support women's ability to combine motherhood
with paid employment. The United States once came close
to having a nationwide child care system: the Comprehen-
sive Child Development Act passed by a bipartisan vote of
Democrats and Republicans in 1971. The act would have
funded a national network of child care centers providing
high-quality educational, medical, and nutritional ser-
vices, a crucial first step for universal child care. President
Richard Nixon vetoed the act and criticized the "family-
weakening implications of the system" it envisioned. In his
official veto, Nixon wrote: "For the Federal Government
to plunge headlong financially into supporting child de-
velopment would commit the vast moral authority of the

National Government to the side of communal approaches to child rearing over against the family-centered approach." This "family-centered" approach required the unpaid labor of women in the home, reinforcing the traditional gender roles of male breadwinner and female homemaker. In essence, Nixon asked, Why should the government pay for something that we can get women to do for free?[20]

Although research shows that children are not harmed by quality center-based child care, and may even enjoy greater cognitive, linguistic, and socioemotional development than children cared for at home, American conservatives hate the idea of child care because it also challenges male authority in the family. One op-ed contributor for Fox News sees universal child care as part of an evil plot, arguing "totalitarian governments have gone to great lengths to indoctrinate children, and the biggest obstacles they faced was parents who contradicted what the government was telling their kids." In this view, everything that state socialist countries did to support women—increasing labor force participation, liberalizing divorce laws, creating kindergartens and crèches, and supporting women's economic independence—was aimed at brainwashing children. Even public schools served the primary purpose of indoctrination.[21]

Women's rights and entitlements are thus painted as part of a coordinated plan to promote world communism, a threat spreading across the West. From this perspective, even democratic socialist Sweden has "aggressively instituted a very costly system of nursery school care" to "force women out of the home and into the labor force." As if Swedish women wouldn't choose to work of their own

accord. Behind the fear of government indoctrination of children is a real fear of women's economic independence and the breakdown of the traditional family.[22]

For now, it is still women who must gestate and deliver the actual babies (at least until scientists develop ectogenesis), but fathers can be just as involved in child care as mothers. The number of stay-at-home dads is growing, and it may be that one day employers will view male employees as potential caregivers in the same way they now view women. But until that time, competitive labor markets will continue to penalize women for their biology. The high cost of private child care—combined with the gender wage gap and social expectations that young children need mothers more than fathers—means that it is overwhelmingly still women who interrupt their work lives to stay home with small children. In the United States, these years out of the labor force hurt mothers in a variety of ways: lost income, being passed over for promotions, less money toward social security or retirement, and increased economic dependence on men. Of course some women want to stay at home, and this should remain a choice, as long as staying home to do care work does not entail financial dependence. Our goal should be that an equal number of men and women choose to act as stay-at-home parents. While this option should be open to all, I expect most men and women will not take it. With reasonable parental leaves and enough high-quality affordable child care to go around, we really can have our cake and eat it too.

One of the most obvious problems with many state socialist countries was that while citizens were guaranteed employment by the state, they were often forced to work at

jobs they didn't like. Many routine jobs were monotonous and unsatisfying (not so unlike routine jobs in the West). But too many women who want to work are forced to stay home because of the scarcity of quality child care, the high cost when it is available, and the lack of flexibility in the labor market. Other women need to work to survive, particularly since private health insurance in the United States binds employees to their workplaces if they don't want to lose benefits. Not all women have the option of a man who can support her, and even those who do would be wise not to rely too heavily on that option. Women should not be compelled into romantic relations because it is their only chance to have a roof over their heads. Our system also places a massive burden on men, since those who cannot afford to support their spouses are shunned as romantic partners (something that is already happening in the United States, where marriage rates among the poor are at an all-time low).

At the end of the day, differences in reproductive biology make it impossible to treat men and women as equals in labor markets, where employers endeavor to hire those they guess will be their most valuable workers. This is a sticky problem that lacks simple solutions, but policies like parental leaves and state-funded universal child care help alleviate the root causes of gender discrimination. These policies started as socialist propositions and had the explicit goal of gender equity at work and at home. Over the last century, such policies have begun to work their way into the legislation of almost every country around the globe. In 2016, the United States joined New Guinea, Suriname, and some

islands in the South Pacific in being the only countries in the world lacking a national law on paid parental leave.

When I think about the woman who quit Jake's firm to stay home with her baby and my former colleague Leslie, who worked for seventy cents a month, I lament that motherhood—which should be such a source of joy—has devolved into a crushing burden for so many women. Nowhere in the developed world is it harder for ordinary people to start their families. Surely the richest countries on the planet can do better.

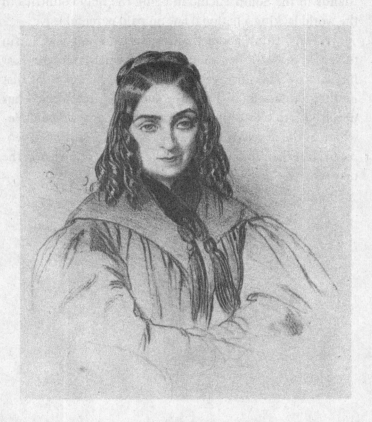

Flora Tristan (1803–1844): A French utopian socialist theorist and activist who argued that the liberation of the working classes could not be achieved without the concomitant emancipation of women. Her 1843 essay, *The Worker's Union*, is a foundational socialist feminist text in which Tristan envisioned a grand labor collective in which workers (both men and women) would pool their resources to provide social services for their own benefit. *Courtesy of TASS.*

3 PANTSUITS ARE NOT ENOUGH: ON LEADERSHIP

In high school, I was a certifiable Model United Nations (MUN) nerd. MUN is a kind of debate club in which students do research on the foreign policies of UN member nations and then represent those countries in mock sessions with fabricated political scenarios based on real current events. To excel at MUN, you needed to learn the ins and outs of international relations as well as understand the social, political, and economic contexts that informed the foreign policy decisions of different countries around the globe. The highest prize of a MUN competition was the gavel, awarded to the student who represented his or her country most convincingly in a mock session. Generally, the most prestigious gavels were awarded to members of the mock Security Council, the most powerful of the UN committees. Students worked their way up from the lesser committees like the General Assembly or the Economic and Social Council (ECOSOC) until they were ready to serve on the Security Council, where the brightest and most informed students discussed and decided the fate of the globe.

To increase your chances of winning a gavel, you wanted to represent one of the five permanent members of

the Security Council—the United States, France, the United Kingdom, the USSR, or China, the only countries with veto power. If you have veto power, you cannot be outvoted, and all other delegates need to secure your support for their resolution or at least guarantee your abstention. In a big competition, your school would be very lucky if it got assigned an allotment of countries that included one of the Big Five. But as a girl, I knew that the boys in my club wouldn't let me represent the US, the UK, and France. This was still more than a decade before Madeleine Albright became the first American female Secretary of State, and the boys argued that it was less likely for one of the Western countries to have a *woman* as a Security Council representative. Even in the era of Margaret Thatcher and Jeane Kirkpatrick, men still dominated foreign affairs.

It was, however, more plausible for communist China and the USSR. Zoya Mironova had been a Soviet deputy Security Council representative from 1959 to 1962, and served as the Ambassador of the U.N. in Geneva from 1966 to 1983. I didn't want to represent China, because they abstained on everything. So, I became the Eastern Bloc specialist, hoping that one day if we got the USSR the Security Council seat would be mine. The lesson I learned at fifteen was that while it was less plausible that a Western country would allow women to make crucial foreign policy decisions on the world stage, this was normal for the Soviet Union. But how could this be? Democracy was good and communism was bad. Why did the bad guys allow girls to do more?

Fast forward thirty years later, to November 2016, as I was sitting on the couch with my own fifteen-year-old daughter. We were watching PBS and ready to pop the champagne to celebrate the election of the first female

president of the United States. Whatever my personal feelings toward Hillary Clinton (you know me well enough now to suspect that I preferred Bernie Sanders), I was thrilled that this glass ceiling would finally be broken. Where I had struggled to find role models of women in power, I hoped my daughter would spend her remaining high school years with a woman in the Oval Office.

The bitter disappointment of that night reflected two unpleasant realities in America: the racist backlash against the first black president and a persistent bias against women in positions of authority. During the Cold War, the rise of a large domestic women's movement—combined with political fears about the perceived progress of women in the state socialist countries—forced Western countries to outlaw discrimination on the basis of sex and promote policies to support gender equality in the workplace. In the course of two short decades, women enjoyed opportunities for labor force participation in almost all sectors of the economy, entering many professions once considered the exclusive purview of men. Today, women make up the majority of college graduates in many advanced capitalist countries. But despite their experience and education, women still face barriers to the top positions in government and business. Over forty years of women's activism has done little to break the male stranglehold on political and economic power.

In the United States and Britain, there exists much handwringing about the lack of women in leadership positions. Even though studies show that diversity in corporate leadership increases profitability, efforts to challenge the status quo find few proponents. Researchers look for explanations, often faulting women for not being ambitious

enough or for not "leaning in." Some blame the challenges of combining work with family responsibilities and the frequent career interruptions for those who perform care work in the home. Others say that competition for top jobs is nasty and full of treachery, and that women aren't willing to join the fray. If they do, ambitious men will backstab them first, believing women less likely to retaliate. While all of these things may contribute to the problem, the underlying issue is the persistence of gender stereotypes in society, stereotypes internalized by girls from the earliest age. Just as I learned that it wasn't plausible for me to represent my country on the Security Council because of my sex, my daughter learned that a well-qualified woman with years of relevant experience could lose an election to a celebrity businessman with no governmental experience.

Two 2014 surveys by the Pew Research Center revealed that most Americans recognize the pervasiveness of this underlying gender discrimination. One poll asked Americans what held women back from moving into "top executive business positions" and "high political offices." Whereas only 9 percent believed that women weren't "tough enough" for the business world, 43 percent claimed that "women are held to higher standards" and that businesses were simply not ready to hire women as leaders despite their equal qualifications with men. In terms of high political office, only 8 percent claimed that women weren't "tough enough," but 38 percent believed that female candidates were held to higher standards, and 37 percent agreed that Americans were simply not ready to elect a woman for a position of power. When asked about prospects for the next decades, a majority of Americans believed that "men will continue

to hold more top business positions than women in the future."[1]

This is not to deny that American culture has changed; it is just to note that it is changing at a far slower pace compared to many of our peers. In 1990, only 7 percent of the US Congress were women. In 2015, this rose to 19 percent. In 2017, the United Kingdom reached an all-time high of 32 percent of elected MPs being women, but this still puts it at 49 in the world rankings (behind Rwanda, Bolivia and Cuba, who top the list). Compare the US statistics with those of some of the democratic socialist Scandinavian countries, and the home of the brave also looks like a laggard. The election of women members in the Swedish parliament grew from 38 percent in 1990 to 44 percent in 2015. In Norway, 36 percent of MPs were women in 1990 and 40 percent in 2015. The relevant figures are 31 percent (1990) to 37 percent (2015) for Denmark and 32 percent (1990) to 42 percent (2015) in Finland. Iceland wins the prize for almost complete gender parity; women's percentage of seats in parliament grew from 21 percent in 1990 to 48 percent in 2015. Why the difference? One word: quotas.[2]

In terms of women in leadership positions in the corporate world, the United States falls even further behind. Although women made up 45 percent of the employees in the top Fortune 500 companies in 2016, they held only 21 percent of the board seats and represented only 11 percent of the top earners. Compare this to Norway, where strict quota laws on board representation mean that 42 percent of corporate board seats were filled by women. In Sweden, this number is 36 percent, and in Finland it is 31 percent. But even democratic socialist countries like Sweden

struggle with getting women into the c-suite; the percentage of women in executive positions was still under 15 percent in 2012. And in 2014, the *Wall Street Journal* reported that out of 145 large Nordic companies, only 3 percent had female chief executive officers. Although women have the education and experience, top leadership positions in business everywhere continue to be gendered male. The only way to crack this continued dominance is through legislation that forces or strongly incentivizes the gender parity of positions at the top.[3]

So what about the state socialist countries? Although there were important efforts made to promote women to the highest ranks, and they certainly supported the idea that women could and should be in positions of power, the story is complicated by the specific nature of twentieth-century East European regimes. First, while there were official quotas for women in parliaments and in the Central Committees of the Communist Parties of most states, the composition of the elite Political Bureau (Politburo), where the real power lay, remained overwhelmingly male. Second, even when women's political participation increased at the local and municipal level, their participation was limited by the centralized nature of the one-party state. In terms of managerial positions within the state-run economy, the picture was also mixed. Decision-making power rested in the hands of the central planners, who were largely (though not exclusively) male. But different countries had different priorities, and certain sectors of the economy were more amenable to women's leadership than others. Women dominated the fields of medicine, law, academia, and banking, and on a symbolic level, at least, the state socialist countries

did have an excellent record of promoting women into top positions compared to countries in the West.[4]

Unlike capitalism, which distributes society's wealth on a competitive model based on ideals of meritocracy and survival of the fittest, socialism supports an egalitarian ideology. Social inequality is considered an inevitable by-product of the private ownership of the means of production: the factories, machines, technologies, intellectual property, and so forth. Capitalist economies create an ever-growing wealth gap between those who own the means of production and those who must sell their labor for less than the value it creates in order to meet their basic needs. Ongoing exploitation of those who work for a living increases the wealth of those at the top; the rich get richer at a faster and faster rate, which allows them to control more and more of the means of production. Socialist policies interrupt this trend toward growing inequality through a number of mechanisms, including the creation of public or collectively owned enterprises (co-ops) and/or redistribution of wealth through progressive taxation and the creation of publicly funded social safety nets to prevent destitution. Other than promoting the interests of the poor majority over those of the rich minority, however, nothing inherent in socialist ideology privileges any one social group over another. And women's emancipation was fundamental to the socialist vision from its inception (even if women's class identity was always privileged over their gendered identity).

The idea that men and women would share political power had roots in the earliest incarnations of socialist

ideals, which emerged after the French Revolution. In the 1820s and 1830s, the utopian socialist Saint-Simonians organized themselves into small religious communities in Paris, pooling their incomes and living collectively. An early leader, Prosper Enfantin, served as the community's "pope"; he proposed to share his position of authority with a woman who would serve as a "popesse." Unlike Mary Wollstonecraft and John Stuart Mill, who based their arguments for sexual equality on men's and women's innate rationality, the Saint-Simonians believed that men and women had different but complementary natures and that both spiritual and political authority required representation from each half of humanity. After internal debates, Enfantin's views prevailed, and the larger Saint-Simonian community was to be ruled by a couple-pope who served as the living representatives of God's masculine and feminine attributes. All positions of power were to be shared by a representative from each sex: each smaller community was headed by a male-female couple, their collective homes were led by a "brother" and "sister" pair, and each of their work syndicates was governed by a "director" and a "directress."[5]

Another prominent utopian socialist was the Frenchman Charles Fourier, who is believed to have coined the word "feminism" in 1837. Fourier was a fierce advocate for women's rights and believed that all professions should be open to women based on their abilities as individuals. Fourier understood that European women were no better than chattel to their fathers and husbands, and he proposed that enlightened societies would demonstrate their moral progress by freeing women from the narrow gender roles that trapped them in conventional marriage. Fourier promoted

the idea of collectively owned agricultural communities (called "phalanxes") in which men and women would work side by side and share the fruits of their labors in common. Fourier wrote: "Social progress and historic changes occur by virtue of the progress of women toward liberty, and decadence of the social order occurs as the result of a decrease in the liberty of women."[6]

The Saint-Simonians and Charles Fourier influenced the work of another important French utopian socialist, the fascinating Flora Tristan. She was the first theorist to connect women's emancipation with the liberation of the working classes. She understood that the relationship of the wife to the husband was analogous to that of the proletariat to the bourgeoisie. Writing and lecturing in the late 1830s and early 1840s, Tristan saw feminism and socialism as mutually dependent movements that would bring about a total transformation of French society; the emancipation of women could not happen without the liberation of workers, and vice versa. Instead of a model in which sexual equality tricked downward from the legal gains and increased educational opportunities of wealthy women, Tristan believed that the creation of one large and diverse worker's union (composed of both men and women) would realize sexual equality first among the toiling classes.[7]

Expanding on these ideas, the German socialists August Bebel and Friedrich Engels proposed a historical justification for women's emancipation, arguing that hunters and gatherers had once lived in primitive communal matriarchies. According to their theories, early humans survived in clans that consisted of men and women who practiced a form of group marriage and raised their

children collectively. Since paternity could not be established, descent was traced through the mother, and women had an equal if not greater share in decision making. Bebel and Engels argued that it was only after the advent of agriculture and private property that wealth could be accumulated. Hunters and gatherers did not horde resources; they consumed everything they hunted and gathered. But when some humans began fencing off large tracts of land to produce more food than they needed to survive and started selling the surplus, a new set of incentives destroyed old social structures. Landowners needed laborers to help them create greater surpluses, and it was at this moment in history that women's bodies became machines for manufacturing more workers. (They argue that this era also coincided with the invention of slavery).[8]

According to Bebel and Engels, once landowners began accumulating private fortunes, this class of men desired to pass their wealth on to legitimate heirs. This precipitated the invention of monogamous marriage and the enforced fidelity of the wife. The old matrilineal system was replaced by a patrilineal system whereby descent was traced through the father. (We can see the operation of this patriliny today, when women take the last names of their husbands upon marriage and children receive the surnames of their fathers. In a matrilineal system, it would be the reverse.) Engels postulated that this desire to accumulate wealth robbed women of their earlier autonomy: "The overthrow of the mother-right was the world historical defeat of the female sex. The man took command in the home also; the woman was degraded and reduced to servitude, she became the slave of his lust and a mere instrument for the production of children."

For early socialists, therefore, the abolition of private property would inevitably lead to the restoration of women's "natural" role as men's equal.[9]

Socialist ideas about women's emancipation would help fuel revolutionary impulses in Russia in 1917. The February revolution that toppled Tsar Nicholas II began on International Women's Day, precipitated by women strikers. As a provisional government tried to stabilize Russia in the following months, these women demanded full suffrage. In July 1917, they won the right to vote and stand for public office. After the October Revolution, Lenin and the Bolsheviks allowed women to vote and run in the elections for the Constituent Assembly. Most people don't realize that the Soviet Union did not become a one-party authoritarian state overnight. Because Lenin hoped to win a popular mandate, he allowed "the freest elections ever held in Russia until after the collapse of the Soviet Union in 1991," according to historian Rochelle Ruthchild. Voting began in November 1917 and lasted for about a month. Voter participation in the Constituent Assembly elections was incredible given the chaos of the time, and women's electoral turnout exceeded all expectations. However, Lenin dissolved the democratically elected Constituent Assembly once it became clear that his Bolshevik party would not have a majority. Soviet women's right to vote became largely superfluous in the dictatorship of the proletariat.[10]

Despite the institution of "war communism" and the centralization of political authority, Lenin did initially empower a group of activists to lay the groundwork for the full emancipation of women. Alexandra Kollontai served

as the people's commissar for social welfare and helped to found the Soviet women's organization the Zhenotdel. As discussed earlier, she would be in charge of implementing a wide range of policies to support women's full incorporation into the Soviet labor force. The American journalist Louise Bryant was awed by Kollontai's commitment and lack of fear when dealing with the Bolshevik men. Bryant reported in 1923:

> Madame Kollontai's political judgment, even from the standpoint of an orthodox Communist, is often very bad. She has unlimited courage and on several occasions has openly opposed Lenin. As for Lenin, he has crushed her with his usual unruffled frankness. Yet in spite of her fiery enthusiasm she understands "party discipline" and takes defeat like a good soldier. If she had left the revolution four months after it began she could have rested forever on her laurels. She seized those rosy first moments of elation, just after the masses had captured the state, to incorporate into the Constitution laws for women which are far-reaching and unprecedented. And the Soviets are very proud of these laws which already have around them the halo of all things connected with the Constitution.[11]

Kollontai would eventually be sent as the Soviet ambassador to Norway, the first Russian woman to hold such a high diplomatic post (and the third female ambassador in the world), but after the rise of Stalin she would fall into relative obscurity, with many of her original dreams for women's emancipation either discredited or forgotten.

Among the other prominent women who worked with the Zhenotdel in the 1920s was Nadezhda Krupskaya, Lenin's wife, a radical pedagogue who served as the deputy minister for education from 1929 to 1939. She worked to build new schools and libraries for a population in which six out of ten people could not read or write in 1917, and her educational ideals would go on to inspire leftist educational reformers like Paulo Freire in Brazil. Another prominent Bolshevik, Inessa Armand, worked as a leader in the Moscow Economic Council, served as a top member of the Moscow Soviet, and would eventually be the director of the Zhenotdel. Countless other Bolshevik women would take up positions of power in the early Soviet government as the country struggled to survive a civil war, a horrific famine, and Lenin's early death.[12]

The Stalinist era saw a relative return to traditional gender roles even as the Soviets encouraged women to engage in military training. The historian Anna Krylova has explored the slow integration of Soviet women into the military despite initial male resistance. By World War II, the USSR had squadrons of trained female fighter pilots. These included the infamous *Nachthexen* (night witches) of the 588th Night Bomber Regiment of the Soviet Air Forces, who flew in stealth mode at night and dropped precision bombs on German targets. The women pilots were all in their late teens and early twenties, and they flew about thirty thousand missions from 1941 to 1945. Although other countries had trained female pilots who flew in support roles, the Soviet Union was the first country in the world to allow women to fly combat missions. The Nazis feared these female pilots, and any German

pilot who shot a "witch" out of the sky supposedly won himself an automatic Iron Cross.[13]

Across Eastern Europe, World War II also inspired thousands of women to take up arms as anti-Nazi guerillas, and many would go on to have careers in national and international politics. For example, Vida Tomšič was a Slovenian communist who fought as a partisan against the Italians and became her country's minister for social policy after the war. She served in a wide variety of government posts and became a dedicated women's activist both within Yugoslavia and internationally during the Cold War. A legal scholar and jurist, Tomšič was revered as a national heroine between 1945 and 1991, and represented Yugoslavia in several posts at the United Nations.[14]

Neighboring Bulgaria also produced spirited antifascist women who would later enter politics. Elena Lagadinova was the youngest female partisan fighting against her country's Nazi-allied monarchy. She later earned a PhD in agrobiology and worked for thirteen years as a research scientist before serving as the president of the Committee of the Bulgarian Women's Movement for twenty-two years. Lagadinova was also a member of Parliament, a member of the Central Committee, and a passionate advocate for women's rights on the international stage, particularly during the United Nations Decade for Women between 1975 and 1985. Another Bulgarian partisan was Tsola Dragoycheva, who fought against Bulgaria's right-wing monarchist regime beginning in the 1930s. A heroine of the Bulgarian Communist Party, Dragoycheva served as Bulgaria's first woman to hold a cabinet position as the minister of the Postal Service, Telegraph and Telephone after World War II. From 1944 to 1948, she also

served as the general secretary of the National Committee of the Fatherland Front, headed the Council of Ministers, and wielded great influence over the development of Bulgaria's newly planned economy. Later she would become a full member of the Bulgarian Politburo, one of the few women in the Eastern Bloc to rise to such a high position without being the wife or daughter of a communist leader.[15]

Other socialist women in Eastern Europe had been in and out of prison for their political activities in the 1930s or spent time as exiles in the Soviet Union until they could return home after the end of World War II. In Romania, the rise of "Aunty Ana" Pauker showed the world that state socialism would allow women to take up the highest positions in government, shocking Western observers. Writing in the *New York Times* in 1948, journalist W. H. Lawrence reported, "Ana Pauker is both architect and builder of the new Rumanian [*sic*] Communist state. She not only plans but she translates political, economic, and social blueprints into action as secretary of the Rumanian Communist Party and Minister for Foreign Affairs of the newly proclaimed republic—the first woman in the world to hold the title of Foreign Minister. . . . From the standpoint of international communism, Ana Pauker's is a Horatio Alger success story—from political rags to political riches." In September 1948, *Time* featured her portrait on its cover and labeled her "the most powerful woman alive."

The Eastern Bloc countries also excelled at strategic international demonstrations of their commitment to women's rights, particularly in the case of Valentina Tereshkova. In June 1963, just five years after the launch of *Sputnik*, the front page of the *New York Herald Tribune* read: "Soviet

Blonde Orbiting as First Woman in Space." In the same year that Betty Friedan published *The Feminine Mystique*, the banner headline of the Massachusetts *Springfield Union* declared: "Soviet Orbits First Cosmonette." The Soviets made Tereshkova a symbol of their progressive social policy, and she headed their delegations to the three UN world conferences on women in 1975, 1980, and 1985. In 1982, cosmonaut Svetlana Sevitskaya was the first woman to fly on a space station, a year before Sally Ride became the first American woman astronaut. Two years later, Sevitskaya completed the first space walk by a woman and became the first woman to complete two separate space missions.[16]

Although Soviet women rarely ventured into the realm of high politics, there were some important exceptions. In 1919, Elena Stasova was the first woman to become a candidate member of the Soviet Politburo, the highest political body in the country, although her tenure was very brief. Decades later, in 1956, Ekaterina Fursteva was elected as a full member of the Politburo, serving for four years. She supported Khrushchev's de-Stalinization policies and eventually left the Politburo to become the minister of culture from 1960 to 1974. In September 1988, Alexandra Biryukova became a candidate member of the Politburo, which carried nonvoting status. Finally, in 1990, Galina Semyonova was the second woman to become a full voting member of the Politburo. Nominated by Gorbachev himself as a first step in his plan to put more women into positions of power, Galina Semyonova earned a doctoral degree in philosophy and spent thirty-one years as a working journalist. At age fifty-three she was a mother and grandmother. Her election signaled that the Soviets were ready to take domestic

women's issues more seriously. In a January 1991 interview with the *Los Angeles Times*, Semyonova was openly critical of the Soviet government's previous policies toward women's leadership. "From the founding of our state," she told the American journalist, "we have many very humane laws. Lenin personally signed many decisions and laws on the family, on marriage, the political rights of women, the liquidation of illiteracy among the female population. But these laws, in fact, were quite often counteracted by social-economic practice. The result was that women were not prepared to assume the leading role in society." Using the new freedoms being granted under perestroika, Semyonova hoped that putting more Soviet women into leadership roles would make politics "more humane and prevent it from becoming too aggressive."[17]

Although these high-profile examples demonstrate the state socialist countries' commitment to the ideal of women's rights, actual practice did not always live up to the rhetoric. Between 2010 and 2017, I spent over a hundred and fifty hours interviewing the octogenarian Elena Lagadinova, the president of Bulgaria's national women's organization. Lagadinova admitted that the socialist states did not achieve as much as she had hoped. I once asked her why more women did not rise up to the highest positions of power given the general commitment to women's rights. Lagadinova acknowledged that this had been an ongoing challenge for the Bulgarian women's committee and claimed that East European countries did not have enough time to overcome the centuries-old idea that leaders should be men. It wasn't just that men disliked women in power, Lagadinova argued; it was that women also felt uncomfortable with women's

leadership. As a result, they were less likely to support their female comrades and more reticent to pursue positions of authority. They preferred to work behind the scenes, she said. High politics in Eastern Europe, just like high politics elsewhere, was a treacherous place, infused with intrigues and betrayals. Lagadinova suggested that women were less inclined to engage in the necessary subterfuges. On the other hand, she believed that political life might have been more civilized if there had been more women at the top. Her organization tried to promote qualified candidates when they could, but the patriarchal culture of the Balkans, combined with the authoritarian nature of the state (ruled by the same man for thirty-five years) discouraged women from getting involved.

To encourage more women to take a chance in politics, Bulgaria and other state socialist countries introduced quotas for women in parliament, and they did have higher percentages of women holding political office than most of the Western democracies throughout the Cold War. Women's positions in the governing apparatus of a one-party state were largely symbolic, but the symbolism was important. After all, male members of parliament and of the Central Committee enjoyed no greater authority than their female comrades. Women fared better in white-collar jobs in the planned economy, often dominating banking, medicine, the academy, and the judiciary. Part of this trend reflected specific policies to promote women in the professions, but it was also the case that blue-collar, industrial jobs paid higher wages under state socialism, so men tended to concentrate their labor in those sectors of the economy. But as discussed in Chapter 1, female labor force participation

rates were the highest in the world. Because the number of women in the workforce was greater, there were numerically more women in managerial positions. Furthermore, the Eastern Bloc countries did an excellent job at funneling women into the science, engineering, and technology sectors. A March 9, 2018, article in the *Financial Times* revealed that eight of the top ten European countries with the highest rates of women in the tech sector were in Eastern Europe, a legacy of the Soviet era, when women were encouraged to pursue these careers. Indeed, between 1979 and 1989, the percentage of women in the USSR working as "engineering and technical specialists" increased from 48 to 50 percent of all workers in those fields—exact parity. Also by 1989, 73 percent of all Soviet "scientific workers, teachers, and educators" were women.[18]

State-mandated quotas for women in political office, on corporate boards, and in public enterprises have been implemented in democratic countries around the world, and studies show that they have been remarkably effective, if properly enforced, in increasing the number of women in positions of authority. Since 1991, over ninety countries have implemented some kind of quota system for women in national parliaments, and the percentage of women in positions of power has skyrocketed, creating role models for the next generation of girls aspiring to careers in politics. In 2017, out of the forty-six countries that have 30 percent or more women in their parliaments, forty of them have some form of quota system in place. But quotas work best in electoral systems based on proportional representation,

in which citizens vote for parties rather than individuals. Quotas can legislate that a certain percentage of the names on an electoral slate are those of women. Because Americans and Britons vote for individual politicians in single-member constituencies, quotas would be difficult to enforce. If political parties had to run a certain number of women, they might concentrate them in constituencies where they know women will lose. But there could be quotas for appointed cabinet positions, for instance, or other creative ways to increase women's participation without revamping the electoral system.[19]

State-mandated quotas for women on the executive boards of corporations and public enterprises have successfully promoted women into leadership positions and are quite doable in the US and UK context. Quotas were first introduced in Norway in 2003; companies faced dissolution if they did not diversify their boards. For large firms, a full 40 percent of board seats needed to go to women. After Norway, other European countries imposed quotas on corporations, albeit with softer penalties for noncompliance. Perhaps not surprisingly, the softer the mandate, the fewer the companies that complied. Although the percentage of women serving on the boards of large publicly traded companies rose from 11 percent in 2007 to 23 percent in 2016, this figure was significantly higher in countries with strict quotas in place: 44 percent in Iceland, 39 percent in Norway, and 36 percent in France. In Germany, where quotas are voluntary, the percentage is only 26 percent. In the UK, where there are no quotas in place, it stood at around 22 percent in 2017. As a result, the European Commission decided in 2017 to push for an EU-wide law requiring that

large companies in all member states impose a 40 percent quota for women on corporate boards.[20]

Of course, no woman wants to feel like a second-class citizen or occupy a position merely because she is female, so it is important to realize that the ongoing discrimination against women in leadership positions is not because Americans think that women are less capable or lack the necessary leadership attributes. A 2014 Pew survey on women and leadership found that most respondents saw no difference between men and women's innate abilities. In some categories, such as honesty, ability to mentor employees, and willingness to compromise, Americans who believed there were differences between men and women thought that women were *better* than men. Discrimination against women in leadership has little basis in differential skill sets and more to do with social attitudes about women in power. So this is not about putting less qualified women into leadership positions because they are female; it's about trying to counteract the deep, unconscious gender stereotypes about men as leaders and women as followers. Some people just feel weird with a girl boss.[21]

We don't associate women with positions of authority because we've seen so few of them. And because there are so few women in positions of authority, both men and women continue to associate leadership with male bodies, a vicious cycle that is hard to break out of. (A similar problem can be found for women in the sciences, engineering, and tech.) When asked about factors affecting their own ambition and willingness to stand for election or compete for top jobs, women often blame a lack of female role models for their reticence. For example, the consulting firm KPMG

conducted a Women's Leadership Study in 2015, survey-
ing 3,014 US women between the ages of eighteen and
sixty-four. In terms of learning about leadership, 67 per-
cent claimed that their most important lessons came from
other women. An additional 88 percent reported that they
were encouraged by seeing women in leadership positions,
and 86 percent agreed with the statement "When they see
more women in leadership, they are encouraged they can
get there themselves." Finally, 69 percent of the women
surveyed agreed "that having more women represented in
senior leadership will help move more women into leader-
ship roles in the future." Because of the importance of role
models, KPMG recommended the promotion of qualified
women into high managerial positions, onto corporate
boards, and into the c-suite. And a 2016 study by the Rocke-
feller Foundation found that 65 percent of Americans "say it
is especially important for women starting their careers to
have women in leadership positions as role models." But we
know from the experiences in Europe that this won't hap-
pen without some sort of external intervention.[22]

While women's leadership is important, it's also worth
noting that quotas in business and politics may only ben-
efit a small percentage of white, middle-class women. If
we focus on promoting women into positions of power to
the exclusion of other pressing issues that affect poor and
working-class women, particularly women of color, we fall
into the dangerous trap of corporate feminism à la Ivanka
Trump. Yes, the glass ceiling needs to be broken, but that
does not mean we should ignore the pressing problems
of those nowhere near as high in the pecking order. Both
executive men and women, as well as men and women in

politics, often build their careers on the backs of poorer women: the nannies, au pairs, cooks, cleaners, home health aides, nurses, and personal assistants to whom they outsource their care work. Policies to help women get to the top always must be combined with practical steps to help those women struggling at the bottom, or they simply exacerbate existing inequalities.

For example, if federal, state, or local governments ever embraced the idea of job programs for the unemployed, it would be wise to couple this policy with a mandatory quota stipulating that 50 percent of all jobs created would be reserved for women. It's not at all unthinkable that politicians might decide to create a special jobs program for men, believing that women don't need to work since they have responsibilities in the home. In the early years of the economic transition in some Eastern European countries, job creation policies targeted displaced men on the assumption that the male breadwinner/female homemaker model was more desirable than the reverse. Since job creation in the private sector paled in comparison to the job losses caused by the rapid privatization or liquidation of state-owned enterprises, there simply weren't enough jobs in the economy to employ all of the people made redundant by the economic transition. In order to control unemployment, women were forced back into the home by refamilization policies, and there was explicit job discrimination against women as the imposition of free markets came bundled with the return of traditional gender roles.

But when most people talk about quotas, they are usually discussing quotas for elite positions of power, and it's also important to realize that quotas alone can't remove all

barriers. There may be other ways to increase the number of women in leadership positions, but the core idea is to create more positive role models, which can start to reshape societal attitudes. All women and girls are harmed when society casts ambitious women as wicked or ugly, imagining power and authority as a naturally masculine character trait. Patriarchal culture permeates society, and both men and women feel uncomfortable with women in power. Strong and competent women are considered less feminine, if not downright unpleasant. Notice the language used in *Time*'s 1948 description of "the most powerful woman alive," Romania's Ana Pauker: "Now she is fat and ugly; but once she was slim and (her friends remember) beautiful. Once she was warmhearted, shy and full of pity for the oppressed, of whom she was one. Now she is cold as the frozen Danube, bold as a Boyar on his own rich land and pitiless as a scythe in the Moldavian grain." Pauker's ugliness develops as her political authority expands; her shy, warmhearted nature is corrupted by her entry into the male-dominated corridors of power. Not surprisingly, the *Time* cover image of Pauker is an unflattering profile of an angry, middle-aged woman with short, grey hair.[23]

This negative image of fat and ugly communist women was consciously produced and reproduced by the American media throughout the Cold War. Growing up in the Reagan era, I believed those awful stereotypes that circulated about unattractive Soviet women. I remember an advertisement for the Wendy's hamburger chain in the mid-1980s—a fashion show, Soviet style. Playing on the worst American tropes, the commercial features a fat, middle-aged woman wearing a grey smock and a grandmotherly kerchief around her hair. She struts up and down a catwalk below a portrait

of Lenin. Another fat, masculine woman in an olive green
military uniform calls out, "Day wear," "Evening wear,"
and "Swim wear" as the first woman walks out wearing the
exact same smock, only holding a flashlight for "evening
wear" and a beach ball for "swim wear." The voiceover of
the ad informs viewers that they have a choice at Wendy's
(unlike people in the USSR), but it was the image of Soviet
femininity (or lack thereof) that made the commercial so
powerful. I was still in my teens when I first saw this ad, and
it certainly occurred to me that wanting to wield veto power
might somehow strip me of my femininity. When I finally
got my shot at a seat on the Security Council, I wondered
whether the boys thought they were punishing me by mak-
ing me represent the "evil empire."

Of course, representing the East Bloc countries was
also much harder than role playing the United States, the
United Kingdom, or France. To be a Western country, all
you had to do was peruse the newspaper or binge-read *U.S.
News and World Report.* Figuring out the ideological and
practical motivations for Soviet and Eastern Bloc foreign
policy positions required savvy research skills. In those
days, long before the internet, foreign policy research had
to be done using print sources, usually available only in a
library. And if you wanted to read actual records from the
United Nations, you had to find a way to get to a university
library. But to win the top prize, I had to read books and
reports produced by the Eastern Bloc countries. I needed
to understand their worldviews so I could represent them
more convincingly.

It was 1987 when I stumbled upon a large, hardcover
coffeetable book as I conducted background research for

the MUN conference, where I was representing the Soviet Union on the Security Council. Published in 1975 to coincide with the United Nations' International Year of Women, *Women in Socialist Society* was an elegant piece of East German propaganda, celebrating the gains of women in the Eastern Bloc. Although I was suspicious of the didactic English text, I was entranced by the images. The photos of Rosa Luxemburg and Alexandra Kollontai, the latter a strikingly beautiful young woman. The lovely twenty-six-year-old Valentina Tereshkova in her uniform. As if directly responding to the Western stereotype of Eastern Bloc women as tired, fat, and ugly, the East Germans included a whole chapter on "Women, Socialism, Beauty and Love," complete with stylized black-and-white nude photographs of gorgeous models baring their perky breasts for the cause. Scattered across the glossy pages were svelte, pretty women working in factories, in labs, in classrooms, and sitting around conference tables with men. Women competing at the Olympics, women smiling at their children, and women laughing together as workmates.

Later, as I learned about the command economy, I understood that the images in the book represented more of the communist ideal than the lived reality of state socialism in Eastern Europe. In the late 1990s, when I first lived in Bulgaria, street vendors sold women's panties on every corner. In newspaper kiosks, you could buy a lace thong with your morning edition, because people were trying to make up for their relative deprivation before 1989. Under state socialism, the central planners ignored women's desires, and there were persistent shortages of the feminine accoutrements women take for granted in the West, including basic

hygiene products. Bulgarian women of a certain age still cringe when they think of the rough cotton batting they had to use once a month (if they could find it). Slavenka Drakulić captured this frustration when she traveled around Eastern Europe for *Ms.* in 1991, reporting the complaint she "heard repeatedly from women in Warsaw, Budapest, Prague, Sofia, East Berlin: 'Look at us—we don't even look like women. There are no deodorants, perfumes, sometimes even no soap or toothpaste. There is no fine underwear, no pantyhose, no nice lingerie. Worst of all, there are no sanitary napkins. What can one say except that it is humiliating?'" While women in Eastern Europe may have had far more career paths open to them, they certainly lacked the consumer products available to women in the West.[24]

But as a high school student, I didn't know any of this yet, and the images in that glossy East German book gave me the confidence I needed to fully embrace my role as a Soviet diplomat to the United Nations. Since it was the eighties, I bought myself a shiny red crushed satin suit with massive shoulder pads, slathered on the eye shadow, and hot-rollered and hair-sprayed my curly hair to precarious heights. Somehow, it helped to know that there were societies that imagined, even if only in an idealized world, that women could be both ambitious *and* beautiful. I could have my breasts and veto power, too.

In the end, although patriarchal culture changes at a glacial pace, experts from politicians in the European Union to the consultants at KPMG believe that affirmative steps must be taken to promote women's leadership. There is no one-size-fits-all solution, but quotas can be an important part of the process. States have a role in shaping societal

attitudes to increase diversity and inclusivity, and it is essential that we use the tools of thoughtful legislation to create more opportunities for women to stand for elected office or serve on executive boards. Yes, popular attitudes have to change, but this change requires that little girls grow up seeing more women in positions of power. The only way for girls to see women in positions of power is to find a way to challenge the political and economic cultures that prevent their participation in the first place.

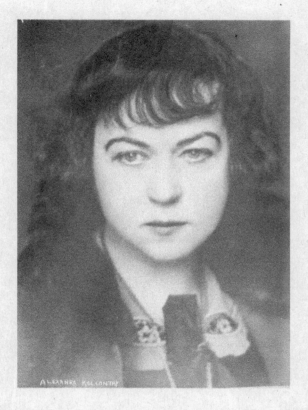

ALEXANDRA KOLLONTAI

Alexandra Kollontai (1872–1952): A socialist theorist of women's emancipation and a strident proponent of sexual relations freed from all economic considerations. After the October Revolution, Kollontai became the People's Commissar of Social Welfare and helped to found the Zhenotdel (Women's Section). She oversaw a wide variety of legal reforms and public policies to help liberate working women and to create the basis of a new communist sexual morality. But Russians were not ready for her vision of emancipation, and she was sent away to Norway to serve as the first Russian female ambassador (and only the third female ambassador in the world). *Courtesy of U.S. Library of Congress.*

4 CAPITALISM BETWEEN THE SHEETS: ON SEX (PART I)

My best buddy from college, whom I will call Ken, was an economics major who lost his life on September 11, 2001, in the North Tower of the World Trade Center. Over our thirteen-year friendship, we racked up long-distance phone bills and traversed continents and oceans to meet in person when a call wasn't enough. We convened in Hong Kong after his divorce; I listened as he sobbed over his vodka martini in a bar called Rick's Café. He took the photos at my wedding in 1998, and on Labor Day weekend of 2001, he flew out to Berkeley to feel my belly when I was seven months pregnant. He was gone before I gave birth.

Born and raised outside of the United States, Ken lived the American dream, starting on Wall Street in 1989 and currency trading his way up into the company of millionaires. Before his marriage, he enjoyed the successful love life of a wealthy New York bachelor. At some gin joint in Oakland, we once traded notes about what people needed for a healthy romantic relationship. I still have the paper on which Ken wrote, "Kristy say: physical, emotional, intellectual, spiritual. I say: nice legs with nice ankle, sad eyes,

nicely shaped 34C boobs + some brain." I had been trying
to argue that there were four kinds of connections between
people and that the best romances were those in which you
bonded in each of the four ways, but Ken insisted that he
liked his women pretty and just smart enough to not be stu-
pid. "I love bimbos!!!" he wrote. But when his gold-digging
wife ditched him immediately after they earned their green
cards, and then bilked him for a massive lump-sum ali-
mony payment, Ken began to question his taste in women.

"I never wanted to date professional women," he told
me on the phone after the sting of his divorce began to wear
off and he felt ready to start dating again. "They have too
much going on in their lives, and they can't be there for you
when you want them to be. I went out with a lawyer once,
and all she did was talk about her cases."

"You talk about your work," I said.

"I know," he said, "And I want my girlfriend to listen to
me."

Ken drew a breath on the other side of the receiver. "But
you know, I think I should try dating more smart women.
I'm tired of the gold diggers."

"Really?" I said. "That would be out of character."

He went on to describe a recent epiphany. Ken ex-
plained that, as I suspected, he avoided intelligent and inde-
pendent women because they made him feel less masculine,
less in control of the relationship. But one of his coworkers
had recently married an "impossibly hot" corporate law-
yer. At the wedding reception after five too many glasses
of wine, Ken watched the new couple dancing and decided
that his coworker was actually manlier because he wasn't
intimidated by being with a successful woman. "I mean,

think about it," Ken told me. "It's easy to get hot chicks if you want them. But it's harder to get a hot *and* smart chick with her own money. And if she's got her own cash, you know she's not with you for yours."

He sighed. "I think they really love each other."

For Ken, attraction and love had always been tied to money and power. He used his wealth to attract women and reveled in the role of the alpha male. But what Ken discovered (rather late in his short life) was the idea that more egalitarian relationships create fewer opportunities for emotional subterfuge and resentment between partners. Ken had adored his ex-wife and assumed that she genuinely reciprocated his affections. She had certainly led him to believe so, ceding him all power in their short-lived marriage. After she dumped him for another man, Ken questioned whether his wife had ever loved him or had simply used him to immigrate to the United States. But what bothered him most was that he couldn't tell the difference; she had played the part of the attentive and loving wife right up until the moment she filed for divorce. He never doubted her authenticity, and he feared repeating the same mistake in his next relationship. Unfortunately, he never had the chance; he was only in his mid-thirties when the World Trade Center came down.

Because Ken was a college economics major and a full-throttle capitalist, I know he would have loved a research paper published just three years after his death. In 2004, a controversial article—"Sexual Economics: Sex as Female Resource for Social Exchange in Heterosexual Interactions"—proposed that sex is something men purchase from women

with either monetary or nonmonetary resources, and that love and romance are mere cognitive veils humans use to occlude the transactional nature of our personal relationships. In their article, Roy Baumeister and Kathleen Vohs took a bold theoretical leap and applied the discipline of economics to the study of human sexuality. Their view precipitated a heated debate among psychologists about the "natural" behaviors of men and women in courtship.[1]

Sexual economics theory, or sexual exchange theory, proposes that the early stages of sexual flirtation and seduction between men and women can be characterized as a market where women sell sex and men buy it with nonsexual resources. "Sexual economics theory rests on standard basic assumptions about economic marketplaces, such as the law of supply and demand. When demand exceeds supply, prices are high (favoring sellers, that is, women). In contrast, when supply exceeds demand, the price is low, favoring buyers (men)." The basic idea is that sex is a female-controlled commodity, because, according to the authors, women's sex drives are weaker than men's. Because of the principle of least interest, and because women are less ruled by their sexual impulses, they have power in sexual relationships with men. They can demand compensation from men because men want the commodity (sex) more than women do. It is also in an attempt to keep the price of sex high that other women supposedly suppress the sexuality of their fellow sellers. Thus, Baumeister and Vohs argue that patriarchy is not responsible for slut shaming. Rather, it is other women who want to punish those who sell their sex too cheaply and thereby reduce its overall price.[2]

The authors are not talking about sex work, in which

sex is exchanged directly for money (although they do use the prevalence of sex work as an example in support of their theory). So with what do men purchase the sexual services of women? Sexual economics theory proponents explain:

> A broad range of valued goods can be exchanged for sex. In return for sex, women can obtain love, commitment, respect, attention, protection, material favors, opportunities, course grades or workplace promotions, as well as money. Throughout the history of civilization, one standard exchange has been that a man makes a long-term commitment to supply the woman with resources (often the fruits of his labor) in exchange for sex—or, often more precisely, for exclusive sexual access to that woman's sexuality. Whether one approves of such exchanges or condemns them is beside the point. Rather, the key fact is that these opportunities exist almost exclusively for women. Men usually cannot trade sex for other benefits.[3]

Sexual economics theory has been attacked by other psychologists as being based on the flawed assumption that women's sex drives are weaker than men's and that women have a "natural" desire to extract resources from men in exchange for sex. Feminists have also pointed to the deeply patriarchal and misogynistic assumptions embedded in sexual economics theory, since the price of sex also varies with the perceived desirability of the woman offering it (as determined by the male buyers). Others have criticized the economistic thinking that reduces romance and mutual affection to an adversarial competition between men and

women in which each side is trying to get the best deal. While these critiques are important, sexual economics theory has won many followers because it seems intuitive, especially in the individualistic and materialistic culture of the United States.[4]

In fact, some American right-wingers have embraced sexual economics theory as a way of blaming women for the current ills of our society. Indeed, a viral 2014 animated YouTube video from the conservative Austin Institute for the Study of Family and Culture extrapolated from the work of Baumeister and Vohs and blamed the falling marriage rate and the social maladjustment of young men in the United States on loose women who have made the price of sex too low. In their worldview, the availability of birth control (and one presumes abortion) has reduced the risks associated with sex, since it is now less likely to result in an unwanted pregnancy that must be carried to term. When sex entailed the risk of parenthood, they argue, women extracted a much higher price for access to their bodies, at minimum a serious commitment and ideally marriage. But once birth control reduced the risk of pregnancy, women could do with their bodies as they liked, and the price they demanded for sex fell, particularly since they had other opportunities to earn money.[5]

Is this a terrible thing? Other than the falling marriage rate (the old "Why buy the cow when you can get the milk for free?" argument), a low price for sex harms men who, according to these theories, apparently have no incentive to do anything with their lives other than the pursuit of sex. This is not a joke, I assure you. According to the ideologues over at the Austin Institute, young men these days

are camping out in their parent's basements, playing video games, and subsisting on Domino's pizza because cheap sex is just a text away. When women have no birth control, the price of sex is higher. When women have no access to abortion, the price is higher still. When women have fewer educational or economic opportunities outside of their relationships with men, the price for sex is usually marriage. When the price of sex is very high, according to this worldview, sex-starved men have incentives to go out and get jobs, earn money, and make something of their lives so they can buy access to a woman's sexuality for life through marriage. In cultures with more men than women, for instance, economists have shown that there is a higher rate of male entrepreneurship. When the price of sex is too low, however, men have no intrinsic incentive to do anything productive.[6]

To be fair, the original authors of sexual economics theory don't suggest any normative changes to our society; they are just observers, gathering evidence for their theoretical model. They also recognize that sexual marketplaces are embedded in specific cultural contexts that influence the supply and demand for sex. To support their claims, the proponents of sexual economics theory posit that women's status in society is one important factor affecting the underlying operation of the marketplace for sex. They note, for instance, that women's emancipation reduces the price of sex because educational opportunities and paid employment give women other avenues to provide for their basic needs. Their model predicts that the price of sex is higher in more traditional societies, where women are shut out of political and economic life.

To prove this point, Roy Baumeister and Juan Pablo

Mendoza correlated the results of a global sex survey with an independent measure of gender inequality to show that economic opportunity for women results in freer sex. They found that in countries where men and women are more equal there was "more casual sex, more sexual partners per capita, younger ages for first sex, and greater tolerance/approval for premarital sex." Thus the authors argue that women's economic independence often accompanies a loosening of social mores around sexuality. "According to sexual economics theory," Baumeister and Mendoza explain, "when women lack direct or easy access to resources such as political influence, health care, money, education, and jobs then sex becomes a crucial means by which women can gain access to a good life, and so it is vital to female self-interest to keep the price of sex high." Women do this by reducing the supply (no more casual sex), which drives the price up. It's according to a similar logic that, for a certain group of extreme social conservatives, the only way to "Make America Great Again" is to abolish birth control and abortion while ensuring that women have few economic opportunities to pay for basic goods outside of selling their sex. When their sexuality is their only means of survival, they will supposedly raise its price and thereby save an entire generation of men from a life of sloth.[7]

Sexual economics theory assumes an underlying capitalist economy in which women have an asset (sex) they can choose to sell or give away either as sex workers or in less overt, but no less transactional ways, as sugar babies, girlfriends, or wives. In order to meet their basic needs (food, shelter, health care, education), they must either sell their sex or earn money to pay for these resources another way.

The more opportunities they have to earn money (i.e., in societies with high levels of gender equality), the less reliant they are on selling their sex, and the more likely they are to have sex for pleasure. Similarly, one would also assume that women living in a society that provides its citizens with subsidized access to basic needs such as food, shelter, health care, and education would have fewer incentives to horde their sex in order to keep its price high. In other words, in societies with high levels of gender equality, with strong protections for reproductive freedom, and with large social safety nets, women almost never have to worry about the price their sex will fetch on the open market. Under these circumstances, the sexual economics theory model would predict that women's sexuality would cease to be a salable commodity at all.

As someone who is often critical of reductionist economistic models, I am fascinated by sexual economics theory and think the model gives valuable insight into the way sexuality is experienced in capitalist societies. Essentially, sexual economics theory is right, but only within the confines of the free market system. In fact, a beautiful confluence emerges when you read the works of Baumeister and his colleagues alongside socialist critiques of capitalist sexuality. Although they may not realize it, sexual economics theorists basically embrace a long-standing socialist critique of capitalism: that it commodifies all human interactions and reduces women to chattel. Back in 1848, Karl Marx and Friedrich Engels observed that capitalism

> has left remaining no other nexus between man and man than naked self-interest, than callous "cash payment."

It has drowned the most heavenly ecstasies of religious fervour, of chivalrous enthusiasm, of philistine sentimentalism, in the icy water of egotistical calculation. It has resolved personal worth into exchange value, and in place of the numberless indefeasible chartered freedoms, has set up that single, unconscionable freedom—Free Trade. . . . The bourgeoisie has torn away from the family its sentimental veil, and has reduced the family relation to a mere money relation.

Since then, socialist theorists have also blamed capitalism for the commodification of women's sexuality, and argued that women's economic independence from men and the collective ownership of the means of production would liberate personal relations from economic calculation. In their view, a more egalitarian society with men and women living and working together as equals would lead to a new kind of relationship based on love and mutual affection, unsullied by questions of worth, value, and exchange.[8]

As far back as the era of utopian socialism in the 1830s, theorists argued that postcapitalist societies would generate a new form of sexual morality. In his 1879 book, *Woman and Socialism*, August Bebel wrote that sexual desire was natural and healthy, and that women needed to be freed from the then socially accepted property relations that distorted and suppressed their sexuality in order to render it scarce:

The woman of the future society is socially and economically independent, she is no longer subjected to even a

vestige of domination or exploitation, she is free and on a par with man and mistress of her destiny.... In choosing the object of her love, woman, like man, is free and unhampered. She woos or is wooed, and enters into a union from no considerations other than her own inclinations.... Under the proviso that the satisfaction of his instincts inflicts no injury and disadvantage on others, the individual shall see to his own needs. *The gratification of the sexual instinct is as much a private concern as the satisfaction of any other natural instinct.* No one is accountable for it to others and no unsolicited judge has the right to interfere. What I shall eat, how I shall drink, sleep and dress, is my own affair, as is also my intercourse with a person of the opposite sex. [emphasis in the original][9]

Reading these words in the twenty-first century, it's hard to understand how radical they would have sounded in the late nineteenth, when his book was first published. Bebel truly believed that sexuality was a private concern (and has been celebrated by modern LGBT rights activists as the first politician to publicly defend the rights of gay people in 1898). Friedrich Engels also argued, in 1884, that women's subjugation resulted from the male desire for legitimate heirs to inherit his wealth. To ensure that his children were really his, the man needed to control women's sexuality through the institution of monogamous marriage. Women's fidelity and reproductive capacity thereby became commodities to be exchanged between men for the purpose of projecting their accumulated wealth and power onto future generations of their descendants. But monogamy was

primarily monogamy for the woman, since men could have sexual relations outside of marriage with impunity, and the marriage contract deprived most women not only of control of their bodies but also of their fundamental rights as individuals. Marriage reduced women to the status of property of their husbands.[10]

Alexandra Kollontai rebelled against this continued commodification of women. Born into a family of Russian nobility in 1872, she showed a deep empathy for the atrocious conditions of Russia's working classes from an early age and was slowly drawn into political work, which often landed her in trouble with the tsarist authorities. From observing the situation of women in her own class, Kollontai grew to abhor the exchange of women's sexuality for money, goods, services, or social position. As a child, she watched her mother push her twenty-year-old sister into marrying a man forty years her senior because he was considered a "good match." Kollontai rejected marriages of convenience and wanted to marry for love, for what she called a "great passion." She wrote, "As regards sexual relations, communist morality demands first of all an end to all relations based on financial or other economic considerations. The buying and selling of caresses destroys the sense of equality between the sexes, and thus undermines the basis of solidarity without which communist society cannot exist."[11]

In 1894, she read August Bebel's *Woman and Socialism*, and it provided the basis for her own views on a new form of progressive morality. Like Bebel, she believed that sexuality needed to be liberated from social stigmatization: "The sexual act must be seen not as something shameful and sinful but as something which is as natural as the other needs

of [a] healthy organism, such as hunger and thirst. Such phenomena cannot be judged as moral or immoral." Kollontai argued that only under socialism would people love and have sex with each other as free individuals, based on their mutual attraction and affection and without regard for money or social position. But it is important to realize that Kollontai was never arguing for unbridled promiscuity or a form of "free love" in the sole pursuit of hedonistic pleasure. Instead, she believed that by destroying the link between property and sexuality, men and women would have more authentic and meaningful relationships. Although she has subsequently been characterized as a sexual libertine, she was relatively conservative (by modern standards) in her views, advocating for sexual fulfillment only within heterosexual relationships based on love.[12]

Kollontai considered sex for pleasure as a bourgeois distraction from the necessary work of the revolution, contrasting the "wingless Eros" of pure physical sex with her idealized "winged Eros" of emotional and even spiritual connection. This romanticized love between men and women was supposed to contribute to the generalized love of humanity that underpinned the basis of socialist ideology (Kollontai might actually be the original hippie). In her 1921 pamphlet, *Theses on Communist Morality in the Sphere of Marital Relations*, Kollontai wrote, "The bourgeois attitude to sexual relations as simply a matter of sex must be criticized and replaced by an understanding of the whole gamut of joyful love-experience that enriches life and makes for greater happiness. The greater the intellectual and emotional development of the individual the less place will there be in his or her relationship for the bare

physiological side of love, and the brighter will be the love experience."[13]

Kollontai viewed marriage as an institution that perpetuated the subjugation of women, and it was this institution that she attempted to dismantle in the first years after the 1917 October Revolution in Russia. She and a small cadre of radical jurists tried to challenge the traditional basis of matrimony by replacing church marriages with civil ceremonies, liberalizing divorce laws, legalizing abortion, decriminalizing homosexuality, equalizing rights for legitimate and illegitimate children, and mobilizing women into the labor force, while socializing domestic work through the establishment of public laundries, cafeterias, and children's homes. But as discussed earlier, Lenin and the other male Bolsheviks had concerns that they considered more pressing than the woman question, and Kollontai was eventually dispatched as a diplomat to Norway (to get her out of the country). Reflecting back on her life in 1926, Kollontai wrote, "No matter what further tasks I shall be carrying out, it is perfectly clear to me that the complete liberation of the working woman and the creation of the foundation of a new sexual morality will always remain the highest aim of my activity, and of my life."[14]

Kollontai's vision of a sexuality free from economic consideration was shared by many Soviet youth in the 1920s. For example, a 1922 survey of 1,552 students at the Sverdlov Communist University in Moscow found that only 21 percent of men and 14 percent of women considered marriage as the ideal way to organize one's sex life. In contrast, a full two-thirds of the women and one half of the men preferred a long-term relationship based on love.

But these liberal attitudes did not extend to the rest of the population. The traditional conservativism of Russian peasant culture, combined with the expert advice of a prudish medical establishment, conspired to subvert Kollontai's attempts at social reform. Without access to reliable birth control, women could not control their fertility, and men who declared their undying love disappeared once a child was on the way. The courts attempted to enforce alimony payments, but men evaded their responsibilities. Women's wages were not high enough to support children, and many turned to sex work to survive, precisely the type of economic exchange Kollontai had hoped to eradicate. The Soviet state attempted to create a network of orphanages to care for homeless children, but the whole project was too costly. Kollontai made one last attempt to replace alimony with a general insurance fund that would allow the state to support all children, but her ideas were ridiculed and rejected. By the mid-1920s, hundreds of thousands of red orphans roamed the streets of Soviet Russia, begging, stealing, and embodying the failures of a premature attempt at sexual revolution.[15]

Stalin, who ascended to dictatorial power at the end of the 1920s, decided it was much easier to return to a system in which women did all of the childbearing and child rearing for free within the confines of more traditional forms of marriage, while also forcing them to work outside the home to help build Soviet industrial power. Many social conservatives in the United States would find much to love in Josef Stalin's policies: he outlawed abortion again, promoted premarital abstinence, repressed public discussions of sexuality, persecuted gay people, and emphasized traditional

gender roles in heterosexual, monogamous marriage. Even
after Stalin's death, when the abortion law was once again
liberalized, most studies confirm that public discourse
around sexuality in the USSR was nonexistent. Before this,
most Soviet women viewed sex as a marital duty for the sole
purpose of procreation, and Soviet society was decidedly
prudish. Kollontai died in 1952, long before her vision of a
Soviet sexuality based on love and mutual affection had a
chance to develop.[16]

Yet Kollontai's conception of a society in which sexuality
is free from economic constraint has continued to inspire
feminist thought since the early twentieth century. Between
her socialist vision of a sexuality based on mutual affection
and the vision proposed by sexual economics theory, we
have two competing views of how to organize heterosexual
sexuality. One view celebrates women's economic indepen-
dence as a prerequisite for a more authentic form of love,
and the other view sees women's economic independence
as just one factor affecting the relative price of sex within
a marketplace wherein sex is a commodity to be bought by
men. Although certainly a wide variety of positions exist
between these two models, for the sake of argument, let's
focus on these two views as poles on a spectrum of possi-
ble models for heterosexual relationships. Which would be
better?

Clearly, there is no easy answer. Human sexuality is
complex and rather difficult to study, making any kind of
normative judgment about sex fraught with problems. But
setting aside the people who would choose sex work without

economic necessity, I'm going to go out on a limb here and suggest that sex is not as great when you are forced to sell it to pay your rent. Furthermore, if a man feels he is paying a woman to access her body, why would he care about her pleasure? He believes she is being compensated for the activity in nonsexual ways. If he hired a woman to clean his home, would he care how much she enjoyed it? Should he be expected to? On the other hand, two people—freely exchanging their affections without any thought of what else they might get out of it—are probably a lot more attentive to each other's needs than those who are consciously or subconsciously worried about the economic nature of the exchange. But how can we know?

We don't have to limit ourselves to speculation. Here's where the experiences of state socialism in Eastern Europe provide an interesting natural experiment to augment our understanding of the effects of political economy on heterosexual courtship. Despite their shortcomings, as we've seen, the countries on the other side of the Iron Curtain did implement a wide range of policies to promote women's economic independence (albeit with much variation across the region), which would have caused the price of sex to fall, according to sexual economics theory. Is there evidence that women and men began to view female sexuality as something to be shared rather than exchanged for resources? Were intimate relations experienced differently in capitalist versus socialist countries? And what happened after the fall of the Berlin Wall? Did the sexual marketplaces described by Baumeister and Vohs return with the privatization and marketization of the postsocialist economy?

All studies of what is called "subjective well-being"—or

people's own self-reported feelings of happiness or sexual satisfaction—share the problem that people's emotional states are difficult to research in an objective fashion. When you study something like cancer, a doctor can examine a human body and empirically determine the presence or absence of cancer cells. But when doctors study pain, they have to rely on the patient's own account of how much something hurts. But people vary in how they report pain. Doctors often use a one-to-ten scale to measure pain. This is not an absolute scale but one relative to the patient's own pain threshold. When you are in the hospital, for instance, the doctors and nurses will continuously ask you to rank your pain to get a sense of your individual scale and try to extrapolate from that how much and what kind of medicine you require. Pain objectively exists, and someone with a broken femur should feel more pain than someone with an ingrown toenail, even if the person with the ingrown toenail wails louder than the person with the fractured leg. We know this by aggregating the self-reported levels of pain from all patients suffering from these two conditions and comparing the averages.

Feelings of happiness and sexual satisfaction are more like pain than they are like cancer in this respect. Psychologists, sexologists, and other researchers identify representative samples of defined populations and then ask individual questions about their emotional states or their feelings about certain experiences. The choice of questions, the way they are asked, and the form and sequence in which answers are expected are all important aspects of studies of subjective well-being. In well-designed studies, researchers ask different formulations of the same questions multiple

times to control for various kinds of misunderstanding or bias. In theory, if the number of people sampled is large enough, certain patterns emerge, and generalizable claims can be made (at least within a given cultural milieu).

It turns out that contemporary historians, anthropologists, and sociologists have taken a great interest in whether noncapitalist sexuality had a different character than the sorts of intimate relations people had (and have) in the market economies of the West. In searching for sources, they have discovered a range of studies conducted before and after 1989 that suggest that there were some fascinating differences in the way people experienced their sexuality behind the Iron Curtain, results I will discuss in the next chapter. Because state socialist scientists were concerned with falling birthrates, they primarily focused on heterosexual relations between men and women, but many of their insights into the damage that market exchanges can do to human relationships are relevant to people of all sexualities. Again, the key here is not to glorify or suggest that we return to the state socialist past. Instead, we can better understand how capitalism affects our most intimate experiences by looking to societies in which market forces had less of an impact. If sexual economics theory describes the way that the capitalist system reduces our affections and attentions to the status of salable goods, what policy levers might we have to push back against the operations of the unfettered free market? Perhaps we can find ways to have more fulfilling private lives in a society that also guarantees individual freedoms and a robust public sphere, undermining the operations of sexual economics theory without embracing authoritarianism.

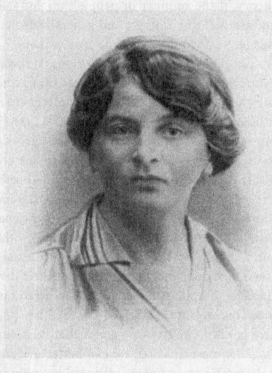

Inessa Armand (1874–1920): Born in Paris, Armand was a French-Russian Bolshevik and feminist who was a key figure in the prerevolutionary communist movement. After 1917, she served as the head of the Moscow Economic Council, sat as an executive member of the Moscow Soviet, and headed the Zhenotdel, leading efforts to ensure sexual equality and to socialize domestic work. She helped organize children's homes, mass cafeterias, and public laundries until her untimely death from cholera at the age of forty-six. *Courtesy of Sputnik.*

5 TO EACH ACCORDING TO HER NEEDS: ON SEX (PART II)

K en and I actually dated in college for a short while back in 1988. Even though he was a senior and I was a first-year student, we lived in the same dormitory and shared a circle of friends. But I was only eighteen, and he was going to graduate; we both knew it was bound to be short-lived. Besides, from early on, we also understood that our friendship was more valuable than our brief romance. Our shared interests were mostly intellectual, and we spent much of our time together discussing books and music and politics. We shared a mutual love of Springsteen and Dylan. He introduced me to Dire Straits, and I shared my obsession with U2. I proofread his papers, and he taught me the basics of macroeconomic theory as I helped him study for one of his exams. After he earned his degree and moved to New York, I dropped out of college and flew to Europe. We became regular pen pals (on paper) until the invention of email moved our communication from the analog to the digital. When I returned to California to finish my BA, we spoke on the phone every few weeks. He thrilled to hear what I was learning about at the university. I think he always suspected that I would become some sort of academic,

and that's probably why we never considered getting back together.

Ken died before I finished my PhD, and to this day I still miss his persistent questions and endless curiosity. For many years after 2001, I found myself wanting to call him to tell him about an article I just read or to discuss the research I was doing for one of my books. The whole model posed by sexual economics theory would have fascinated him, and he would have provided countless data points in support of that view of heterosexual courtship. For a long time, it bothered (and later fascinated) Ken that I didn't conform to his idea of what women want. I was just a statistical outlier as far as he was concerned. But many years later, as I dug into the scholarship on the relationship between women's economic independence and sexuality, I wished I could tell Ken that his view of women was unique to capitalism. What he thought of as "natural" was really just a product of a particular way of organizing society.

To prove this, I would have started by sending him a case study from the Soviet Union that showed that Alexandra Kollontai's ideas of a socialist sexual morality did eventually begin to take hold across the socialist world in the 1970s and 1980s. Two Russian sociologists, Anna Temkina and Elena Zdravomyslova, conducted in-depth, biographical interviews with two sets of middle-class Russian women in 1997 and 2005. They examined the generational changes in the way women described their amorous lives both during and after the Soviet Union. The authors' research revealed five basic narratives that women used to discuss their heterosexual relations with men, what they call "sexual scripts": the pro-natalist script, the romantic script, the

friendship script, the hedonistic script, and the instrumental script. In their 1997 interviews, the Russian researchers found that the Soviet "silent generation" (those born between 1920 and 1945), primarily related to the pro-natalist script, meaning that sex was something you endured in marriage to have babies. Love and pleasure had nothing to do with it. And even though Soviet women had access to abortion again after 1955, the lack of birth control and the double burden of work and family responsibilities conspired to depress sexual function in many women. There is no doubt about it: for this generation, Soviet sex sucked.[1]

But things began to change after Stalin's death. Despite a continued lack of privacy because of housing shortages, the paucity of official sex education, and the complete lack of erotica (all pornography was banned), Temkina and Zdravomyslova found that middle-class urban women born between 1945 and 1965 described a marked move away from the pro-natalist script. Although the pro-natalist view of sexual relations continued, it was complemented by two new ways of talking about sexuality: romance and friendship. The emergence of the romantic script was the result of a larger shift in Soviet public narratives about sexuality. In the late Soviet era, doctors, psychologists, and other experts began to emphasize the role of "true love," "common interests," and "spiritual unity" as the basis for a successful marriage. "The romantic script implies that sexual life is interpreted as an integral part of strong emotion and feelings," write the Russian researchers. "Sex is described as an attribute of love, romance, and passion. Love is the central category in the narrative of sexual experience." This romantic script of sexuality is exactly what early socialists such

as August Bebel and Alexandra Kollontai would have envisioned for a society in which economic considerations had less influence on the choice of an amorous partner.[2]

The other way to describe sex that began to emerge among middle-class women in the late Soviet period is the friendship script. Unlike what we would call "friends with benefits"—uncommitted, recreational sex with a partner of the opposite sex—the Soviet friendship script described sex that occurred in a meaningful relationship between two people who worked together or shared a social circle, with the partners using sex as a way to show each other affection and respect. This friendship script presumably arose because women had access to their own resources and didn't depend on men to provide for their material needs. Because some urban Soviet women felt secure in their economic position, sexuality lost its exchange value and became something to be shared.[3]

If sexual economics theory is on the right track, you would guess that the introduction of free markets and the rapid dismantling of the social welfare state after the collapse of the USSR would precipitate a return of a worldview in which women's sexuality is once again a commodity. And this is exactly what Temkina and Zdravomyslova found in their 1997 and 2005 interviews with women of the post-Soviet generation. In addition to the "hedonistic script," in which sex is purely physical for the purpose of experiencing individual pleasure, often assisted by sex toys and other products that can be purchased in a capitalist economy (a script absent, for obvious reasons, in the Soviet era), they note the emergence of something they called the "instrumental script," which became ubiquitous after the advent

of free markets. "Commercialization of different spheres of social life, gender polarization and inequality as well as the lack of resources legitimate the instrumental script of sexuality," write Temkina and Zdravomyslova. "This script presupposed that sexualized femininity (as well as young age) could be profitably exchanged for material and other benefits. In this script marriage is represented as a calculation." The commodification of women's sexuality in Russia could be observed in the dramatic increase in sex work, pornography, strategic marriages for money, and what the authors call "sponsorship," whereby wealthy men sponsor their mistresses. According to Temkina and Zdravomyslova, this instrumental script was "very seldom found in the narratives of sexual life" of the older women who grew up in the Soviet Union.[4]

Evidence of the post-1991 prevalence of this instrumental script can also be found in Peter Pomerantsev's 2014 exposé of the booming growth in Russian "gold digger" academies. As he observed a class in this special form of educational institution in Moscow, he described "a pool of serious blonde girls taking careful notes" because "finding a sugar daddy is a craft, a profession." Aspiring gold diggers pay a thousand dollars a week for these courses in the hope of finding a "sponsor" to pay their bills. For many young women, training oneself to find a rich husband is a better investment than a university education or pursuing a career. Once they graduate from these academies, Pomerantsev explains that these women lurk around "a constellation of clubs and restaurants designed almost exclusively for the purpose of sponsors looking for girls and girls looking for sponsors. The guys are known as 'Forbeses' (as

in *Forbes* rich list); the girls as 'tiolki,' cattle. It's a buyer's market: there are dozens, no, hundreds, of 'cattle' for every 'Forbes.'" Thus, the reintroduction of free markets in Russia coincided with a return to the commodification of women, particularly when compared with the late Soviet past.[5]

The clash between the socialist vision of free sexuality and the capitalist idea of commodified sexuality can also be observed in the discussions and debates surrounding the reunification of the two Germanys—the German Democratic Republic (GDR) and the Federal Republic of Germany (FRG). Until the end of World War II, Germany was one nation, but after the defeat of the Nazis, the victorious Allies divided Germany amongst themselves. As the Cold War began, the alliance between Stalin and the Western powers fractured. East Germany fell on the Soviet side of the Iron Curtain under the one-party rule of the Socialist Unity Party (SED).

The division of Germany presents an interesting natural experiment in women's rights and sexuality. The populations of the two countries were close to identical in all respects save for the divergence in their political and economic systems. For four decades, the two Germanys followed different paths, particularly with regard to the construction of ideal masculinities and femininities. The West Germans embraced capitalism, traditional gender roles, and the breadwinner/homemaker model of bourgeois monogamous marriage. In the East, the goal of women's emancipation combined with labor shortages led to a

massive mobilization of women into the labor force. As the historian Dagmar Herzog argued in her 2007 book, *Sex After Fascism*, the East German state actively promoted gender equality and women's economic independence as the unique features of socialism, trying to demonstrate their moral superiority over the democratic capitalist West. As early as the 1950s, state publications encouraged East German men to participate in domestic work, sharing the burden of child care more equitably with their wives, who were also employed full-time.[6]

According to German cultural studies professor Ingrid Sharp, the East Germans created a situation in which women were no longer dependent on men, giving them a sense of autonomy that encouraged more generous male behavior in the bedroom. If West German girlfriends and wives were unhappy with the sexual performance of their male partners, they had few options open to them. Because women relied on men to support them financially, at best they could gently try to nudge their partners into being more attentive to their needs. In the East, men who desired sexual relations with women could not rely on money to buy them access, and had incentives to improve their behavior. Sharp explains: "Divorce in the GDR was relatively simple and had few financial or social consequences for either partner. Both marriage and divorce rates were far higher than in the West. The SED argued that these figures reflected a beneficial desire for marriages based on love; stale, unsatisfying relationships could be readily dissolved and productive ones easily begun. The fact that women instigated the majority of divorce proceedings was heralded

as a sign of their emancipation. Unlike in the West, women were not forced by economic dependence to remain in marriages they no longer enjoyed."[7]

Women's economic independence and the concomitant decline in relationships based on economic exchange fueled East German claims that socialists enjoyed more satisfying personal lives. But rather than merely focusing on love, as Kollontai would have done, East German researchers went out of their way to demonstrate that their compatriots had more frequent and more satisfying sex. They argued that the socialist system improved people's sex lives precisely because sex was no longer a commodity to be bought and sold on the open market. Herzog observes: "The main concern in the East was to show citizens that socialism provided the best conditions for lasting happiness and love. (In fact, Eastern authors frequently pointed out that sexual relationships really were more love based and hence honorable in the East than in the West specifically because under socialism women did not need to 'sell' themselves into marriage in order to support themselves.)"[8]

Because East German researchers focused on sexual satisfaction, and especially female sexual satisfaction, they conducted a wide variety of empirical studies to try to demonstrate the superiority of socialism in the bedroom. Bearing in mind the methodological challenges discussed in the previous chapter, these studies provide some interesting evidence that people had better sex under socialism. For instance, in 1984, Kurt Starke and Walter Friedrich published a book of their research findings about love and sexuality among East Germans under the age of thirty. The authors found that GDR youth, both male and female, were

highly satisfied with their sexual lives, and that two-thirds of the young women self-reported that they achieved orgasm "almost always," with an additional 18 percent saying that they did so "often." Starke and Friedrich claimed that these levels of personal satisfaction in the bedroom resulted from socialist life: "the sense of social security, equal educational and professional responsibilities, equal rights and possibilities for participating in and determining the life of society."[9]

Subsequent studies would corroborate these early results. In 1988, Kurt Starke and Ulrich Clement conducted the first comparative study of the self-reported sexual experiences of East and West German female students. They found that the East German women said they enjoyed sex more and reported a higher rate of orgasm than their Western counterparts. In 1990, another study comparing the sexual attitudes of youth in the two Germanys found that GDR men's and women's preferences were more in sync with each other than those of young men and women in the West. For example, one survey found that 73 percent of East German women and 74 percent of East German men wanted to get married. In contrast, 71 percent of women in the West desired marriage, but only 57 percent of Western men did, a fourteen-point difference. A different survey about sexual experiences uncovered much higher levels of self-reported sensual enjoyment among East German women. When asked if their last tryst had left them feeling satisfied, 75 percent of GDR women and 74 percent of GDR men said yes, compared to 84 percent of FRG men and a mere 46 percent of FRG women. Finally, respondents were asked to report whether they felt "happy" after sex. Among

the East German women 82 percent agreed, whereas among West German women only 52 percent reported feeling "happy." To reverse that statistic, only 18 percent of GDR females were not "happy" after sex, compared to almost half of the surveyed females in the FRG.[10]

When the FRG and the GDR unified under the West German constitution in 1990, the different sexual cultures of the two societies collided and became the subject of many ongoing debates and misunderstandings. Ingrid Sharp also studied the "sexual unification of Germany" and argued that Western men initially fetishized the idea of the passionate East German woman. "Hard statistics," Sharp writes (with no pun intended), "apparently confirmed the greater sexual responsiveness of Eastern women. A survey of women's sexual practices conducted by the Gewis-Institut, Hamburg, for *Neue Revue* reported that 80 percent of Eastern women always experienced orgasm, compared to 63 percent of women in the West. . . . The context [of this study] was the ideological battle between East and West, the cold war being slogged out in the arena of sexuality, with orgasmic potential replacing nuclear capacity." Indeed, Sharp reports that the continued claims by Eastern sexologists that GDR women's greater sensual enjoyment was linked to women's economic independence and self-confidence threatened West Germans' sense of superiority. The West German media lashed out against the idea that anything in the East could have been better, launching what Sharp called "The Great Orgasm War."[11]

The ongoing debates about the comparative sexual satisfaction of East and West Germans inspired the historians Paul Betts and Josie McLellan to explore the topic further,

with the latter's 2011 book, *Love in the Time of Communism*, providing a 239-page rumination on the subject. Betts and McLellan confirm the idea that female economic independence did contribute to a unique, noncommodified, perhaps more "natural" and "free," form of sexuality that flourished in the East, lending credence to the idea that sexual economics theory does provide a good description of sex markets, but only those in capitalist societies. Yet as Betts and McLellan note, there were also other factors that contributed to the differences in sexual cultures. In the first place, the church played a much stronger role in regulating morality and sexuality in the West than in the secular and atheist East (although it is important to note that the 1984 study by Starke and Friedrich found no difference between atheists and those who professed religious affiliation in their responses). Nevertheless, West German culture certainly embraced the traditional gender roles of the Protestant and Catholic churches to a much greater extent than the East. Second, the authoritarian nature of the GDR regime foreclosed the public sphere to East Germans, and they responded by retreating into the private sphere, where they constructed cozy, unideological private lives as a way to find refuge from the otherwise omnipresent state. Third, there was less to do in the East compared to the many commercial distractions available in the West, so people probably had more time for sex. And finally, the East German regime encouraged people to enjoy their sex lives as a way of distracting them from the monotony and relative deprivation of the socialist economy and the travel restrictions.[12]

Furthermore, as with Kollontai, the East German idea of sex remained a conservative one when compared to our

modern standards. Gays and lesbians, although not overtly
persecuted, lived circumscribed lives confined to the private
sphere. And as much as the state tried to convince men to
help out in the home, East German women still performed
the majority of domestic work. Despite the availability of
birth control and abortion, the GDR, like all other social-
ist states, was still strongly pro-natal in its outlook; child-
bearing was considered a duty of East German women, and
socialists tended to view sex as something that would even-
tually lead to marriage and children. Finally, even if they
wanted sex to be pleasurable for both men and women, the
state was never in favor of unbridled promiscuity or "he-
donistic" sex. Sex was supposed to be an expression of love
and affection between equal comrades.

Despite these important caveats, many East Germans
believed that their pre-1989 sexuality was more sponta-
neous, natural, and joyful compared to the commercial-
ized and instrumentalized sexuality they found when they
joined West Germany. Rather than trying to preserve the
best aspects of both systems while discarding the bad parts,
German reunification led to the erasure of the East German
way of life, including support for women's economic inde-
pendence. The introduction of capitalist markets also meant
a radical revaluation of human value. "Without a doubt,
most devastating for the former East was a loss of economic
security and the new idea that human worth would now be
measured primarily by money," Herzog writes. "East Ger-
man citizens felt enormous anxieties about the loss of jobs
and social security, rising rents, and uncertain futures. . . .
Throughout the 1990s, and over and over, Easterners (gay
and straight alike) articulated the conviction that sex in the

East had been more genuine and loving, more sensual, and more gratifying—and less grounded in self-involvement—than West German sex."[13]

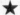

Nearby Hungary presents another case study to help us think about how state socialism shaped sexual morality. The Hungarian sociologist Judit Takács has explored the intimate lives of her compatriots before 1989 and suggests that their sex lives flourished even under repressive circumstances. Writing retrospectively in 2014, Takács proposed that, although Hungarians suffered from a lack of private space as a result of housing shortages and lived under constant surveillance when out in public, "they seemed to be able to negotiate their lives between the constraints of state socialism and their longing for enjoyable relationships with partners of a different and/or the same gender." In other words, as in East Germany and the Soviet Union, there was a considerable disjuncture between private life and the public sphere in Hungary, but women's economic independence contributed to a culture in which sex was something to be shared rather than sold.

Furthermore, although the Hungarians never managed to redefine traditional gender roles, and domestic patriarchy was strengthened by pro-natalist family policies, younger Hungarians seem to share the same aversion to the commercialization of sexuality as East Germans. In one sociological study conducted in the early 1970s, researchers surveyed the sexual attitudes of 250 young students and workers between the ages of eighteen and twenty-four. Young Hungarians read eight stories about sexual practices

that were considered common in their country and then ranked them based on whether they liked or disliked the protagonists. These eight stories included (1) a virgin who wants to wait until marriage until she has sex, (2) a female "demi-virgin" who fools around with men but stops short of actual coitus, (3) a single mother who was dumped by her sexual partner after she got pregnant with his child, (4) a prostitute who meets random men in bars and has sex for money, (5) a bachelor "womanizer" who has sex with as many women as possible, (6) a gay man who has discreet relations with men, (7) a man who satisfies his sexual needs through repeated masturbation, and (8) a young couple who fall in love with each other and proceed to have sex before marriage.

Among the vast majority of the students surveyed, the unmarried but loving couple were ranked as the most likeable (although the female workers rated the single mother slightly higher than the couple). The majority of the surveyed students also ranked the prostitute as the least likable character; she was the most abhorred of the male and female students and of the female workers. Only the male workers found the gay man less likeable. Also toward the bottom of the list were the "womanizer," the "demi-virgin" (tease), and the chronic "self-satisfier." The virgin was somewhere in the middle. Particularly fascinating, in relation to sexual economics theory, are the reasons given for the resounding disapproval of the prostitute character. The respondents believed that the prostitute had no legitimate reasons to sell her affections since the socialist state met her basic needs. They also worried that "emotionless sex" would be bad for her personal development. Interestingly, the

male and female students were more sympathetic to the gay man, and the female students actually ranked the "woman- izer" below the gay man, suggesting that their distaste for promiscuity (for both men and women) was greater than their early-1970s homophobia. Socialist sexuality in Hun- gary (at least among this group of eighteen- to twenty-four- year-old men and women) idealized loving relationships based on mutual affection, just as Kollontai suggested they would once the market incentives for "selling caresses" were overcome.

These students' attitudes toward marriage, prostitution, and single motherhood are confirmed by broader public opinion data from the first wave of the World Values Sur- vey (1981–1984). For instance, when asked if marriage was an "outdated institution," 16 percent of Hungarians agreed, compared to only 8 percent of Americans. In the same sur- vey, researchers asked respondents in Hungary and the United States: "If a woman wants to have a child as a sin- gle parent but she doesn't want to have a stable relationship with a man, do you approve or disapprove?" Only 8 percent of the Hungarians said they "disapproved," compared to 56 percent of Americans, demonstrating a much more liberal attitude toward single mothers and women's independence in the state socialist country. Furthermore, whereas 63 per- cent of Americans reported that prostitution is "never jus- tifiable," a full 80 percent of the Hungarians surveyed said the same. An even bigger gap appears when the data for this question are disaggregated by gender: only 55 percent of American men claimed that prostitution was "never justifi- able," compared to 76 percent of Hungarian men. The latter were perhaps more averse to prostitution because they had

been raised in a society that strove to decouple sex and romance from economic exchange.[14]

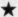

To the north, the situation in Catholic Poland allows us to further consider the role of religion in shaping human sexual behaviors. Because of the ongoing influence of the church, the Poles did little to challenge traditional gender roles, and in fact, socialist-era sexologists tended to reinforce rather than undermine presocialist ideals of masculinity and femininity (unlike in East Germany). However, women were fully incorporated into the labor force, and the Polish state women's organization ensured that abortion remained legal and accessible after 1956 and that Polish youth received sex education in schools after 1969 (although there were relevant publications circulating before this). Despite their relative independence, domestic responsibilities in the home led to a double burden that neither male partners nor the Communist Party did much to alleviate. Women also earned significantly less than men and, because of their familial duties, had fewer opportunities for career advancement, making them more dependent than in other state socialist countries. "Nevertheless," writes Agnieszka Kościańska, a Polish anthropologist, "access to waged work, with the money earned as well as the social networks and social life built through the workplace, gave women independence and power vis-à-vis men, and many families struggled with this new model of gender relations."[15]

Because of these new challenges to the traditional ideal of Polish heterosexual relationships, the socialist state committed resources to the scientific study of intimacy. Scholars

who write in the field of sexuality studies draw heavily on the work of the French theorist Michel Foucault and his investigation of how expert medical knowledge affects our individual subjective experiences of health and illness. When we think about sex, for instance, the way we feel about it will be heavily influenced by religious values and societal norms, but our understanding of whether our sexuality is healthy or "good" will also be shaped by what physicians and psychologists consider "normal" and "abnormal." Thus, for example, a young gay man growing up in a culture where doctors assert that homosexuality is a disease to be cured is going to experience his sexuality differently than a young man growing up in a society where doctors consider homosexuality normal and healthy. Similarly, medical and psychological understandings of what constitutes good sex for men and women are going to influence the way people judge the quality of their own sex lives. When experts say that the lack of female pleasure in heterosexual relationships is not "normal," women may become better advocates for their own needs, bolstered as they are by the authoritative opinions of the medical establishment.

To explore these issues, Kościańska researched the expert advice given by Polish sexologists during and after the state socialist era, and found that the 1970s and 1980s were a kind of "golden age" with regard to the understanding of human sexuality. Polish views contrasted with the traditional American conceptual models, which focused on physiology and proposed that "good sex" was the result of a universal four-stage sexual response cycle. Based on the lab experiments of William Masters and Virginia Johnson, this biological view ultimately led to the medicalization and

pharmaceuticalization of treatment options for sexual dys-
function. Pharmaceutical companies sought (and continue
to seek) commercializable solutions to sexual problems,
preferably in the form of a patentable pill, which limits the
scope of sexological research to finding cures that could
generate profits.[16]

Alternatively, in state socialist Poland, sexology devel-
oped into "a holistic discipline embracing the achievements
of various branches of medicine, social science and human-
ities, with psychology, sociology, anthropology, philosophy,
history, religious studies, and even theology providing re-
sources for sex education and therapy. Sexuality was per-
ceived as multidimensional and embedded in relationships,
culture, economy and society at large." Unlike most of their
Western counterparts, socialist-era Polish sex therapists
explored individual desires for love, intimacy, and mean-
ing, and listened carefully to the dreams and frustrations of
their patients. The socialist state funded their salaries and
research budgets, in a stark contrast with the dominance of
corporate funding in the West. This had particularly posi-
tive impacts on local understandings of women's sexuality.
According to Kościańska, Polish sexologists "didn't limit
sex to bodily experiences and stressed the importance of
social and cultural contexts for sexual pleasure. Even the
best stimulation—they argued—will not help to achieve
pleasure if a woman is stressed or overworked, [or] worried
about her future and financial stability." Similar to the line
taken by the Eastern Germans, socialist sex was supposedly
better because women enjoyed greater economic security,
and because sex was less commodified than in the capitalist

West. And because men weren't paying for it, they perhaps cared more about their partners' pleasure.[17]

After the collapse of state socialism, Poland experienced a rapid resurgence of conservative gender roles, with once guaranteed reproductive freedoms rescinded and a reversal of many of the achievements of state socialism with regard to women's rights. The rise of nationalism in Poland has also heralded an increase in homophobia, xenophobia, and anti-Semitism. But, interestingly, there still remains a legacy of the more holistic view of sexuality developed during the 1970s and 1980s. Although the field of sexology has now been forced to deal with the same market pressures prevalent in the West, research suggests that Polish women still report higher levels of sexual satisfaction than women in the United States. Kościańska cites a 2012 study that found that three-quarters of Polish women were free of "sexual dysfunction," and contrasts this with a 1999 study that found that only 55 percent of American women could say the same.[18]

Once again, we can't generalize about the experiences of all state socialist countries in Eastern Europe before 1989. They each approached the woman question uniquely, even if they all started from a similar theoretical basis in the works of Bebel, Engels, or Kollontai. In my view, the worst place to be a woman was Romania, where state socialism did little to challenge a despotic, patriarchal culture. Like Romania, Albania seems to have been a rather inhospitable climate for intimate relations. Bulgaria was rather more prudish than East Germany, but the state-run women's magazine did regularly publish a column on sexology. In

1979, the government also facilitated the publication and wide distribution of one of the most popular East German sex handbooks, *The Man and Woman Intimately*, by Siegfried Schnabl. Although the language was medicalized, and Schnabl was less than what we would consider enlightened about homosexuality and masturbation, the Bulgarian edition that I have does open with some statistics on the female experience of orgasm in the GDR and includes anatomical diagrams of where the clitoris is and what it looks like in various stages of arousal. According to the Bulgarian novelist Georgi Gospodinov, the book was a huge best seller, and few Bulgarian homes lacked a copy tucked away behind the volumes on the highest bookshelf. Compared to their Romanian neighbors to the north, Bulgarian women enjoyed greater access to birth control, and sexuality was less taboo. In response to my op-ed on sex and socialism in the *New York Times*, for instance, one young Bulgarian woman posted on Facebook: "I was born into Socialism. Growing up, sexuality seemed just about the most normal thing: my family would talk about it openly, there were sex education books lying around semi-hidden, we'd go to nude beaches. . . . The second thing my mum still asks me when I call her (after 'How are you?') is 'Are you having sex often enough?' . . . I am not saying Socialism was great, but it was definitely interesting to read this article having a first hand experience!"[19]

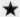

One last case of interest is that of state socialist Czechoslovakia, explored in depth by Czech researchers Kateřina Lišková, Hana Havelková, Libora Oates-Indruchová, and

Věra Sokolová.. Although the Czechs and Slovaks had a long history of interest in sexology dating back to the 1920s, the advent of state socialism produced a unique confluence of socialist ideology with expert medical discourse. In the early 1950s, sexologists in Czechoslovakia focused on female pleasure and argued that "good sex" was only possible when men and women were social equals. They supported women's access to birth control and abortion, their full incorporation into the labor force, and steps taken to alleviate their domestic burdens or to share them more equitably with men. As in other state socialist societies, all citizens were guaranteed employment and opportunities for leisure, and they enjoyed universally accessible health care and the security of pensions for the elderly, which reduced women's economic dependence on men. Once again, the liberation of love, sex, and romance from economic consideration was considered a unique feature of state socialism.

Czechoslovak sexologists started doing research on the female orgasm as early as 1952, and in 1961 they organized an entire conference to discuss barriers to women's sexual pleasure. Based on their expert opinions, women could not fully enjoy sex if they were economically dependent on men. "Capitalist society was condemned mostly from the standpoint of women," Lišková writes of the Czechoslovak sexologists. "Even though the authors were men, they viewed and criticized capitalism from the disadvantaged and marginalized position of women. These sexologists connected public and private discrimination with economic dependency. In economically unequal societies, people, and especially women, could not seek spiritual companions as their life partners and suffered in unhappy marriages and

from sexual double standards. . . . The capitalist order was equated with the subjugation of women and patriarchy, and socialist arrangements were hailed as an antidote to capitalist exploitation of women as property." Although the early emphasis on gender equality would be reversed after the Soviet tanks crushed the Prague Spring in 1968, and Czechoslovaks would retreat into the private sphere to find solace during the period of "Normalization," legacies of the more liberal postwar era remained.[20]

The experiences of some of the state socialist countries in Eastern Europe suggest that there was something different about sexual relations under socialism, and that at least one significant factor in this regard is the social supports put in place to promote women's economic independence. Although these policies were never fully realized, and were in part implemented to support the developmental goals of the socialist economy, one consequence of these policies was that women were less economically dependent on men and therefore able to leave unsatisfying relationships more easily than women in the West. In addition, to varying degrees, socialist states promoted the idea that sexuality should be disentangled from economic exchange, and in the case of East Germany and Czechoslovakia, politicians and doctors openly claimed that this made relationships more "authentic" and "honest" than in the West. In countries like Poland and Bulgaria, medical experts supported the idea that women's sexual pleasure was important for healthy relationships, and disseminated public educational materials (books, pamphlets, articles, and so forth) to educate men about the basics of female anatomy. (Compare this to the United States, where even today many young

people still don't get adequate education on how to avoid pregnancy, let alone information about the intricacies of female pleasure.)

The idea that more egalitarian relationships might lead to better sex has continued to intrigue researchers across the globe. In the United States, for example, one study using data collected between the late 1980s and early 1990s seemed to suggest that men and women who shared domestic duties had sex less frequently than those who adhered to a more traditional gendered division of household labor, because the performance of different gender roles apparently increased sexual attraction. But a subsequent study, "The Gendered Division of Housework and Couples' Sexual Relationships: A Reexamination," revisited the original data and compared it with new data collected in 2006 from low- to middle-income American households with at least one child. These authors found that sexual frequency increased when child care was shared more evenly. Researchers argued that as American gender roles changed in the intervening years, more working-class and middle-class men and women began to accept the idea that men should help out around the home. The perception of fairness in the division of household tasks has become central to couples' intimacy, with the study's authors claiming that "sex has value not only as a gender performance but also as a means of demonstrating love and affection. As such, couples have more and higher quality sex when they are satisfied with their relationships."[21]

Another longitudinal study of 1,338 heterosexual German couples that had been together for an average of ten years (69 percent of whom were married) corroborated

that the perception of fairness in the division of household duties led to fewer resentments within the relationship. This study was designed to investigate the relationship between "male partner housework contributions and sexual functioning" over a five-year period. According to the researchers, "the results tell a clear story: When men contribute fairly to housework, the couple enjoys more frequent and satisfying sex in the future." And since East German men apparently still chip in more around the home than their West German counterparts, it seems the legacies of state socialism continue to influence intimate life in the bedroom.[22]

No matter what the ideal division of labor is in the household, the issue with contemporary sexuality is that most human relationships are formed within a social context infused with economistic thinking and saturated with stress. We shouldn't have to live under authoritarian regimes to have loving relationships based more on mutual affection than on material exchange. The current marketplace for sexuality is filled with many young men and women who are financially insecure and fearful of the future. One of my former students told me that many of her friends and colleagues in their mid-twenties take antidepressants to cope with the pressures of daily life. These drugs control anxiety but often squash libido, turning young men and women into dutiful workaholic automatons who have little time or interest in romance. Cultural theorist Mark Fisher has argued that the deteriorating quality of mental health in the West can be attributed to the precariousness of the capitalist economic system. Like climate change and environmental degradation, the skyrocketing incidence of

depression and anxiety are the negative externalities of a system that reduces human worth to its exchange value.[23]

Whether we like it or not, capitalism commodifies almost every aspect of our private lives, as sexual economics theory predicts. Personal relationships take time and energy that few of us have to spare as we scramble to make ends meet in the precarious gig economy. We are often exhausted and drained, unwilling to invest the emotional resources necessary to maintain loving relationships without compensation. I'm always stunned by the prevalence of young, college-educated women and men looking for "sugar daddies" and "sugar mommies" on websites like Seekingarrangement .com, or signing up with escort agencies to help pay for groceries. All relationships require some emotional labor, and young people are learning that they might as well get paid for doing it.[24]

Many will argue that there is nothing morally wrong with sex work, and it should be legalized, protected, unionized, and fairly compensated for those who freely choose to seek employment in this sector of the economy. Sex work existed long before the advent of capitalism, it continued to varying degrees throughout the state socialist countries, and it will no doubt exist in some form well into the future. But much overt sex work, as well as the subtler forms of commodified sexuality for sale, is the result of an economic system that provides little material security for women, and encourages all people to turn everything they have (their labor, their reputations, their emotions, their bodily fluids and ova, and so forth) into a product that can be sold on a market where prices are determined by the caprices of supply and demand. This form of amorous exchange is not

sex-positive empowerment for women, but a desperate attempt to survive in a world with few social safety nets.

If we take sexual economics theory as one extreme model for how sexuality operates in a capitalist economy, then considering the experiences of the other extreme, the state socialist model, can help us think about possible ways to move toward something that combines the good aspects of both models while rejecting their obvious negatives. By implementing socialist policies to increase opportunities for women's employment and leadership (through job guarantees or some form of quotas) as well as state-supported programs for parental leave and subsidized child care, women will be less coerced into selling their sexuality to meet their basic needs. Even universal health care would go a long way in reducing women's economic dependence on men. Building a universal health care system is a *very long way* from implementing some form of authoritarianism, no matter what the right-wing pundits want us to believe. Critics of the American health care system often point out that employer-based health care traps workers in jobs they hate because the costs of individual plans are so prohibitive. But rarely is it mentioned that dependent wives are also trapped in their marriages because our health care system gives them access to medical care through their husbands. In the case of divorce, a woman loses access to her ex-husband's employer-based plan, leaving her to fend for herself.[25]

Americans worship at the twin altars of liberty and choice, but some fundamental aspects of our economic system rob ordinary people of the ability to make the decision

to leave an unsatisfying job or relationship because they might lose access to basic medical care. "This crippling of individuals I consider the worst evil of capitalism," wrote Albert Einstein in his 1949 essay, "Why Socialism?" Living in Princeton, New Jersey, for the last years of his life, Einstein believed that "the economic anarchy of capitalist society" undermined basic human freedoms, which could be restored if Americans embraced certain aspects of socialism. And there are many policy options open to us, a number of which operate in the European social democracies today, to increase our own personal freedoms.[26] Those who do enjoy universal healthcare, meanwhile, should take note: where it is under threat of cuts and privatization, so too is a vital source of economic independence.

Which makes me think about Ken and his ex-wife. Because he was my close friend, I always took his side in their divorce, sharing his outrage at the crassness of her economic calculation. But in many respects, she was a victim, too. Ken was a well-known lady's man who used his wealth to attract women. The rules of the game were clear: women gave him access to their sexuality, and he paid their bills. That is how he met the woman he married, and she understood the rules of the exchange. But somewhere along the way, Ken fell in love with her and expected that she would reciprocate his affections. Both of them mistook money for attractiveness and the transactional exchange of affection for love. Ken's economic power was supposed to be satisfying in the bedroom. But then Ken had a change of heart and tried to rewrite the rules. He realized that the transaction wasn't enough for him anymore; he wanted a real emotional connection. Ken wanted her to desire him for who he was

and not for what he could buy. He needed to know that she would love him even if he lost his wealth. For her, the honest thing to do at that point would have been to tell him the truth and walk away from the relationship. But she was poor and uneducated, and his marriage proposal offered her a golden ticket to a green card and a new life in America. So she played along. Of the economic choices available to her, faking her love for a wealthy man was a pretty good option.

Was it her fault that she actually fell for someone else, a man who didn't have Ken's money but to whom she felt a genuine attraction? Once her residency permit came through, she couldn't fake it any longer, and ran away to be with the man she deemed her "true love." Poor Ken was left heartbroken and embittered by her deceit, but if he had stopped for one minute to think about the power imbalance in their relationship, he would have seen that her economic dependency on him fueled her ongoing subterfuge. In those last years of his short life, Ken realized that if he wanted a relationship with someone who loved him for who he was (and not for what he could pay), he needed to imitate his colleague and find a woman who could meet her own basic needs. Although it may sound corny to our twenty-first-century ears, Bebel and Kollontai were basically right. Intimate relationships that are relatively free from the transactional ethos of sexual economics theory are generally more honest, authentic, and, well, just better.

Rosa Luxemburg (1871–1919): One of the most important social theorists of European Marxism. A philosopher, economist, and pacifist, Luxemburg earned her doctoral degree at the University of Zurich in 1897. An incredible orator and a passionate writer, she was considered a luminary among the German socialist leaders of her day. After the outbreak of World War I, she broke with her colleagues in the German Social Democratic Party and helped to found the Spartacus League, which eventually became the German Communist Party. She was murdered in 1919 along with her colleague, Karl Liebknecht. *Courtesy of Rosa Luxemburg Stiftung.*

6 FROM BARRICADES TO BALLOT BOXES: ON CITIZENSHIP

I n 2006, I bought a map that everyone should own. Produced by the Oxford Cartographers, the "World History Timeline: The Rise and Fall of Nations" is a color-coded chart of the different civilizations and states from 3000 BCE to 2000 CE. The x-axis of the map is the timeline spanning five thousand years of human history. The y-axis of the map presents six geographic formations whose relative size corresponds to the amount of written history we have about them: the Americas, sub-Saharan Africa, Europe, North Africa and the Middle East, Asia, and Australasia. What I love about this map, and what makes it so useful as a teaching tool, is that by showing that empires are temporary, it provides an infographic for the possibility of social change.

I've been teaching young people for almost twenty years. I marvel at how fixed and static millennials believe the world to be and how easily this worldview leads them down a path of political despair. Because I grew up during the last decades of the Cold War, and was nineteen when the Berlin Wall fell and twenty-one when the Soviet Union imploded, I spent my twenties and thirties with a clear understanding that big political changes are not only possible

but that they can come when you least expect them. In fact, in the summer of 1989 I decided to drop out of college so I could see the world before the whole thing got blown to bits in a nuclear war. The threat of mutually assured destruction was so palpable in the late 1980s that it didn't make sense to try to live an ordinary life. I certainly didn't want to be stuck in a classroom taking a chemistry midterm when the bombs started falling. I bought a one-way ticket to Spain and left the United States in late September of 1989. Less than two months later, the Cold War ended. Just like that.

In the summer of 1990, as I backpacked through Eastern Europe, I remember the euphoria and the sense of endless possibility. Young people were especially jubilant that they would have free and prosperous futures, enjoying opportunities denied their parents and grandparents. In those heady months, many people still believed that the streets of New York and London were paved with gold, and that democracy and capitalism would usher in a new consumer Xanadu of unlimited Levi's jeans and Cacharel perfumes. Later, as I began doing research in the region, I heard countless stories of suicides and desperate acts of self-harm committed in the few days before the wall fell on November 9, 1989. As they took stock of their lives, these men and women believed that their world would never change. Although there were growing protests across Eastern Europe, few expected the scale of the transformation to come. How could they have known that their world would be so different just a few days later? If they had hung on for forty-eight hours more, they could have lived out the rest of their lives in circumstances radically altered from those in which they felt so trapped. If only they could have believed

that this particular present never extends infinitely into the future.

People born after 1989 came into a world where capitalism was triumphant. It was the only political and economic system left standing after the turbulent twentieth century, with Francis Fukuyama famously declaring that humanity had reached the "end of history," the zenith of our civilizational development. If they found themselves disenchanted with the chaos wrought by rampaging neoliberalism, there were no alternatives. Their political consciousness was forged in a world where American hegemony appeared ossified and uncontested. To riff off a line from the Borg: resistance was futile; you would be assimilated whether you liked it or not. The ideological stranglehold of democrocapitalism bred apathy and inertia in many young people, who repeated the same mantra year after year, "Nothing will change. That's just the way things are."[1]

Whenever I hear that phrase, or some permutation of it, I always pull out my Oxford Cartographers World History Timeline and try to get students to think about what it means to say that nothing can change. In the middle of this map is a huge, orange-red shape that represents the Roman Empire, with its thousand-year history and its geographic dominance over most of Europe, North Africa, and the Middle East. Rome's collapse plunged Europe into the Dark Ages, and the fall of the Roman Empire is signified by an abrupt line that demarcates the temporal boundary. Imagine, I tell the students, that you were born in 456 CE just outside the city of Rome. You had your twentieth birthday on September 1, 476, and had spent your whole life in an empire that had existed for almost a millennium. Sure,

there were problems with the barbarians in the North and all sorts of intrigues and plots undermining political stability, but this was Rome. It had survived far greater crises than a few armies of rabid Visigoths.

Can you even begin to imagine what it would have felt like on September 4, 476, when Flavius Odoacer deposed Romulus Augustulus on what is generally considered the specific day that marks the end of the Roman Empire? Rather than a Roman emperor, an Italian king now ruled, and all of your future days would be lived in a state of liminal chaos and irrevocable decline. At this point, I point to a little purple rectangle down in the bottom right corner of the World History Timeline. This represents the history of the United States, which seems rather small and insignificant compared to the long histories of other cultures and civilizations. By examining this map, it is easy to see the self-deception necessary to maintain the myth that things can never change. The whole history of the world is one of constant upheaval. Nations and empires rise and fall. Sometimes they are defeated from the outside. Sometimes they implode from within. Usually it is a combination of both. Almost always it is completely unexpected. The anthropologist Alexei Yurchak captured the zeitgeist of growing up in the USSR of the 1980s in the title of his book: *Everything Was Forever Until It Was No More*.[2]

Positive change can and does happen, and while there are always random historical contingencies at work, it is ultimately people working collectively who shape history. "Never doubt that a small group of thoughtful, committed citizens can change the world," begins a quote attributed to the anthropologist Margaret Mead. "Indeed, it is the only thing

that ever has." Of course, things don't always change for the better, as Yurchak and many of his compatriots in Eastern Europe found out. Regression happens just as often as progress, which may be why so many people cling to the status quo. But trying to tread water and stay in one place makes it easier for those trying to pull us backward to succeed. Only strong forward momentum can counteract the tug of people hoping for a return of the social mores of the past.[3]

Women stand to lose the most in the coming struggles that will redefine the future of our republic. There are already those clamoring for our disenfranchisement, both figuratively and literally. In 2020, the United States will celebrate a century of women's suffrage, but there are plenty of our fellow citizens who believe a century is long enough.

In the weeks before the 2016 US presidential election, the Twitter hashtag #Repealthe19th started trending in response to two tweets by prognosticator Nate Silver. On his popular website FiveThirtyEight.com, Silver decided to predict the election outcome if only men or if only women voted. The electoral map for the men showed a handy victory for Donald Trump, whereas the women's map revealed a landslide for Hillary Clinton. Some Trump supporters then suggested that in order to ensure a Trump victory, the United States should repeal the Nineteenth Amendment to the Constitution, which granted women's suffrage. "I would be willing to give up my right to vote to make this happen," wrote one female Trump supporter. Twitter outrage ensued, and the story was covered by the mainstream media, including the *Los Angeles Times*, *Salon*, and *USA Today*,

further fanning the flames of digital hysteria. Although it was later revealed that more people were using the hashtag to tweet against the idea, the hashtag reflected a popular belief among some conservatives worried about demographic trends and the future prospects of the Republican Party.[4]

Back in 2007, the right-wing pundit Ann Coulter told a radio interviewer that the American political system would be vastly improved if the country repealed the Nineteenth Amendment and only let men go to the polls. "If we took away women's right to vote," she explained, "we'd never have to worry about another Democrat [sic] president. It's kind of a pipe dream, it's a personal fantasy of mine." Coulter went on to say that women voted "stupidly," especially single women, and argued that the Democratic Party should be ashamed that more men didn't vote for its candidates. Coulter opined that the Democratic Party was the party of women, bribing "soccer moms" with "health care and tuition and day care."[5]

Coulter's diatribe against the women's vote, and especially the votes of single women, may have been inspired by an influential paper that appeared in the *Journal of Political Economy* in 1999. The authors, John Lott and Lawrence Kenny, correlated the growth of US government spending in the early twentieth century with the spread of women's suffrage across states (culminating with the constitutional amendment in 1920) to argue that women are more likely to vote for more socially progressive candidates than men. Lott and Kenny suggest that because women have lower wages and more barriers to self-sufficiency, they may prefer less risk and a larger role for government. Using empirical evidence, the authors purport to show how women have

used their votes to steadily increase the size of the government: "Since women tend to have lower incomes, they benefit more from various government programs that redistribute income to the poor, such as progressive taxation." And over time, single women in particular have understood they benefit from more robust social services and vote accordingly. Lott and Kenny argue that, "after women have to raise children on their own, they are more likely to classify themselves as liberal, vote for Democrats, and support policies such as progressive income taxation. . . . It is not difficult to see that giving women the right to vote is likely to have played some role in determining the path of government spending over time."[6]

To many conservatives, for whom the expansion of government spending is anathema, Lott and Kenny squarely place the blame for the historical growth of federal expenditures in the United States at the feet of women who are voting in their own economic interests. If you spend any time on the internet reading the blogs of "men's rights" activists, you will find that they rely heavily on Lott and Kenny's 1999 article to support their claims that women should no longer vote (although really, you're probably better off reading dog food labels than reading men's rights blogs).[7] Even though women's political enfranchisement only shows up on the World History Timeline in the last century, the basic thrust of the men's rights movement is that female suffrage has destroyed Western civilization. In one book, *The Curse of 1920*, the author proposes that, "Women's rights are like cancer—if you have surgery and don't get it all, it will come back. The only solution to a vast amount of our nation's besetting ills is to remove the cause—women in politics and

government." In his own little March 2017 screed on how to save the West, Roosh V (of *Don't Bang Denmark* notoriety) states unequivocally that repealing the Nineteenth is the only way to save the United States from certain socialist doom. "Remove a woman's right to vote and within just one national election, every single leftist party would be crushed. Within two elections, politicians would speak directly to men and their innate interest for patriarchy, economic success, stable families, and an equitable distribution of females among society." I'm not sure who is going to be in charge of this equitable distribution of females, but it certainly won't be the females themselves.[8]

While always wrapped in a thick blanket of misogyny, what all of the men's rights activists agree on is that women vote for progressive candidates because *it is in their own economic interests to do so.* Although the 1999 paper by Lott and Kenny continues to be used in these women-hating diatribes, an alternative read of their research actually confirms the idea that redistributive policies are a better guarantor of women's independence than the unbridled free market. In fact, men's rights activists know what many women fail to realize themselves: women have immense political power at the ballot box.

Just as the proponents of sexual economics theory admit that capitalism commodifies women's sexuality and that gender equality and generous social safety nets give women other ways of meeting their basic needs besides selling themselves to the highest bidder, Lott and Kenny provide evidence that women's political participation has (at least over the long term) resulted in a government that better serves the needs of the many. Indeed, over and over the

far right accuses women voters of electing "socialist" leaders hell-bent on undermining both patriarchy and private property. Of course, with few exceptions, the United States hasn't had anything close to a socialist leader, but in this paranoid rewriting of our country's past, perhaps the lads of the alt-right are showing women a path toward a possible future.

"Repeal the 19th" only means something in the year 2018 because the demographic composition of the electorate of the near future bodes ill for men and "their innate interest for patriarchy, economic success, stable families, and an equitable distribution of females among society." This is perhaps why conservatives are so keen to tar anyone flirting with socialist ideas with the black brush of Stalinism. Desperate to discredit the political demands of "social justice warriors," opponents will shout about the purges, famines, and Gulag, arguing that voter-supported attempts to build a universal, single-payer health care system or a national network of quality child care facilities will inevitably lead this country down a slippery slope toward totalitarianism. But after years of bullying and intimidation, the voices of the far right (although still well-funded) are starting to be drowned out by a rising tide of millennials fed up with the idea that capitalism is the only game in town.

Conservatives fear this growing youth disaffection with global capitalism. And they worry that American women, and especially younger millennial women, will vote for left-leaning or socialist candidates, especially when women understand that they disproportionately benefit from state

regulation of markets, single-payer health care, tuition-free postsecondary education, social ownership of large enterprises like utilities or banks that are "too big to fail," and other redistributive policies. Today, millennials and members of generation Z view democratic socialism as an answer to their many frustrations—one less libido-inhibiting than selective serotonin reuptake inhibitors. In a widely shared article for the *Nation* in January 2017, "Why Millennials Aren't Afraid of Socialism," Julia Mead recounts her personal discovery of socialist ideals and how American political discourse foreclosed their discussion before the emergence of Bernie Sanders in the 2016 Democratic primary:

> The erasure of socialist ideas from serious political discourse throughout most of my life wasn't a historical fluke. The West's victory in the Cold War—liberal democracy for everyone!—came at the price of iconoclasm, much of it celebratory. . . . So communism was killed, and along with it went any discussion of socialism and Marxism. This was the world of my childhood and adolescence, full of establishment progressives who were aggressively centrist and just as willing as conservatives to privilege the interests of capital over those of labor: think of the reckless expansion of so-called free trade, or the brutal military-industrial complex. For most of my life, I would have been hard-pressed to define capitalism, because in the news and in my textbooks, no other ways of organizing an economy were even acknowledged. I didn't know that there could be an alternative.[9]

Mead argued that millennials embrace socialism because they are "tired of the unequal world they inherited." Exactly six months later, *Nation* editor Sarah Leonard followed Mead's piece with her own op-ed for the *New York Times*, "Why Are So Many Young Voters Falling for Old Socialists?" Reflecting on the popularity of senior white men like Bernie Sanders in the United States and Jeremy Corbyn in Britain, Leonard argued that the growing millennial support for socialism had less to do with the inherent radicalism of youth and more to do with the failures of traditional parties to rein in the worst excesses of capitalism: "Our politics have been shaped by an era of financial crisis and government complicity. Especially since 2008, we have seen corporations take our families' homes, exploit our medical debt and cost us our jobs. We have seen governments impose brutal austerity to please bankers. The capitalists didn't do it by accident, they did it for profit, and they invested that profit in our political parties. For many of us, capitalism is something to fear, not celebrate, and our enemy is on Wall Street and in the City of London."[10]

For Republican politicians and their wealthy backers, the sentiments expressed by Mead and Leonard, both young leftist women, represent a real threat. For the first time in the 2016 election, millennial and generation X voters outnumbered baby boomers. By the 2020 election, the millennial voters will enjoy huge electoral influence if they go to the polls. Demographically, their generation outnumbers gen Xers and will further expand with the growing number of younger naturalized immigrants. For establishment Republicans hoping for more deregulation and tax cuts for the rich, the swelling ranks of younger voters poses a clear

and present danger to their long-term political prospects. According to a July 2017 report of the Pew Research Center, millennial voters are far more likely than their parents or grandparents to identify as Democrats or Democrat-leaning independents.[11]

The growing influence of young voters means that real change is possible if they go to the polls. I have no doubt that conservatives will do everything possible to suppress voter turnout and to demonize anyone who runs on a platform of redistribution and market regulation or advocates for forms of social ownership. But those inspired by the ideals of socialism must not let themselves be derailed by horror stories about the past. For too long, the history of twentieth-century state socialism has served as a cudgel to quash debate on how socialist ideals and theories might be dusted off, reexamined, repurposed, and applied to the twenty-first century. Of course, the mistakes and atrocities of the twentieth century should not be ignored, and robust debates about this past should flourish as part of a general intellectual culture of open inquiry. Although some East European governments are now trying to legislate a particular version of the past, social progress requires a thorough understanding of how historical truth gets made and by whom. We need to watch for the ways that history is strategically deployed to promote or suppress different political projects.

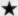

Ultimately, this thing we call "government" is not inherently good or bad. It is a vessel that is steered by those who happen to control it at any one moment in time. That's why

they call it "the ship of state." I'll also venture to say that this thing we call "the market" is neither good nor bad but merely a tool that can be used by those who believe it will further their interests. These days it seems the market is a tool used by the super-rich to increase their wealth, which they use to buy influence and power over our government. Even though we have presidential elections once every four years, real political power has accrued to the super-rich, and our government does their bidding while pretending to represent the people, just as state socialist governments in Eastern Europe once did the bidding of dictators and high-ranking elites while pretending to work for the good of the people.

The difference between governments and markets is that governments, or at least democratic governments, are ostensibly meant to serve the citizens. That's the whole idea of one person, one vote. Markets, on the other hand, are always going to be rigged in favor of those who start the game with the biggest pile of cash. And given the confluence of the way markets work with the 2010 Supreme Court ruling in *Citizens United* that has allowed for unlimited campaign donations, the more cash one has, the more influence one has on the government. A vicious cycle thus emerges, with unregulated markets eroding the power of the government. This creates greater profits for those who can buy more influence over the government to repeal the regulations protecting our education system, our environment, and our social services, which makes the rich even richer.

The solution is real citizen control of the government. We must make the state work in the interests of ordinary people. Democracy means rule by the people; the Greek root

demos refers to the common people of a state. Plutocracy, on the other hand, means rule by the wealthy, after the Greek word *ploutos* (wealth). The massive Wall Street bailouts after the Global Recession and Donald Trump's 2017 tax heist clearly demonstrate which of these two political systems we are living in. It might sound hyperbolic, but it's not impossible that the United States could become a one-party state, ruled by the dark money of a shadow Plutocratic Party. But we are not there yet. For now, economic elites are still invested in maintaining the façade of democracy, and here is where young American women can make a huge difference.

If young women don't get wise and start going to the polls to vote in their own long-term economic and political interests, they will have little power to reverse the inevitable social upheavals the future has in store. As the Republicans wrack up irresponsible deficits in the short term, they already have their eye on the social programs they will need to gut to prevent the United States from collapsing into bankruptcy. When programs like Social Security and Medicare disappear because the government can no longer afford to pay for them—or when Britain's privatized care homes go bankrupt, as some have already begun to do— all of the care work needed to look after our parents will descend onto the shoulders of women who are already at home because they can't afford daycare for their children. And without some form of universal health care, future cuts to Medicaid will mean that more and more Americans will need constant care at home, waited on, no doubt, by their daughters, mothers, sisters, and wives. With women responsible for a growing heap of care work in the private sphere, their autonomy will shrink, and they will find

themselves economically dependent and helpless to leave unsatisfying, violent, or emotionally abusive relationships.

Some people will argue that it's already too late and that our political system is too broken to be fixed. Certainly, if the plutocrats are stuffing ballot boxes or tampering with voting machines, the game is over, and citizens have lost. Then we really need to start thinking about what to do next. But until then, our democratic process still offers the possibility of radical political change or what Bernie Sanders called a "revolution from below." If younger voters, especially younger women, start hauling their butts to the polls, they have the power to make a difference. That is why the über-conservatives want to take away their right to vote. Millennial women have the demographic power to have an impact on our collective future, especially if they can convince their baby boomer parents that they're going to have to fend for themselves if the Republicans and Conservatives finally get their way and dismantle Social Security. If the young manage to elect political leaders who make the government more responsive to the needs of its citizens, then the plutocrats, if they want to maintain the status quo, will have to abandon the façade of democracy altogether. When that happens, we will no longer be living in the United States of America or in the United Kingdom, but in some other countries governed by a different set of rules.

While the first step is definitely voting (and mobilizing others to get out and vote), casting a ballot is not enough. Young people need to educate themselves in the basics of political theory. Read books, watch videos, listen to podcasts, peruse infographics—whatever it is you need to do to expand your understanding of how and why we organize into

nation-states and allow ourselves to be ruled by others, and how and why this has changed over time. And don't just stay in your comfort zone; open your mind to opposing perspectives no matter how painful it might be. If you're a *Jacobin* reader, click through the pages of *Reason*; if you read the *New Statesman* make sure to glance at least occasionally at the *Spectator*. Scroll through both the *New York Times* and the *Wall Street Journal*; don't just read the *Guardian,* read the *Financial Times* as well. If you can stomach it, go out and talk to people. Break out of your digital bubble, and engage where you can by sharing what you've learned: at school, at work, at church, at your local library, and so on. Join a book club or a reading group, or sign yourself up to the organizing committee of a social movement or political party. As an introvert, I know this is easier said than done for some of us, but if you are the gregarious type, find your voice and use it.

Outside of the electoral process, other political strategies can be mobilized to force business leaders and government officials to respond to the needs of ordinary people. For instance, you can join with others to agitate for policies to expand public employment; provide high quality, subsidized child care; guarantee job-protected, paid parental leaves with built-in incentives for fathers to take it as well as mothers; implement quotas to increase all forms of leadership diversity; create a universal health care system; and reduce the cost of college tuition. Such policies will go a long way toward mitigating inequality and building a society that works for the multitudes at the bottom rather than just the 1 percent at the top. A wider social safety net, like those found in the contemporary Northern European countries, will *increase* rather than decrease personal freedom because

it will restore to citizens the ability to make the most important decisions about their own lives. No one should have to stay in a job she hates for the health insurance, or stick with a partner who beats her because she's not sure how she'll feed the kids, or have sex with some sugar elder because she can't afford textbooks.

Most importantly, reclaim your time, emotional energy, and self-worth from the reductive logic of capitalism. You are not a commodity. Your depression and anxiety are not just chemical imbalances in your brain but reasonable responses to a system that thrives on your dehumanization. As Mark Fisher argued in 2012, "mental health is a political issue," and to the extent that our private lives inform our mental health, relationships are a political issue, too. We must push back at the dominant ideology that mangles our social bonds into nodes of economic exchange. We can share our attentions without quantifying their value, giving and receiving rather than selling and buying. Women need to establish what I want to call "affective sovereignty," to gain full control of our emotional labor. In the summer of 2017, the awning of a bookstore in Munich read, "Love kills capitalism." If people are happy in their intimate lives, if they feel loved and supported for who they are rather than what they own, capitalism loses one of the most valuable tools it has: it can no longer convince us that we need to buy more things to fill the void left by our lack of personal connection. Our growing anomie is profitable. By preventing our affections from becoming yet another thing to be bought and sold, we are taking the first steps of resistance.[12]

One of the most important things I learned from studying the collapse of twentieth-century state socialism in Eastern Europe is that people there were completely unprepared for the sudden changes ushered in by the creation of free markets. Because their governments controlled the flow of information about the West, ordinary citizens actually knew very little about how capitalist democracies worked in practice. If they heard anything about homelessness, poverty, unemployment, or the boom-and-bust cycles of the market, they disregarded these facts as mere propaganda. Most importantly, East European citizens lacked access to some of the basic texts explaining how and why liberal democracy differed from what they called "really-existing socialism" (to distinguish what they had from the ideal to which they were striving). They had no way to explore for themselves the contrasts in the fundamental political philosophies that brought the world to the brink of nuclear annihilation. There is a popular saying in many East European nations today: "Everything they told us about communism was lies. But everything they told us about capitalism was true."

In the Western world, no one is preventing us from reading whatever we want, but few people take the time to think about what kind of society we might have if our democracy falters and we find ourselves living in a nation (or nations) that are post-American. Because I watched radical social change happen in the countries of Eastern Europe, I know that even if this is a peaceful dissolution or a velvet divorce (as the breakup of Czechoslovakia was referred to), the process of rebuilding trust in society will be painful and disorienting. If the sudden social change results in violence (as in the case of Yugoslavia), many lives will be

lost unnecessarily, and it will be decades before the psychic wounds heal for those who survive. I know it's old-fashioned to talk about things like civic duty, but as our Western democracies become increasingly polarized, those hoping for a more just, sustainable, and equitable world have a lot of work to do if we want to be able to nudge things in a progressive direction.

Some will argue that attempts at reform only prolong the life of a failing economic system, and we would all be better off if we just let capitalism impale itself on a skewer of its own internal contradictions. But a sudden collapse of twenty-first-century capitalism would have massive global repercussions and cause widespread human suffering to many of the same people who would ultimately benefit from its demise. Self-proclaimed revolutionaries will certainly disagree, but all forms of regime change (even good ones) create collateral human damage, and if we can, we should try to minimize this as much as possible. One of the biggest problems with twentieth-century state socialism in Eastern Europe was that some leaders were too eager to sacrifice the lives of their own citizens for the sake of building a more just and egalitarian future. Rosa Luxemburg believed that revolution and reform were just different paths to the same end goal of socialism. Yes, empires rise and fall, but ordinary people fare better if they collapse with a whimper rather than a bang. The star of capitalism may go out like a supernova, but the transition to postcapitalism will be easier for most of us if it dies the death of a white dwarf.[13]

Which brings me back to my Timeline of World History map and its big blocks of color representing the rise and fall of empires. It's a beautiful thing to stare at when you

are feeling helpless about the future, frustrated at the glacial pace of change, or fearful about the present-day Visigoths hoping to plunge us all into the Dark Ages 2.0. Although the Oxford Cartographers didn't draw them, their map is populated with over a hundred billion people—all of the men and women who ever lived on Earth. Every single one of these people was born to a mother, and if they survived their childhood, they grew to adulthood and lived in some sort of clan or community. They ate, drank, slept, dreamt, had sex, formed families, and eventually got sick and died in ways not so different from the way we do today. It is these billions of men and women who made our history, not just those named in our textbooks. It is ordinary people who made the babies, built the dams, grew the crops, fought the wars, raised the temples, and started the revolutions.

And unless a huge meteor smashes into the planet and wipes us all out tomorrow, it is still ordinary people who can push history forward. Coordinated collective action can have a huge impact on the world. If two billion people spontaneously decided to quit using Facebook tomorrow or stopped shopping on Amazon.com, two of the richest and most powerful corporations in the world could cease to exist. If millions of men and women walked to any bank and demanded their deposits on the same day, they could cripple even the most powerful among them. Once upon a time, when there were strong unions and workers bargained collectively, citizens retained a greater portion of the wealth they helped to produce. The most dangerous enemy of plutocracy is large numbers of citizens working together for a common cause. It's no coincidence that capitalism thrives

on an ideology of self-interest and individualism, and that its defenders will try to discredit collectivist ideals based on altruism and cooperation.

I know it's not an easy task to find common cause while also respecting our many differences, and we should always be mindful of the power hierarchies that give some of us more privilege than others. Forming powerful citizen co-alitions that also acknowledge and support our diversity is an urgent task, and we need to draw on as deep a toolkit as possible if we are going to find a collective way out of our current political and economic morass. Twentieth-century experiments with Marxism-Leninism failed, but their fail-ure should provide lessons to help us avoid their many mistakes rather than inspiring a knee-jerk rejection of all communalist ideas.

There was a baby in all that bathwater. It's time we got around to saving it.

Bebel

August Bebel (1840–1913): A cofounder of the Social Democratic Worker's Party of Germany who would go on to head the Social Democratic Party of Germany. The author of the influential book *Woman and Socialism* and a prominent advocate for women's rights, Bebel argued that women would only be freed from their economic dependence on men when workers collectively owned and controlled the means of production. Bebel is widely credited with being the first political figure to deliver a public speech in favor of gay rights. *Courtesy of U.S. Library of Congress.*

SUGGESTIONS FOR FURTHER READING

There are many wonderful books about the intersections of socialism and feminism. Below I list only a sample of relevant titles to explore.

Bebel, August. *Woman and Socialism.* Translated by Meta L. Stern. New York: Socialist Literature, 1910. (Available online at www .marxists.org.)

Boxer, Marilyn J., and Jean H. Quataert. *Socialist Women: European Socialist Feminism in the Nineteenth and Early Twentieth Centuries.* New York: Elsevier, 1978.

Brown, Wendy. *Undoing the Demos: Neoliberalism's Stealth Revolution.* Cambridge, MA: Zone Books, 2017.

Bucur, Maria. *The Century of Women: How Women Have Transformed the World Since 1900.* Lanham, MD: Rowman & Littlefield, 2018.

Carleton, Gregory. *Sexual Revolution in Bolshevik Russia.* Pittsburgh: University of Pittsburgh Press, 2005.

Clements, Barbara Evans. *Bolshevik Feminist: The Life of Aleksandra Kollontai.* Bloomington: University of Indiana Press, 1979.

Cobble, Dorothy Sue. *The Other Women's Movement: Workplace Justice and Social Rights in Modern America.* Princeton, NJ: Princeton University Press, 2005.

Cobble, Dorothy Sue, Linda Gordon, and Astrid Henry. *Feminism Unfinished: A Short, Surprising History of American Women's Movements.* New York: W. W. Norton, 2015.

Collins, Patricia Hill. *Black Feminist Thought: Knowledge,*

Consciousness, and the Politics of Empowerment. New York: Routledge, 2008.

Davis, Angela. *Women, Race & Class*. New York: Vintage, 1983.

Dodge, Norton T. *Women in the Soviet Economy*. Baltimore: Johns Hopkins University Press, 1966.

Du Plessix Gray, Francine. *Soviet Women*. New York: Bantam Doubleday Dell, 1990.

Ehrenreich, Barbara, and Arlie Russell Hochschild. *Global Woman: Nannies, Maids, and Sex Workers in the New Economy*. New York: Henry Holt, 2004.

Engels, Friedrich. *The Origin of the Family, Private Property and the State*. 1884. (Available online at www.marxists.org.)

Evans, Kate. *Red Rosa: A Graphic Biography of Rosa Luxemburg*. London: Verso, 2015.

Featherstone, Liza. *Selling Women Short: The Landmark Battle for Workers' Rights at Walmart*. New York: Basic Books, 2005.

Federici, Silvia. *Revolution at Point Zero: Housework, Reproduction, and Feminist Struggle*. New York: Common Notions, 2012.

Fidelis, Malgorzata. *Women, Communism, and Industrialization in Postwar Poland*. New York: Cambridge University Press, 2010.

Firestone, Shulamith. *The Dialectic of Sex: The Case for Feminist Revolution*. New York: Farrar, Straus and Giroux, 2003.

Fisher, Mark. *Capitalist Realism: Is There No Alternative?* Ropley, Hampshire, UK: Zero Books, 2009.

Fitzpatrick, Sheila. *Everyday Stalinism: Ordinary Life in Extraordinary Times: Soviet Russia in the 1930s*. New York: Oxford University Press, 2001.

Fraser, Nancy. *Fortunes of Feminism: From State-Managed Capitalism to Neoliberal Crisis*. New York: Verso, 2013.

———. *Scales of Justice: Reimagining Political Space in a Globalizing World*. New York: Columbia University Press, 2010.

Frink, Helen H. *Women After Communism: The East German Experience*. Lanham, MD: University Press of America, 2001.

Gal, Susan, and Gail Kligman. *The Politics of Gender After Socialism: A Comparative Historical Essay*. Princeton, NJ: Princeton University Press, 2000.

———, editors. *Reproducing Gender: Politics, Publics, and Everyday Life After Socialism*. Princeton, NJ: Princeton University Press, 2000.

Ghodsee, Kristen. *The Left Side of History: World War II and the Unfulfilled Promise of Communism in Eastern Europe*. Durham, NC: Duke University Press, 2015.

———. *The Red Riviera: Gender, Tourism, and Postsocialism on the Black Sea*. Durham, NC: Duke University Press, 2005.

———. *Second World, Second Sex: Socialist Women's Activism and Global Solidarity During the Cold War*. Durham, NC: Duke University Press, 2019.

Goldman, Wendy Z. *Women, the State, and Revolution: Soviet Family Policy and Social Life, 1917–1936*. Cambridge: Cambridge University Press, 1993.

Grant, Melissa Gira. *Playing the Whore: The Work of Sex Work*. New York: Verso, 2014.

Havelkova, Hana and Libora Oates-Indruchová, *The Politics of Gender Culture Under State Socialism: An Expropriated Voice*. London: Rutledge, 2014.

Hensel, Jana. *After the Wall: Confessions of an East German Childhood and the Life That Came Next*. New York: PublicAffairs, 2008.

Herzog, Dagmar. *Sex After Fascism: Memory and Morality in Twentieth-Century Germany*. Princeton, NJ: Princeton University Press, 2005.

———. *Sexuality in Europe: A Twentieth-Century History*. Cambridge: Cambridge University Press, 2011.

Hochschild, Arlie Russell. *The Managed Heart: Commercialization of Human Feeling*. Berkeley: University of California Press, 2012.

Holmstrom, Nancy. *The Socialist Feminist Project: A Contemporary Reader in Theory and Politics*. New York: Monthly Review Press, 2004.

Holt, Alix. *Alexandra Kollontai: Selected Writings*. New York: W. W. Norton, 1980.

Kligman, Gail. *The Politics of Duplicity: Controlling Reproduction in Ceausescu's Romania*. Berkeley: University of California Press, 1998.

Kollontai, Alexandra. *The Autobiography of a Sexually Emancipated Communist Woman*. New York: Prism Key, 2011.

Krylova, Anna. *Soviet Women in Combat: A History of Violence on the Eastern Front*. New York: Cambridge University Press, 2011.

Lapidus, Gail Warshofsky. *Women in Soviet Society: Equality, Development, and Social Change.* Berkeley: University of California Press, 1978.

Lišková, Kateřina. *Sexual Liberation, Socialist Style: Communist Czechoslovakia and the Science of Desire, 1945–89.* Cambridge: Cambridge University Press, 2018.

Lorde, Audre. *Sister Outsider: Essays and Speeches.* New York: Crossing, 2007.

Luxemburg, Rosa. *Reform or Revolution and Other Writings.* New York: Dover Books, 2006.

McDuffie, Erik S. *Sojourning for Freedom: Black Women, American Communism, and the Making of Black Left Feminism.* Durham, NC: Duke University Press, 2011.

McLellan, Josie. *Love in the Time of Communism: Intimacy and Sexuality in the GDR.* New York: Cambridge University Press, 2011.

Meyer, Alfred G. *The Feminism and Socialism of Lily Braun.* Bloomington: Indiana University Press, 1985.

Millar, James R. *Politics, Work, and Daily Life in the USSR: A Survey of Former Soviet Citizens.* New York: Cambridge University Press, 1987.

Moraga, Cherríe, and Gloria E. Anzaldúa. *This Bridge Called My Back: Writings by Radical Women of Color.* 4th ed. Albany: SUNY Press, 2015.

Penn, Shauna, and Jill Massino. *Gender Politics and Everyday Life in State Socialist Eastern and Central Europe.* New York: Palgrave McMillian, 2009.

Piketty, Thomas. *Capital in the Twenty-First Century.* Cambridge, MA: Harvard University Press, 2014.

Porter, Cathy. *Alexandra Kollontai: A Biography.* Chicago: Haymarket Books, 2014.

Ruthchild, Rochelle. *Equality and Revolution: Women's Rights in the Russian Empire, 1905–1917.* Pittsburgh: University of Pittsburgh Press, 2010.

Sanders, Bernie. *Our Revolution.* New York: Thomas Dunne Books, 2016.

Shaw, George Bernard. *The Intelligent Woman's Guide to Socialism & Capitalism.* New York: Welcome Rain Publishers, 2016.

Stites, Richard. *The Women's Liberation Movement in Russia: Feminism, Nihilism and Bolshevism, 1860–1930.* Princeton, NJ: Princeton University Press, 1978.

Sunkara, Bhaskar, editor. *The ABCs of Socialism*. London: Verso, 2016.

Vaizey, Hester. *Born in the GDR: Living in the Shadow of the Wall*. Oxford: Oxford University Press, 2017.

Varoufakis, Yanis. *Talking to My Daughter About the Economy: A Brief History of Capitalism*. London: Bodley Head, 2017.

Verdery, Katherine. *What Was Socialism and What Comes Next?* Princeton, NJ: Princeton University Press, 1996.

Wagenknecht, Sahra. *Prosperity Without Greed: How to Save Ourselves from Capitalism*. Frankfurt: Campus Verlag Books, 2018.

Weeks, Kathi. *The Problem with Work: Feminism, Marxism, Antiwork Politics, and Postwork Imaginaries*. Durham, NC: Duke University Press, 2011.

Weigand, Kate. *Red Feminism: American Communism and the Making of the Women's Movement*. Baltimore: Johns Hopkins University Press, 2001.

Weigel, Moira. *Labor of Love: The Invention of Dating*. New York: Farrar, Straus, and Giroux, 2016.

Yalom, Marilyn. *The History of the Wife*. New York: Harper Perennial, 2002.

Yamahtta-Taylor, Keeanga. *From #BlackLivesMatter to Black Liberation*. Chicago: Haymarket Books, 2016.

Zheng, Wang. *Finding Women in the State: A Socialist Feminist Revolution in the People's Republic of China, 1949–1964*. Berkeley: University of California Press, 2017.

Žižek, Slavoj. *The Courage of Hopelessness: A Year of Acting Dangerously*. New York: Melville House, 2018.

Nadezhda Krupskaya (1869–1939): A radical Russian pedagogue and a prominent figure in the prerevolutionary communist movement. She served as the Soviet Union's deputy minister of education for ten years and is widely credited with helping to build a mass education system and expanding a network of libraries across the USSR. Krupskaya was involved in the founding of the Soviet youth organizations the Young Pioneers and the Komsomol. *Courtesy of Public Domain (Russia).*

ACKNOWLEDGMENTS

Writing this book challenged me to break out of my usual academic register. I had much help from family, friends, and colleagues who encouraged me to pursue this project, gave moral support, provided general editorial advice, and read or commented on individual chapters: Courtney Berger, Susan Faludi, Dagmar Herzog, Agnieszka Kościańska, Marwan Kraidy, Sonya Michel, Mira Nikolova, Mitchell Orenstein, Kevin M. F. Platt, Rochelle Ruthchild, Russ Rymer, Laura Sell, Julia Verkholanstev, and Alina Yakubova. I am especially grateful to my colleagues Rachel Ex Connelly, Julia Mead, and Scott Sehon, who read through the entire manuscript and helped me shape my arguments. I am also thankful to Linda Gordon and the members of the HOWAG seminar at NYU for a lively discussion about the various reactions to my initial op-ed. I give much gratitude to Joan Wallach Scott for being a thoughtful interlocutor and for helping me to consider the political stakes of this project within a broader historical framework. Many thanks to my editors, the amazing Alessandra Bastagli and Katy O'Donell, and the Nation Books team, especially Kleaver Cruz, who have been wonderful to work with. At PublicAffairs, I am immensely grateful

for the support of Clive Priddle, Lindsay Fradkoff, Miguel Cervantes, and Kristina Fazzalaro. For the UK edition, my most heartfelt thanks go to Will Hammond and his superb team at the Bodley Head for their work in helping this book find a wider international audience.

Finally, Professor Freeman Dyson's ruthless optimism and vast life experience convinced me that cynicism is a cop-out and that the world is much brighter today than it was a hundred years ago. In an email exchange in February 2018, when I was despairing about politics and the state of the world, Professor Dyson (who was a teenager in the 1930s and served at British Bomber Command during World War II), helped me keep things in perspective. He also shared some advice from one of the many great minds he has known over the course of his ninety-four years: "Another wise counselor was my Princeton colleague Albert Hirschman, who wrote a book, *Exit, Voice and Loyalty*, describing the three choices available to a member of a country or an organization that is becoming corrupt or tyrannical. Exit means you escape and give up hope of reform. Voice means you risk your life fighting the evil power. Loyalty means you join the winning side and keep quiet. In the real world, the big majority chooses Loyalty, most of the minority choose Exit, and only a few heroes choose Voice."

I'm certainly no hero. But it is with Professor Dyson's voice ringing in my ears that I decided to attempt, however feebly, to choose Voice.

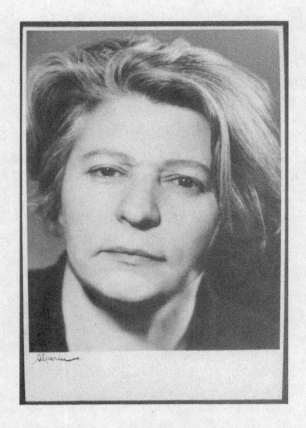

Ana Pauker (1893–1960): A Romanian Communist politician who served as the unofficial head of the Romanian Communist Party after World War II. She was the first woman in the world to serve as a Foreign Minister, and in 1948, *Time Magazine* featured her on its cover and called her "*The Most Powerful Woman Alive.*" Pauker was an influential leader until Stalin decided to have her purged. *Courtesy of National History Museum of Romania.*

NOTES

Notes to Introduction

1. Cynthia Hess and Stephanie Roman, "Poverty, Gender, and Public Policies," IWPR Briefing Paper, Feb. 29, 2016, iwpr.org/publications/poverty-gender-and-public-policies; Maria Shriver, "The Female Face of Poverty," *Atlantic*, Jan. 8, 2014; Juliette Cubanski, Giselle Casillas, and Anthony Damico, "Poverty Among Seniors: An Updated Analysis of National and State Level Poverty Rates Under the Official and Supplemental Poverty Measures," KKF.org, Jan. 10, 2015, www.kff.org/medicare/issue-brief/poverty-among-seniors-an-updated-analysis-of-national-and-state-level-poverty-rates-under-the-official-and-supplemental-poverty-measures; Heidi Moore, "Living Longer and Earning Less: Are Elderly Women Doomed to Be Poor?" *Guardian* (London), Sept. 26, 2013, www.theguardian.com/money/us-money-blog/2013/sep/26/are-elderly-women-doomed-poverty.

2. Elaine Tyler May, *Homeward Bound: American Families in the Cold War Era* (New York: Basic Books, 1988).

3. US Senate, "Sputnik Spurs Passage of the National Defense Education Act," Oct. 4, 1957, www.senate.gov/artandhistory/history/minute/Sputnik_Spurs_Passage_of_National_Defense_Education_Act.htm; "Executive Order 10980—Establishing the President's Commission on the Status of Women," Dec. 14, 1961, www.presidency.ucsb.edu/ws/?pid=58918; Tim Sharp, "Valentina Tereshkova: First Woman in Space," Space.com, Jan. 22, 2018, www.space.com/21571-valentina-tereshkova.html; Susan Ware, *Title IX: A Brief History with Documents* (Long Grove, IL: Waveland, 2014).

4. Norton T. Dodge, *Women in the Soviet Economy: Their Role in Economic, Scientific, and Technical Development* (Baltimore: Johns Hopkins University Press, 1966).

5. Milan Kundera, *The Unbearable Lightness of Being* (New York: Harper Perennial, 2009), 254.

6. International Labor Organization, "Women in Economic Activity: A Global Statistical Survey (1950–2000)," A Joint Publication of the International Labor Organization and INSTRAW, 1985.

7. Inessa Armand as quoted in Barbara Evans Clements, *Bolshevik Feminist: The Life of Aleksandra Kollontai* (Bloomington: University of Indiana Press, 1979), 155; Fatos Tarifa, "Disappearing from Politics (Albania)," in *Women in the Politics of Postcommunist Eastern Europe*, edited by Marilyn Rueschemeyer (Armonk, NY: M. E. Sharpe, 1998), 269.

8. Katherine Verdery, *What Was Communism and What Comes Next* (Princeton, NJ: Princeton University Press, 1996); Josie McLellan, *Love in the Time of Communism: Intimacy and Sexuality in the GDR* (New York: Cambridge University Press, 2011). Other sources will be discussed in later chapters.

9. Susan Gal and Gail Kligman, *The Politics of Gender After Socialism* (Princeton, NJ: Princeton University Press, 2000).

10. Janine R. Wedel, *Collision and Collusion: The Strange Case of Western Aid to Eastern Europe, 1989–1998* (New York: St. Martin's, 1998); quote from Dagmar Herzog. "Post Coitum Triste Est . . . ? Sexual Politics and Culture in Postunification Germany," *German Politics and Society* 94, no. 28 (2010): 111–140; Soviet quote from Doug Henwood, personal email communication with the author, Aug. 18, 2017.

11. Kristen Ghodsee, "Fires," in *Red Hangover: Legacies of Twentieth-Century Communism* (Durham, NC: Duke University Press, 2017).

12. Slavenka Drakulić, *How We Survived Communism and Even Laughed* (New York: Harper Perennial, 1993), 132; Peter Pomerantsev, *Nothing Is True and Everything Is Possible: The Surreal Heart of the New Russia* (New York: PublicAffairs, 2014); Justyna Pawlak, "Sex Slavery Plagues Romania and Bulgaria," Reuters, Jan. 21, 2007, www.reuters.com/article/us-eu-candidates-trafficking/sex -slavery-plagues-romania-and-bulgaria-idUSEIC87273820061228; Krista Georgieva, "I Was Kidnapped by a Bulgarian Human Trafficking Ring," *Vice*, Apr. 28, 2013, www.vice.com/en_us/article/avnb8g /human-trafficking-bulgaria-south-italy; Ana Maria Touma and Maria Cheresheva, "Modern Slavery Risk Highlighted in Bulgaria,

Romania," BalkanInsight.com, Aug. 17, 2017, www.balkaninsight
.com/en/article/romania-bulgarians-at-great-risk-of-modern-slavery
-experts-warn-08-16-2017.

13. INSCOP Research, "Barometrul," Nov. 2013, In Roma-
nian: www.inscop.ro/wp-content/uploads/2014/01/INSCOP-noiem-
brie-ISTORIE.pdf; for the Polish results see Janusz Czapiński and
Tomasz Panek, editors, "Special Issue: Social Diagnosis 2011 Objec-
tive and Subjective Quality of Life in Poland Report," *Contemporary
Economics: Quarterly of University of Finance and Management in
Warsaw*, 5, no. 3 (2011): 182, ce.vizja.pl/en/issues/volume/5/issue
/3#art254; Pew Research Center, "End of Communism Cheered
but Now with More Reservations," Nov. 9, 2011, www.pewglobal
.org/2009/11/02/end-of-communism-cheered-but-now-with-more
-reservations; John Feffer, *Aftershock: A Journey into Eastern Europe's
Broken Dreams* (London: Zed, 2017).

14. Kristen Ghodsee, "A Tale of Two Totalitarianisms: The Crisis
of Capitalism and the Historical Memory of Communism," *History
of the Present: A Journal of Critical History* 4, no. 2 (2014): 115–142;
Bulgarian woman in audience, personal email communication with
the author, 2011.

15. Costi Rogozanu, "Condamnarea ritualică a comunismului și
de unde începe reformarea stîngii," December 18, 2014, voxpublica
.realitatea.net/politica-societate/condamnarea-ritualica-a-comu
nismului-si-reformarea-reala-a-stingii-110586.html, translated and
quoted by Liviu Chelcea and Oana Druță, "Zombie Socialism and
the Rise of Neoliberalism in Post-Socialist Central and Eastern
Europe," *Eurasian Geography and Economics* 57, nos. 4–5 (2016):
521–544, 521.

16. Kristen Ghodsee and Scott Sehon, "Anti-Anti-
Communism," *Aeon.co*, March 22, 2018, aeon.co/essays/the-merits
-of-taking-an-anti-anti-communism-stance.

17. *World Happiness Report 2017*, worldhappiness.report
/ed/2017/; Katie Baker, "Cockblocked by Redistribution: A Pick-up
Artist in Denmark," *Dissent Magazine* (Fall 2013), www.dissent
magazine.org/article/cockblocked-by-redistribution; Roosh V., *Don't
Bang Denmark: How to Sleep with Danish Women in Denmark* (If
You Must) (self-published, 2011).

18. William Jordan, "Democrats More Divided on Socialism,"
Yougov.com, Jan. 28, 2016, today.yougov.com/topics/politics/

articles-reports/2016/01/28/democrats-remain-divided-socialism; Justin McCarthy, "In U.S., Socialist Presidential Candidates Least Appealing," Gallup, June 22, 2015, news.gallup.com/poll/183713/socialist-presidential-candidates-least-appealing.aspx; Catherine Rampell, "Millennials Have a Higher Opinion of Socialism Than of Capitalism," Washington Post, Feb. 5, 2016, www.washingtonpost.com/news/rampage/wp/2016/02/05/millennials-have-a-higher-opinion-of-socialism-than-of-capitalism; Marion Smith, "44% of Millennials Prefer Socialism. Do They Know What It Means?" Dissident, Nov. 2, 2017, blog.victimsofcommunism.org/44-of-millennials-prefer-socialism-do-they-know-what-it-means.

19. Victims of Communism Memorial Foundation (VOCMF), "Annual Report on Attitudes Towards Socialism," Oct. 2017, www.victimsofcommunism.org/survey.

20. George Orwell, 1984 (London: Harvill Secker, 1949).

21. See VOCMF mission statement, victimsofcommunism.org/education; see VOCMF educational initiatives, victimsofcommunism.org/initiative/educational-curriculum; Warner Todd Huston, "Billboards Against Communism Appear in New York's Times Square," Breitbart, Oct. 16, 2016, www.breitbart.com/big-government/2016/10/16/billboards-communism-appear-new-yorks-times-square/; Jacqueline Klimas, "Cold War Casualties of Communism Seek Museum on National Mall," Washington Times, June 17, 2014, www.washingtontimes.com/news/2014/jun/17/museum-honor-victims-communism-seek-spot-national-/; Ghodsee and Sehon, "Anti-Anti-Communism."

22. Patrick Sharkey, Figure 2 in Neighborhoods and the Black-White Mobility Gap, Pew Charitable Trusts, 2009, www.pewtrusts.org/en/research-and-analysis/reports/0001/01/01/neighborhoods-and-the-blackwhite-mobility-gap.

23. Baruch/Benedict Spinoza as quoted by David A. Teutsch, editor, Imagining the Jewish Future: Essays and Responses (Albany: SUNY Press, 1992), 139.

Notes to Chapter 1

1. George Bernard Shaw, An Intelligent Woman's Guide to Capitalism and Socialism (New York: Welcome Rain Publishers, 2016), 201.

2. Margaret Atwood, The Handmaid's Tale (New York: Houghton Mifflin Harcourt, 2017).

3. Marilyn Yalom, *The History of the Wife* (New York: Harper Perennial, 2001).

4. Shaw, *The Intelligent Woman's Guide*, 197.

5. Emily Shire, "Why Sexism Persists in the Culinary World," *Week*, Nov. 14, 2013, theweek.com/articles/456436/why-sexism -persists-culinary-world.

6. Richard Savill, "Harry Potter and the Mystery of J K's Lost Initial," *Telegraph* (London), July 19, 2000, www.telegraph.co.uk/news /uknews/1349288/Harry-Potter-and-the-mystery-of-J-Ks-lost-initial .html; Lillian MacNell, Adam Driscoll, and Andrea Hunt, "What's in a Name: Exposing Gender Bias in Student Ratings of Teaching," *Innovative Higher Education* 40, no. 4 (2015): 291–303.

7. Claudia Golden and Cecilia Rouse, "Orchestrating Impartiality: The Impact of 'Blind' Auditions on Female Musicians," *American Economic Review* 90, no. 4 (2000): 715–741.

8. Elaine Tyler May, *Homeward Bound: American Families in the Cold War Era* (New York: Basic Books, 1988); Anna Krylova, *Soviet Women in Combat: A History of Violence on the Eastern Front* (New York: Cambridge University Press, 2010).

9. International Labor Organization, "Women in Economic Activity: A Global Statistical Survey (1950-2000)," A Joint Publication of the International Labor Organization and INSTRAW, 1985.

10. Kristen Ghodsee, "Pressuring the Politburo: The Committee of the Bulgarian Women's Movement and State Socialist Feminism," *Slavic Review* 73, no. 3 (2014): 538–562.

11. Zsuzsa Ferge, "Women and Social Transformation in Central-Eastern Europe." *Czech Sociological Review* 5, no. 2 (1997): 159– 178, 161.

12. Niall McCarthy, "Scandinavia Leads the World in Public Sector Employment," *Forbes*, July 21, 2017, www.forbes.com/sites /niallmccarthy/2017/07/21/scandinavia-leads-the-world-in-public -sector-employment-infographic/#19dd03061820; OECD, *Government at a Glance*, 2017, 96, www.oecd.org/gov/government-at-a -glance-22214399.htm; Sheila Wild, "The Growing Gender Pay Gap in the Public Sector Is a Problem for Us All," Guardian (London), Nov. 9, 2016, www.theguardian.com/public-leaders-network/2015 /nov/09/growing-gender-gap-public-sector-equal-pay-day.

13. Michael Greenstone and Adam Looney, "Should the United States Have 2.2 Million More Jobs?" The Hamilton Project,

May 3, 2013, www.hamiltonproject.org/papers/does_the_united
_states_have_2.2_million_too_few_jobs; Dawn Foster, "Who works
where in the UK public sector?: the statistics," *The Guardian*, April
26, 2017, https://www.theguardian.com/wellbeing-at-work/2017/
apr/26/who-works-where-uk-public-sector.

14. David J. Deming, Noam Yuchtman, Amira Abulafi, Claudia
Goldin, and Lawrence F. Katz, "The Value of Postsecondary Creden-
tials in the Labor Market: An Experimental Study," *American Eco-
nomic Review* 106, no. 3 (2016): 778–806; Mehrsa Baradaran, "Postal
Banking Worked—Let's Bring It Back," *Nation*, Jan. 7, 2016, www
.thenation.com/article/postal-banking-worked-lets-bring-it-
back; Lisa Dando, "We supported women with complex needs.
What will they do now?" *The Guardian*, May 12, 2018, https://
www.theguardian.com/public-leaders-network/2018/may/12/
supported-women-complex-needs

15. Thomas Piketty, *Capital in the Twenty-First Century* (Cam-
bridge, MA: Harvard University Press, 2014); Oxfam International,
"Just 8 Men Own Same Wealth as Half the World," Jan. 16, 2017,
www.oxfam.org/en/pressroom/pressreleases/2017-01-16/just-8-men
-own-same-wealth-half-world. See also David Harvey, *Seventeen
Contradictions and the End of Capitalism* (Oxford: Oxford University
Press, 2014); Sif Sigmarsdottir, "Once More, Iceland Has Shown It
Is the Best Place in the World to Be Female," *Guardian* (London),
Jan. 5, 2018, www.theguardian.com/commentisfree/2018/jan/05
/iceland-female-women-equal-pay-gender-equality.

16. Center for American Progress, "Toward a Marshall Plan
for America: Rebuilding Our Towns, Cities, and the Middle Class,"
May 16, 2017, www.americanprogress.org/issues/economy/reports
/2017/05/16/432499/toward-marshall-plan-america; and Anne Low-
rey, "Should the Government Guarantee Everyone a Job?" *Atlan-
tic*, May 18, 2017, www.theatlantic.com/business/archive/2017/05
/should-the-government-guarantee-everyone-a-job/527208.

17. My description of the parable is a paraphrase based on the
notes I took after the sermon. For a further discussion of the social
justice implications of this parable, see Matthew Skinner, "Matthew
20:1-16: Justice Comes in the Evening," *HuffingtonPost*, September 14,
2011, www.huffingtonpost.com/matthew-l-skinner/parable-of-the
-workers-in-the-vineyard-commentary_b_961120.html.

18. Aditya Chakrabortty, "A Basic Income for Everyone? Yes,
Finland Shows It Can Really work," *Guardian* (London), Nov. 1,

2017, www.theguardian.com/commentisfree/2017/oct/31/finland
-universal-basic-income; for an excellent critique of UBI see
Alyssa Battistoni, "The False Promise of Universal Basic In-
come," *Dissent* (Spring 2017), www.dissentmagazine.org/article
/false-promise-universal-basic-income-andy-stern-ruger-bregman.

Notes to Chapter 2

1. A. Michael Spence, *Market Signaling: Informational Trans-
fer in Hiring and Related Screen Processes* (Cambridge, MA: Harvard
University Press, 1974).

2. Alfred Meyer, *The Feminism and Socialism of Lily Braun*
(Bloomington: Indiana University Press, 1986), 66.

3. International Socialist Congress, 1910; Second International
Conference of Socialist Women, archive.org/details/International
SocialistCongress1910SecondInternationalConferenceOf, 22.

4. Richard Stites, *The Women's Liberation Movement in Russia:
Feminism, Nihilism and Bolshevism, 1860–1930* (Princeton, NJ:
Princeton University Press, 1978); Gail Lapidus, *Women in Soviet
Society: Equality, Development, and Social Change* (Berkeley: Uni-
versity of California Press, 1978); Beatrice Brodsky Farnsworth,
"Bolshevism, the Woman Question, and Aleksandra Kollontai,"
American Historical Review 81, no. 2 (1976): 292–316, 296; Elizabeth
Wood, *The Baba and the Comrade: Gender and Politics in Revolution-
ary Russia* (Bloomington: Indiana University Press, 1997).

5. Alexandre Avdeev, Alain Blum, and Irina Troitskaya, "The
History of Abortion Statistics in Russia and the USSR from 1990 to
1991," *Population* 7 (1995): 452.

6. CESifo: DICE [Database for International Comparisons
in Europe], *Parental Leave Entitlements: Historical Perspectives*
(Around 1870–2014), www.cesifo-group.de/ifoHome/facts/DICE
/Social-Policy/Family/Work-Family-Balance/parental-leave
-entitlements-historical-perspective/fileBinary/parental-leave
-entitlements-historical-perspective.pdf.

7. Article 43, paragraph 1, *Constitution of the People's Republic
of Bulgaria*, 1971, parliament.bg/bg/19 (in Bulgarian); Milanka Vi-
dova, Nevyana Abadjieva, and Roumyana Gancheva, *100 Questions
and Answers Concerning Bulgarian Women* (Sofia, Bulgaria: Sofia
Press, 1983).

8. *Enhancing the Role of Women in the Building of a Developed*

Socialist Society: Decision of the Politburo of the Central Committee of the Bulgarian Communist Party of March 6, 1973 (Sofia: Sofia Press, 1974), 10.

9. Josie McLellan, *Love in the Time of Communism: Intimacy and Sexuality in the GDR* (New York: Cambridge University Press, 2011); Kristen Ghodsee, "Pressuring the Politburo: The Committee of the Bulgarian Women's Movement and State Socialist Feminism," *Slavic Review* 73, no. 3 (2014): 538–562.

10. A reader, personal email communication with the author, Oct. 4, 2017.

11. Kristen R. Ghodsee, "Sozialismus und Sex," *Die Weltwoche*, 2017, www.weltwoche.ch/ausgaben/2017-34/artikel/sozialismus -und-sex-die-weltwoche-ausgabe-342017.html; Cambridge Women's Pornography Cooperative, *Porn for Women* (San Francisco: Chronicle Books, 2007).

12. Myra Marx Ferre, *Varieties of Feminism: German Gender Politics in a Global Perspective* (Stanford, CA: Stanford University Press, 2012), 161; Cynthia Gabriel, "'Now It Is Completely the Other Way Around': Political Economies of Fertility in Re-Unified Germany," in *Barren States: The Population "Implosion" in Europe*, edited by Carrie B. Douglass (New York: Berg, 2005), 73–92.

13. Dagmar Herzog, *Sex After Fascism: Memory and Morality in Twentieth-Century Germany* (Princeton, NJ: Princeton University Press, 2005); Helen Frink, *Women After Communism: The East German Experience* (Lanham, MD: University Press of America, 2001).

14. Gail Kligman, *The Politics of Duplicity: Controlling Reproduction in Ceausescu's Romania* (Berkeley: University of California Press, 1998).

15. Jessica Deahl, "Countries Around the World Beat the U.S. on Paid Parental Leave," National Public Radio, Oct. 6, 2016, www.npr.org/2016/10/06/495839588/countries-around -the-world-beat-the-u-s-on-paid-parental-leave.

16. Steven Saxonberg and Tomas Sirovatka, "Failing Family Policy in Post-Communist Central Europe," *Journal of Comparative Policy Analysis* 8, no. 2 (2006): 185–202.

17. Susan Gal and Gail Kligman, *The Politics of Gender after Socialism* (Princeton, NJ: Princeton University Press, 2000).

18. Valentina Romei, "Eastern Europe Has the Largest Population Loss in Modern History," *Financial Times*, May 27, 2016,

www.ft.com/content/70813826-0c64-33d3-8a0c-72059ae1b5e3; Ruth Alexander, "Why Is Bulgaria's Population Falling Off a Cliff?" *BBC News*, Sept. 7, 2017, www.bbc.co.uk/news/world-europe-41109572.

19. CESifo: DICE, *Parental Leave Entitlements*; Nadja Popovich, "The US Is Still the Only Developed Country That Doesn't Guarantee Paid Maternity Leave," *Guardian* (London), Dec. 3, 2014, www.theguardian.com/us-news/2014/dec/03/-sp-america-only-developed-country-paid-maternity-leave.

20. Nancy L. Cohen, "Why America Never Had Universal Child Care," *New Republic*, April 24, 2013, newrepublic.com/article/113009 /child-care-america-was-very-close-universal-day-care; Richard Nixon, "387—Veto of the Economic Opportunity Amendments of 1971," Dec. 9, 1971, www.presidency.ucsb.edu/ws/?pid=3251.

21. "The Relation of Child Care to Cognitive and Language Development: National Institute of Child Health and Human Development Early Child Care Research Network," *Child Development* 71, no. 4 (2000): 960–980, and Ellen Peisner-Feinberg and Margaret Burchinol, "Relations Between Preschool Children's Child-Care Experiences and Concurrent Development: The Cost, Quality, and Outcomes Study," *Merrill-Palmer Quarterly* 43, no. 3 (1997): 451–477; John R. Lott Jr., personal email communication with the author, Aug. 14 and Aug. 15, 2017; John R. Lott, "Public Schooling, Indoctrination, and Totalitarianism," *Journal of Political Economy* 107, no. 6 (1999): S127–S157.

22. John R. Lott, "The New York Times Wants Us to Believe Communists Have Better Sex," *Fox News*, Aug. 14, 2017, www.foxnews .com/opinion/2017/08/14/new-york-times-wants-us-to-believe-com munists-have-better-sex.html.

Notes to Chapter 3

1. Pew Research Center, *Women and Leadership: Public Says Women Are Equally Qualified, but Barriers Persist*, Jan. 14, 2015, www.pewsocialtrends.org/2015/01/14/women-and-leadership.

2. All figures come from the website of the Inter-Parliamentary Union, www.ipu.org, particularly its database on women in politics: archive.ipu.org/wmn-e/classif.htm; House of Commons Library, "Women in Parliament and Government," February 6, 2018, https://researchbriefings.parliament.uk/ResearchBriefing/Summary/ SN01250

3. Data on the United States comes from Catalyst, "Women the S&P 500 Companies," www.catalyst.org/knowledge/women-sp-500-companies, and data on women in Scandinavia comes from a report by the Harvard Law School Forum on Corporate Governance and Financial Regulation, "Gender Parity on Boards Around the World," Jan. 5, 2017, corpgov.law.harvard.edu/2017/01/05/gender-parity-on-boards-around-the-world; Nathan Hegedus, "In Sweden, Women Make Up 45% of Parliament But Only 13% of Corporate Leadership," *Quartz.com*, Dec. 17, 2012, qz.com/37036/in-sweden-women-make-up-45-of-parliament-but-only-13-of-corporate-leadership; Cristina Zander, "Even Scandinavia Has a CEO Gender Gap," *Wall Street Journal*, May 21, 2014, www.wsj.com/articles/how-sandvik-scania-are-addressing-the-ceo-gender-gap-1400712884.

4. Ghodsee, "Pressuring the Politburo: The Committee of the Bulgarian Women's Movement and State Socialist Feminism," *Slavic Review* 73, no. 3 (2014): 538–562.

5. Clare Goldberg Moses, "Equality and Difference in Historical Perspective: A Comparative Examination of the Feminisms of the French Revolutionaries and the Utopian Socialists," in *Rebel Daughters: Women and the French Revolution*, edited by Sara Melzer and Leslie Rabine (New York: Oxford University Press, 1992), 231–253.

6. L. Goldstein, "Early Feminist Themes in French Utopian Socialism: The St.-Simonians and Fourier," *Journal of the History of Ideas* 43, no. 1 (1982); "Degradation of Women in Civilization," *Théorie des Quatre Mouvements et des Destinées Générales (The Theory of the Four Movements and of the General Destinies)*, 3rd ed. (originally published in 1808, this ed. 1841–1848, reprinted in *Women, the Family, and Freedom: The Debate in Documents, Volume One, 1750–1880*, edited by Susan Groag Bell and Karen M. Offen (Stanford, CA: Stanford University Press, 1983), 40–41.

7. S. Joan Moon, "Feminism and Socialism: The Utopian Synthesis of Flora Tristan," in *Socialist Women: European Socialist Feminism in the Nineteenth and Early Twentieth Centuries*, edited by Marilyn J. Boxer and Jean H. Quataert (New York: Elsevier, 1978).

8. Friedrich Engels, *The Origin of the Family, Private Property, and the State*, 1884, www.marxists.org/archive/marx/works/1884/origin-family/ch02c.htm.

9. Engels, *The Origin of the Family*.

10. See also Rochelle Ruthchild, *Equality and Revolution: Women's Rights in the Russian Empire 1905–1917* (Pittsburgh: University of Pittsburgh Press, 2010), 235, and Rochelle Ruthchild, "'Going to the Ballot Box Is a Moral Duty for Every Woman': The Great War and Women's Rights in Russia," in *Russia's Home Front in War & Revolution, 1914–22, Book 2: The Experience of War and Revolution*, edited by Adele Lindenmeyr, Christopher Read, and Peter Waldron (Bloomington, IN: Slavica, 2018), 1–38.

11. Louise Bryant, "Mirrors on Moscow," 1923, www.marxists .org/archive/bryant/works/1923-mom/kollontai.htm.

12. R. C. Elwood, *Inessa Armand: Revolutionary and Feminist* (New York: Cambridge University Press, 2002); Robert McNeal, *Bride of the Revolution: Krupskaya and Lenin* (Ann Arbor: University of Michigan Press, 1972); Cathy Porter, *Alexandra Kollontai: A Biography* (Chicago: Haymarket Books, 2014). On Russian literacy campaigns see Ben Eklof, "Russian Literacy Campaigns 1861–1939," in *National Literacy Campaigns* and *Movements: Historical and Comparative Perspectives*, edited by Robert F. Arnove and Harvey J. Graff (New Brunswick, NJ: Transaction Publishers, 2008), 128–129; Helen McCarthy and James Southern, "Women, Gender, and Diplomacy: A Historical Survey," in Gender and Diplomacy, edited by Jennifer Cassidy (New York: Routledge, 2017), 15–31, 24.

13. Anna Krylova, *Soviet Women in Combat: A History of Violence on the Eastern Front* (New York: Cambridge University Press, 2011).

14. Mateja Jeraj, "Vida Tomšič," in *A Biographical Dictionary of Women's Movements and Feminisms: Central, Eastern and South-Eastern Europe, 19th and 20th Centuries*, edited by Francisca de Haan, Krasimira Daskalova, and Anna Loutfi (Budapest: Central European University Press, 2006), 575–579; Chiara Bonfigioli, "Revolutionary Networks: Women's Political and Social Activism in Cold War Italy and Yugoslavia (1945–1957)," PhD diss., University of Utrecht, 2012.

15. Kristen Ghodsee, "The Left Side of History: The Legacy of Bulgaria's Elena Lagadinova," *Foreign Affairs*, April 29, 2015, www .foreignaffairs.com/articles/bulgaria/2015-04-29/left-side-history; Kristen Ghodsee, *The Left Side of History: World War II and the Unfulfilled Promise of Communism in Eastern Europe* (Durham, NC: Duke University Press, 2015); Krassimira Daskalova, "A Woman Politician in the Cold War Balkans: From Biography to History,"

Aspasia: The International Yearbook of Central, Eastern, and South-eastern European Women's and Gender History 10 (2016); and John D. Bell, *The Bulgarian Communist Party from Blagoev to Zhivkov* (Stanford, CA: Hoover Institution Press, 1985).

16. "A Girl Who Hated Cream Puffs," *Time*, Sept. 20, 1948, 33; W. H. Lawrence, "Aunty Ana," *New York Times*, Feb. 29, 1948; Robert Levy, *Ana Pauker: The Rise and Fall of a Jewish Communist* (Berkeley: University of California Press, 2001); Valentina Tereshkova, *Valentina Tereshkova, The First Lady of Space: In Her Own Words*, Spacebusiness.com, 2015.

17. Michael Parks, "Profile: Galina Semyonova: No Mere Token in Soviet Politburo," *Los Angeles Times*, Jan. 15, 1991, articles.latimes.com/1991-01-15/news/wr-327_1_soviet-union; Leonid Lipilin, "Woman of Action," *Soviet Life* (March 1991): 22–23; Bill Keller, "A Soviet Woman's Point of View," *New York Times*, Jan. 24, 1989, www.nytimes.com/1989/01/24/world/a-soviet-woman-s-point-of-view.html.

18. *Women in the Politics of Postcommunist Eastern Europe*, edited by Marilyn Rueschemeyer (Armonk, NY: M. E. Sharpe, 1998); Marilyn Rueschemeyer and Sharon Wolchik, editors, *Women in Power in Post-Communist Parliaments* (Bloomington: Indiana University Press, 2009); *The World's Women 1970–1990: Trends and Statistics*, United Nations, 1991; Kerin Hope, "Bulgaria Builds on Legacy of Female Engineering Elite," *Financial Times*, March 9, 2018, www.ft.com/content/e2fdfe6e-0513-11e8-9e12-af73e8db3c71; Peter Lentini, "Statistical Data on Women in the USSR," Lorton Paper #10, 1994.

19. Susan Wellford, "A Quota Worth Making," *U.S. News and World Report*, Feb. 21, 2017, www.usnews.com/opinion/civil-wars/articles/2017-02-21/the-us-should-consider-gender-quotas-to-increase-women-in-politics.

20. Quotas not only promote gender diversity but also increase the pool of qualified applicants overall. And some evidence suggests that corporations with more diversity on their boards are actually more profitable. Marcus Noland, Tyler Moran, and Barbara Kotschwar, "Is Gender Diversity Profitable? Evidence from a Global Survey," Working Paper Series of the Peterson Institute for International Economics, Feb. 2016; Margarethe Weirsema and Marie Louise Mors, "What Board Directors Really Think of Gender Quotas," *Harvard Business Review*, Nov. 14, 2016; Oliver Staley, "You Know Those Quotas for

Female Board Members in Europe? They're Working," *Quartz.com*, May 3, 2016, qz.com/674276/you-know-those-quotas-for-female -board-members-in-europe-theyre-working; and Daniel Boffey, "EU to Push for 40% Quota for Women on Company Boards," *Guardian* (London), Nov. 20, 2017, www.theguardian.com/world/2017/nov/20 /eu-to-push-for-40-quota-for-women-on-company-boards; Judith Turner, "Women make up less than a quarter of UK boardrooms," *The Guardian*, March 27, 2017, https://www.theguardian.com/ sustainable-business/2017/mar/27/women-make-up-less-than- a-quarter-of-uk-boardrooms

21. Pew Research Center, *Women and Leadership: Public Says Women Are Equally Qualified, but Barriers Persist*, Jan. 14, 2015, www.pewsocialtrends.org/2015/01/14/women-and-leadership.

22. The Rockefeller Foundation, "Women in Leadership: Why It Matters," May 12, 2016, www.rockefellerfoundation.org/report /women-in-leadership-why-it-matters, and KPMG, "KPMG Women's Leadership Study," Sept. 13, 2016, home.kpmg.com/ph/en/home /insights/2016/09/kpmg-women-s-leadership-study.html.

23. "A Girl Who Hated Cream Puffs," 33.

24. Slavenka Drakulić, *How We Survived Communism and Even Laughed* (New York: Harper Perennial, 1993), 31.

Notes to Chapter 4

1. Roy Baumeister and Kathleen Vohs, "Sexual Economics: Sex as Female Resource for Social Exchange in Heterosexual Inter-actions," *Personality and Social Psychology Review* 8, no. 4 (2004): 339–363.

2. Roy Baumeister, Tania Reynolds, Bo Winegard, and Kathleen Vohs, "Competing for Love: Applying Sexual Economics Theory to Mating Contests." *Journal of Economic Psychology* 63 (Dec. 2017): 230–241.

3. Baumeister et al., "Competing for Love."

4. See, for instance, Laurie A. Rudman, "Myths of Sexual Economics Theory: Implications for Gender Equality," *Psychology of Women Quarterly* 4, no. 3 (2017): 299–313.

5. The Austin Institute video *The Economics of Sex* can be found here: www.youtube.com/watch?v=cO1ifNaNABY. For an interest-ing critique of the effects on young people who watch it, see Laurie A. Rudman and Janelle Fetteroff, "Exposure to Sexual Economics Theory Promotes a Hostile View of Heterosexual Relationships,"

Psychology of Women Quarterly 4, no. 1 (2017): 77–88. On the economics of abortion, see George Akerlof, Janet Yellen, and Michael Katz, "An Analysis of Out-of-Wedlock Childbearing in the United States," *Quarterly Journal of Economics* 11, no. 2 (1996): 277–317. Shoshana Gossbard's works on the economics of love and marriage are also important precursors to sexual economics theory.

6. Simon Chang, Rachel Connelly, and Ping Ma, "What Will You Do If I Say 'I Do'?: The Effect of the Sex Ratio on Time Use Within Taiwanese Married Couples," *Population Research and Policy Review* 35, no. 4 (20164): 471–500, and Simon Chang and Xiaobo Zhang, "Mating Competition and Entrepreneurship: Evidence from a Natural Experiment in Taiwan," IFPRI Discussion Paper 01203, Aug. 29, 2013, papers.ssrn.com/sol3/papers.cfm?abstract_id=2143013.

7. Roy Baumeister and Juan Pablo Mendoza, "Cultural Variations in the Sexual Marketplace: Gender Equality Correlates With More Sexual Activity," *Journal of Social Psychology* 151, no. 3 (2011): 350–360.

8. Karl Marx and Friedrich Engels, *The Communist Manifesto*, 1848, www.marxists.org.

9. August Bebel, "Woman of the Future," in *Woman and Socialism*, translated by Meta L. Stern (New York: Socialist Literature, 1910), www.marxists.org/archive/bebel/1879/woman-socialism /index.htm.

10. Bebel, *Woman and Socialism*; John Lauritsen, "The First Politician to Speak Out for Homosexual Rights," 1978, paganpress-books.com/jpl/BEBEL.HTM. Although state socialist countries in the twentieth century would generally view homosexuality as an unfortunate remnant of bourgeois decadence to be persecuted, sexologists in Czechoslovakia and Eastern Germany would eventually take a less critical position, with the East Germans preparing to officially sanction same-sex relations right on the eve of the Berlin Wall's collapse. See Josie McLellan, *Love in the Time of Communism: Intimacy and Sexuality in the GDR* (New York: Cambridge University Press, 2011); Friedrich Engels, *The Origin of the Family, Private Property and the State*, 1884, www.marxists.org/archive/marx/works/1884 /origin-family/ch02c.htm.

11. John Simkin, "Alexandra Kollontai," Spartacus Educational, Sept. 1997, updated Oct. 2017, spartacus-educational.com /RUSkollontai.htm; Alexandra Kollontai, *Autobiography of a Sexually Emancipated Communist Woman*, 1926, www.marxists.org

/archive/kollonta/1926/autobiography.htm; Alexandra Kollontai, "Theses on Communist Morality in the Sphere of Marital Relations," 1921, www.marxists.org/archive/kollonta/1921/theses-morality.htm.

12. Cathy Porter, *Alexandra Kollontai: A Biography* (Chicago: Haymarket Books, 2014); Alix Holt, *Alexandra Kollontai: Selected Writings* (New York: W. W. Norton, 1980).

13. Kollontai, "Theses on Communist Morality."

14. Wendy Z. Goldman, *Women, the State, and Revolution: Soviet Family Policy and Social Life, 1917–1936* (Cambridge: Cambridge University Press, 1993), and Kollontai, *Autobiography.*

15. Data on 1922 Moscow students cited in Sheila Fitzpatrick, "Sex and Revolution: An Examination of Literary and Statistical Data on the Mores of Soviet Students in the 1920s," *Journal of Modern History* 50, no. 2 (1978): 252–278. See also Goldman, *Women, the State, and Revolution*; Richard Stites, *The Women's Liberation Movement in Russia: Feminism, Nihilism, and Bolshevism, 1860-1930* (Princeton, NJ: Princeton University Press, 1978); Gail Lapidus, editor, *Women, Work, and Family in the Soviet Union* (New York: Routledge, 1981); Gail Lapidus, *Women in Soviet Society: Equality, Development and Social Change* (Berkeley: University of California Press, 1978).

16. Frances Lee Bernstein, *The Dictatorship of Sex: Lifestyle Advice for the Soviet Masses* (DeKalb: Northern Illinois University Press, 2011).

Notes to Chapter 5

1. Mikhail Stern and August Stern, *Sex in the Soviet Union*, edited and translated by Mark Howson and Cary Ryan (New York: Times Books, 1980).

2. Anna Temkina and Elena Zdravomyslova, "The Sexual Scripts and Identity of Middle-Class Russian Women," *Sexuality & Culture* 19 (2015): 297–320, 306.

3. Temkina and Zdravomyslova, "The Sexual Scripts," 307.

4. Temkina and Zdravomyslova, "The Sexual Scripts," 308.

5. Peter Pomerantsev, *Nothing Is True and Everything Is Possible: The Surreal Heart of the New Russia* (New York: PublicAffairs, 2015).

6. Dagmar Herzog, *Sex After Fascism: Memory and Morality in Twentieth-Century Germany* (Princeton, NJ: Princeton University Press, 2007); Dagmar Herzog, "East Germany's Sexual Evolution," in *Socialist Modern: East German Everyday Culture and Politics*, edited by Katherine Pence and Paul Betts (Ann Arbor: University

of Michigan Press, 2008), 72. See also Donna Harsch, *Revenge of the Domestic: Women, the Family, and Communism in the German Democratic Republic* (Princeton, NJ: Princeton University Press, 2008).

7. Ingrid Sharp, "The Sexual Unification of Germany," *Journal of the History of Sexuality* 13, no. 3 (July 2004): 348–365.

8. Herzog, "East Germany's Sexual Evolution," 73.

9. Kurt Starke and Walter Friedrich, *Liebe und Sexalität bis 30* (Berlin: Deutcher Verlag der Wissenschaften, 1984), 187, 202–203, cited in Herzog, "East Germany's Sexual Evolution," 86.

10. Ulrich Clement and Kurt Starke, "Sexualverhalten und Einstellungen zur Sexualität bei Studenten in der DRD und in der DDR," *Zitschrift für Sexualforschung 1* (1988) cited in Herzog, "East Germany's Sexual Evolution," 87; Werner Habermehl, "Zur Sexualität Jugendlicher in der BRD und DDR," in *Sexualität BDR/DDR im Verhleich*, 20–40, 38; and Kurt Starke and Konrad Weller, "Differences in Sexual Conduct Between East and West German Adolescents Before Unification," paper presented at the Annual Conference of the International Academy of Sex Research, Prague, 1992, both cited in Sharp, "The Sexual Unification of Germany," 354–355.

11. Sharp, "The Sexual Unification of Germany," 356.

12. Paul Betts, *Within Walls: Private Life in the German Democratic Republic* (Oxford: Oxford University Press, 2013), and Josie McLellan, *Love in the Time of Communism: Intimacy and Sexuality in the GDR* (New York: Cambridge University Press, 2011).

13. Herzog, "East Germany's Sexual Evolution," 90.

14. All figures come from the first wave of the World Values Survey (1981–1984), using the "Online Data Analysis" webpage: www.worldvaluessurvey.org/WVSOnline.jsp.

15. Agnieszka Kościańska, "Sex on Equal Terms? Polish Sexology on Women's Emancipation and 'Good Sex' from the 1970s to the Present," *Sexualities* 19, nos. 1–2 (2016): 236–256. On the Polish women's committee see Jean Robinson, "Women, the State, and the Need for Civil Society: The Liga Kobiet in Poland," in *Comparative State Feminism*, edited by Dorothy McBride Stetson and Amy G. Mazur (Thousand Oaks, CA: Sage, 1995), 203–220, and Malgorzata Fidelis, *Women, Communism, and Industrialization in Postwar Poland* (New York: Cambridge University Press, 2014).

16. Agnieszka Kościańska, "Beyond Viagra: Sex Therapy in Poland," *Czech Sociological Review* 20, no. 6 (2014): 919–938, 919.

17. Agnieszka Kościańska, personal email communication with the author, Aug. 2017; Agnieszka Kościańska, "Feminist and Queer Sex Therapy: The Ethnography of Expert Knowledge in Poland," in *Rethinking Ethnography in Central Europe*, edited by Hana Cervinkova, Michal Buchowski, and Zdenek Uherek (New York: Palgrave MacMillan, 2015).

18. Agnieszka Kościańska, "Beyond Viagra: Sex Therapy in Poland," *Czech Sociological Review* 20, no. 6 (2014): 919–938.

19. See for instance, Maria Bucur, "Sex in the Time of Communism," 2012, www.publicseminar.org/2017/12/sex-in-the-time-of-communism, and Gail Kligman, *The Politics of Duplicity: Controlling Reproduction in Ceausescu's Romania* (Berkeley: University of California Press, 1998); Georgi Gospodinov, "Секс по време на социализъм: хигиена, медицина и физкултура" in Любовта при социализма, edited by Daniela Koleva (Sofia: RIBA, 2015). The quote comes from a public Facebook status update, Oct. 12, 2017.

20. Kateřina Lišková, "Sex Under Socialism: From Emancipation of Women to Normalized Families in Czechoslovakia," *Sexualities* 19, no. 2 (2016): 211–235.

21. The original study using only the 1992–1994 data is S. Kornrich, J. Brines, and K. Leupp, "Egalitarianism, Housework, and Sexual Frequency in Marriage," *American Sociological Review* 78 (2013): 26–50. The follow-up study using the 1992–1994 data and the 2006 data is Daniel Carlson, Amanda Miller, Sharon Sassler, and Sarah Hanson, "The Gendered Division of Housework and Couples' Sexual Relationships: A Re-Examination," *Journal of Marriage and Family* 78, no. 4 (2016): 975–995.

22. The longitudinal study of German couples is M. D. Johnson, N. L. Galambos, and J. R. Anderson, "Skip the Dishes? Not So Fast! Sex and Housework Revisited," *Journal of Family Psychology* 30, no. 2 (2016): 203–213.

23. Mark Fisher, *Capitalist Realism: Is There No Alternative?* (Ropley, Hampshire, UK: Zero Books, 2009).

24. On emotional labor, see Arlie Russell Hochschild, *The Managed Heart: Commercialization of Human Feeling* (Berkeley: University of California Press, 2012).

25. Elizabeth O'Brien, "People Are Stalling Their Divorce So They Don't Lose Health Care," *Time*, July 24, 2017, time.com/money/4871186/people-are-stalling-their-divorce-so-they-dont-lose-health-care.

26. Albert Einstein, "Why Socialism?," *Monthly Review* 1 (1949), monthlyreview.org/2009/05/01/why-socialism.

Notes to Chapter 6

1. For information on the Borg, see www.startrek.com/database_article/borg; Francis Fukuyama, *The End of History and the Last Man* (New York: Free Press, 1992).

2. Alexei Yurchak, *Everything Was Forever Until It Was No More* (Princeton, NJ: Princeton University Press, 2005).

3. This quote is attributed to Margaret Mead, although there is no written source. A full explanation of the quote can be found on the website of the Institute for Intercultural Studies: www.interculturalstudies.org/faq.html.

4. Seema Mehta, "Trump Backers Tweet #Repealthe19th After Polls Show He'd Win If Only Men Voted," *Los Angeles Times*, Oct. 12, 2016, www.latimes.com/nation/politics/trailguide/la-na-trailguide-updates-trump-backers-tweet-repealthe19th-1476299001-htmlstory.html.

5. Matthew Biedlingmaier, "Coulter: 'If We Took Away Women's Right to Vote, We'd Never Have to Worry About Another Democrat President,'" Media Matters, Oct. 4, 2007, www.mediamatters.org/research/2007/10/04/coulter-if-we-took-away-womens-right-to-vote-we/140037.

6. John R. Lott and Lawrence Kenny, "Did Women's Suffrage Change the Size and Scope of Government?" *Journal of Political Economy* 107 (1999): 1163–1198, 1164.

7. See the website The Curse of 1920: thecurseof1920.com/index.html.

8. Gary D. Naler, *The Curse of 1920: The Degradation of Our Nation in the Last 100 Years* (Salem, MO: RTC Quest Publications, 2007), 48; Roosh V, "How to Save Western Civilization," Rooshv.com, March 6, 2017, www.rooshv.com/how-to-save-western-civilization. The original Ramzpaul essay "How Female Suffrage Destroyed Western Civilization" was reposted here: www.theapricity.com/forum/showthread.php?164336-How-Female-Suffrage-Destroyed-Western-Civilization.

9. Julia Mead, "Why Millennials Aren't Afraid of Socialism," *Nation*, Jan. 10, 2017, www.thenation.com/article/why-millennials-arent-afraid-of-the-s-word.

10. Sarah Leonard, "Why Are So Many Young Voters Falling for Old Socialists?" *New York Times Sunday Review*, June 16, 2017, www.nytimes.com/2017/06/16/opinion/sunday/sanders-corbyn-socialsts.html.

11. Richard Fry, "Millennials and Gen Xers Outvoted Boomers and Older Generations in 2016 Election," *FactTank*, July 31, 2017, www.pewresearch.org/fact-tank/2017/07/31/millennials-and-gen-xers-outvoted-boomers-and-older-generations-in-2016-election.

12. Mark Fisher, "Why Mental Health Is a Political Issue," *Guardian* (London), July 6, 2010, www.theguardian.com/commentisfree/2012/jul/16/mental-health-political-issue.

13. David Harvey, *Seventeen Contradictions and the End of Capitalism* (Oxford: Oxford University Press, 2015).

INDEX